How the West Was Drawn

American Art and the
Settling of the Frontier

Studies in the Fine Arts: Iconography, No. 6

Linda Seidel, Series Editor

Associate Professor of Art History
University of Chicago

Other Titles in This Series

How the West Was Drawn
American Art and the
Settling of the Frontier

by
Dawn Glanz

UMI RESEARCH PRESS
Ann Arbor, Michigan

Produced and distributed by
UMI Research Press
an imprint of
University Microfilms International
Ann Arbor, Michigan 48106

Library of Congress Cataloging in Publication Data

Glanz, Dawn.
How the West was drawn.

(Studies in fine arts. Iconography ; no. 6)
Revision of the author's thesis: University of North
Carolina at Chapel Hill, 1978.
Bibliography: p.
Includes index
1. West (U.S.) in art. 2. Art American. 3. Art, Modern
—19th century—United States. I. Title. II. Series.

N8214.5.U6G53 1982 704.9′49978 81-16218
ISBN 0-8357-1276-1 AACR2

Contents

List of Figures

Preface

This study is an exploratory probe into the iconography of America's westward expansion in the nineteenth century, as found in the visual arts up to about 1870. It is exploratory because iconographic studies which embrace major questions in American history and culture have been sadly neglected in the past; and it therefore seemed necessary first to demonstrate that images dealing with the West can, in fact, be discussed in relation to substantive issues in American culture studies. Although this project does not attempt to provide a complete catalogue of the paintings, sculpture, and graphic art relevant to the topic, it does consider in some depth certain examples which seem to touch on the broader concerns, offering some new interpretations based on an understanding of these issues.

Several scholars (among them Henry Nash Smith, Richard Slotkin, Arthur Moore, and Roderick Nash, to name just a few), have already studied the American West, the frontier, and the wilderness as imaginative constructs in nineteenth century thought. Exploring the ideologies surrounding these concepts, they have identified as fundamental concerns such issues as: the white man's relationship to nature and to the Native American; the conflict of values between the wilderness and civilization; the American sense of national mission; and the nature of progress on the American continent. Although I am indebted to them for providing the conceptual framework in which to examine the visual material, my intent has not been merely to provide illustrations for their work. Because this study is an art historical discussion, I have organized it on the basis of the data presented by the visual material—the recurring themes and motifs found in the images of westward expansion. The methods of art history, investigating the visual traditions behind these motifs, have considerably expanded their interpretations, which in turn have given us a greater understanding of the larger issues involved.

The amount of visual material pertinent to the topic of westward expansion is so great as to be almost overwhelming. I have thus selected for close study only four of the many themes subsumed in the larger topic: Daniel Boone; the personalities of the fur trade; pioneers and homesteaders on the

frontier; and western wild animals. These topics are related to one another in a thematic and historical sequence. The first chapter is devoted to the imagery of Daniel Boone, America's archetypal pioneer and western hero. As one of the first explorers of the trans-Allegheny interior in the late eighteenth century, he became the spiritual father of the explorers of the trans-Mississippi West in the nineteenth century—the Rocky Mountain fur trappers, whose portrayal in the visual arts is the subject of Chapter 2. The 1830s witnessed the golden age of the Missouri and Rocky Mountain fur trade industry, but in the following decade the dominance of fur trappers in the Far West was eclipsed by pioneer emigrants to Oregon and California. Both literally and figuratively following in the footsteps of the trappers (many of whom served as guides for wagon trains), these emigrants plodded westward towards the Pacific Coast to build new settlements in the Far West. The appearance of these pioneers and homesteaders in the visual arts is the subject of Chapter 3. Finally, in the fourth chapter, the imagery of western wild animals—representatives of a wilderness radically transformed in the third quarter of the century by the advance of American civilization—is examined.

Each chapter constitutes a separate essay on a distinct iconographic problem, and each has its own internal method of organization dictated by the nature of the topic and the images discussed. My justification for this approach is that it seemed more honest and logical than attempting arbitrarily to impose a preconceived method upon the material. There was, nevertheless, a unifying principle guiding the organization and development of each discussion: the desire to interpret the images from the soundest possible understanding of American culture. If the interpretations offered in these essays are open to dispute, I hope that at least the value of attempting them has been demonstrated.

A Hero for All Seasons:
Daniel Boone in the Visual Arts

Daniel Boone (1735-1820) was not the first pioneer of the American West, nor were his achievements in exploring and settling Kentucky unique among those of the many frontiersmen who helped to open the trans-Allegheny regions to American settlement in the late eighteenth century. However, his reputation as the archetypal Western hero has far exceeded those of such contemporaries as John Finley, Simon Kenton, or James Harrod, and has indeed taken on mythic proportions.[1] As a consequence, in the nineteenth century he became the subject of a sizeable body of images in American art. His exploits were commemorated in history paintings and in sculpture; and his portrait adorned popular prints, books on American history and biography, and even bank notes.

The genesis of the Daniel Boone myth lies in the biography of Boone published in 1784 and written by John Filson, a Delaware schoolteacher who had just spent two years with Boone in Kentucky.[2] Written in the first person, this account was supposedly an autobiography dictated by Boone himself, which Filson appended to his *Discovery, Settlement, and Present State of Kentucke*.[3] Filson's account went through several editions before 1800, including foreign language translations into French and German published in Europe.[4] As a result Boone became something of an international figure, appealing to European as well as to American intellectuals.[5]

As Filson presented him, Boone was indeed a perfect representative of Rousseau's "natural man." A backwoodsman with a lifelong passion for hunting, he loved forest solitudes and cheerfully endured the dangers and deprivations of life in the wilderness. His experiences even made him something of a philosopher. At one point in the narrative he comments:

> ...I firmly believe it requires but a little philosophy to make a man happy in whatsoever state he is...; and a resigned soul finds pleasure in a path strewed with briars and thorns.[6]

Later, when describing one of his lonely stints in the Kentucky forests, he

confesses that he "never before was under greater necessity of exercising philosophy and fortitude." Nature's solitude, then, had the rewards of fostering strength of character and a philosophic turn of mind.

But Filson, like many of his fellow countrymen, was ambivalent in his attitude towards the wilderness environment.[7] Sensitive to the demands of his age for progress and the advance of civilization, he recognized in the wilderness a savage state that was the very antithesis of civilization. This wilderness had to be tamed and subdued in order that a new, fresh civilization might rise "from obscurity to shine with splendor." Boone played a role in this scenario as "an instrument ordained to settle the wilderness," bringing order out of the chaos of nature. Thus Filson linked Boone with the destiny of the young American nation in the West, a relationship implied by these words which he put into Boone's mouth in the opening paragraph of his narrative:

> Thus we behold Kentucke, lately an howling wilderness, the habitation of savages and wild beasts, become a fruitful field; this region, so favorably distinguished by nature, now become the habitation of civilization.[8]

The Boone of Filson's creating was thus a dualistic character—at the same time a philosopher of nature and the agent of civilization. Both aspects of this image found enthusiastic proponents in the nineteenth century. As the instrument of civilization Boone is the hero of Daniel Bryan's epic poem *The Mountain Muse,* a grandiose effort seemingly meant to rival Milton's *Paradise Lost.* As the child of nature he makes a cameo appearance in Lord Byron's *Don Juan*, which in turn inspired later American verse.[9] So versatile was the Boone myth as formulated by Filson, so susceptible was it to varying interpretations, that Daniel Boone throughout the nineteenth century came to serve a variety of interrelated ideologies concerning the progress of American civilization, and to epitomize the American experience in the wilderness and on the frontier.

Visual images of Daniel Boone from this period reflect these multiple interpretations of his significance, but in general it can be said that the images evolved from a romantic to a nationalistic interpretation as the American frontier moved west, and as Boone's importance expanded from the local to the national sphere.

Portraiture

In spite of the fact that Filson's biography made Boone a well-known figure even before 1800, no American artist bothered to paint a portrait of the hero until a few months before his death in 1820.[10] In June of that year the young Chester Harding set out into the Missouri backwoods to seek out

Colonel Daniel Boone (then in his eighty-seventh year) to paint his portrait. In his autobiography Harding tells us that he had to travel over one hundred miles from St. Louis before he could locate Boone, who was living in a log cabin at a considerable distance from the main road, and apparently was not very well known to his neighbors. Harding's account of his meeting with the octogenarian reveals a good deal about the artist's sense of humor. It also hints at Boone's condition during the last few weeks of his life, and, when compared to the portraits that resulted from the episode, it provides some indication of the degree to which Harding idealized his sitter:

> I found the object of my search engaged in cooking his dinner. He was lying in his bunk, near the fire, and had a long strip of venison wound around his ramrod, and was busy turning it before a brisk blaze, and using salt and pepper to season his meat. I at once told him the object of my visit. I found that he hardly knew what I meant. I explained the matter to him, and he agreed to sit. He was ninety years old, and rather infirm; his memory of passing events was much impaired, yet he would amuse me every day by his anecdotes of his earlier life. I asked him one day, just after his description of one of his long hunts, if he never got lost, having no compass. "No," said he, "I can't say as ever I was lost, but I was *bewildered* once for three days."[11]

Less than four months, later, on September 16, 1820, Daniel Boone died. The painting by Harding thus became the only portrait of the pioneer known indisputably to have been painted from life by an American artist.[12] From this original, Harding himself made several copies and also created two variants: a full-length portrait, and a half-length portrait of Boone in a fur collar. Artists who subsequently wished to portray Boone had to consult Harding's portraits for an authoritative likeness of the hero, or else they had to compose from imagination.[13]

Iconographically Harding's portraits are extremely interesting. The half-length *Boone in a Fur Collar*, illustrated here (fig. 1) as it was engraved by J. P. Longacre in 1835 (see below, p. 4), can be related to a group of portraits of prominent figures of the Enlightenment who were depicted in costumes with fur trimming. The prototype for these portraits was Allan Ramsay's portrait of Jean Jacques Rousseau in a fur cap and fur collar, which was followed by several portraits of Benjamin Franklin wearing either his famous Canadian fur cap or a coat with a fur collar.[14] In 1805 Rembrandt Peale painted a portrait of Thomas Jefferson in a fur collar (New York Historical Society; fig. 2).[15]

According to art theory regarding portraiture which had been formulated in the sixteenth and seventeenth centuries, a sitter's costume was the means by which his status in life was to be indicated.[16] As Charles Sellers has pointed out, the fur trim in the portraits of Rousseau, Franklin, and Jefferson functioned as a kind of status symbol acceptable to those who rejected status—an attribute, in other words, of the liberal-minded man of the

Enlightment, the child of truth and of nature.[17] In appropriating the motif for the portrait of Daniel Boone, Harding borrowed from and significantly expanded the iconographic tradition. Boone took his place with Franklin and Jefferson as one of America's illustrious philosophers and statesman, and also as a perfect representative of Rousseau's "natural man". Boone's status differed from that of Franklin and Jefferson in at least one very important way, however. The prominently displayed hunting knife stuck through Boone's belt testifies to the fact that he lived and hunted in the wilderness and derived his very livelihood from her resources; hence his knowledge of nature was much more intimate than that of his cosmopolitan fellow-countrymen.

Although the exact date of the fur collar portrait has not been determined, presumably Harding painted it within one or two years of completing the original portrait which he painted from life. James P. Longacre engraved the *Boone in a Fur Collar* in 1835 for inclusion with the biography of Boone in that year's edition of the *National Portrait Gallery of Distinguished Americans.* Along with its many imitations by other artists,[18] this portrait of Boone helped to shape Americans' image of Boone's physical appearance, and, more importantly, to fix his identity as a frontiersman and a hunter. Moreover, through its visual connections with well-known portraits of Franklin and Jefferson, the portrait helped to establish Boone as the equal to these two revered American statesmen and philosophers.

Harding's full-length portrait of Boone, the original of which is now lost, exists today as an engraving by James O. Lewis that was published jointly by Harding and the engraver sometime late in 1820, following news of Boone's death (fig. 3).[19] It would be safe to attribute the regrettably poor quality of the print not to Harding's design, but rather to the uncultivated talents of the engraver, who lived in the frontier town of St. Louis, miles away from the eastern centers of artistic instruction and activity. It is also likely that the engraving was rather hastily executed to take commercial advantage of public sentiment for Boone aroused by news of his death. We are therefore justified in considering it something of a commemorative image, and indeed the contrasting dead and blossoming branches of the tree immediately behind Boone suggest a death-and-immortality motif.

The format of Harding's design follows the tradition of the hunting portrait as exemplified by eighteenth century English paintings in which the subject is placed in landscape setting, holding his gun and accompanied by his dog.[20] Harding may have been familiar with this English tradition through engravings or copies of such portraits; however, in costume Harding's Boone differs decidely from the gentlemen-hunters of England and

Europe. His buckskins are the clothes of the frontiersman who hunts for a living, not the fashionable attire worn by Europeans for whom hunting was a gentlemanly pastime. Boone's gun, the long and graceful Kentucky rifle, is a weapon that had come to be associated with the frontier because of its unique characteristics—its lightness, length, and accuracy—which had evolved to suit the particular demands of frontier life.[21] Even the cleanly-sawn log lying behind Boone refers to the frontiersman's task of clearing forests for future settlement.

Harding's portrait of Boone appeared at a time when the American public was becoming increasingly aware of the frontiersman as a unique and special kind of American. In the years following the War of 1812, westward migration into the Mississippi and Missouri territories became a national phenomenon of immense proportions.[22] In their role as the pioneers for this expansion, the frontier hunters were beginning to enjoy special renown and admiration. There arose, for example, a folk legend about the valor and heroism of the Kentucky backwoodsmen, to whom was credited the American victory in the Battle of New Orleans in early 1816.[23] Public admiration surfaced in a popular song of 1822 entitled "The Hunters of Kentucky," which gives an inaccurate but popularly accepted account of how Kentucky sharpshooters saved the day against the British at New Orleans.[24] Although Harding's portrait precedes the song by a year and a half, its image of Boone as a rugged backwoodsman reflects the same appreciative national mood that celebrated the virtues of the frontiersmen. Considered in this light, the portrait coincides with other symptoms of the rise of Jacksonian democracy.

It was in his role as a representative frontiersman of energetic and enterprising character that Daniel Boone gained increasing importance in the nineteenth century. His individual accomplishments grew in significance because they fit nicely into the larger scheme of American history that was steadily unfolding on the westward-moving frontier. Americans revered Boone not so much because he had led his family to settle in Boonesborough, but because his effort was one of a whole series of moves that eventually led to the "opening of the west," and could thus be made to symbolize the entire phenomenon of westward expansion.

We have dwelt at length on the Harding portraits because of their seminal position in the creation of Daniel Boone imagery, and also because they successfully reconciled two inclinations: one to dignify and exalt this national hero and the other to identify him with the common man. Many, but not all, of the portraits of Boone that appeared after 1820 took Harding's images as their inspiration or model. Certainly many of these later portraits relied on Harding's depiction of Boone for the physical characteristics of

the hero. The following discussion focusses on some of the more iconographically significant examples.

James P. Longacre, the artist who engraved Harding's *Boone in a Fur Collar,* designed a standing portrait-image of Boone possibly inspired by the Harding-Lewis engraving. (Compare the forest setting and the appearance of Boone with his white hair and fur trimmed hunting jacket.[25]) The image was incorporated into designs for banknotes for the state of Missouri and for the Republic of Texas (fig. 4), the latter dating from sometime after 1838.[26] Because Boone spent his last years in Missouri, and was therefore one of the state's most distinguished past residents, his appearance on one of its banknotes is not unusual. However, Boone never set foot inside Texas, and his inclusion on the Texas note must therefore be justified by other reasons.

The colonists who had settled Texas and helped win its independence from Mexico had originally been residents of the United States. As citizens of the new Texan Republic, they voted in 1836 to request admission to the Union as a state. Because of antiexpansionist sentiment in the United States, however, the request was denied and Texas was not annexed until 1845. In the meantime, by appropriating Daniel Boone as a symbol for their Republic, Texans were in effect attempting to establish the legitimacy of their relationship to the United States. The pioneers who settled Texas were Boone's successors and belonged to the same stock as the settlers in Missouri who had won statehood years earlier. The image of Boone on the Texas banknote proves that by the late 1830s he had become a symbol of the pioneering spirit which had led Americans not only into the trans-Allegheny regions (which Boone had actually explored himself), but further into the trans-Mississippi and Southwest regions as well.

There are three full-length portraits of Boone which depict him seated in a landscape setting, a significant variation on the Harding-Lewis standing portrait. Two of the designs, those by John G. Chapman and Alonzo Chappell, are known through engravings published in 1836 and 1861 respectively. The third portrait is a life-size painting by William C. Allen done in 1839.

Chapman's design, engraved on wood by William Redfield, appeared in the Cincinnati *Family Magazine* for March 1836.[27] A dark-haired and contemplative Boone, dressed in buckskins, fur-trimmed hunting jacket, and felt hat, sits casually on a rock on a high eminence beneath which stretches a flat landscape with a river winding its way into the distance. The image may have been inspired by a passage from Filson's narrative in which Boone describes an impressive vista discovered during one of his expeditions into the Kentucky wilderness:

I had gained the summit of a commanding ridge, and, looking round with astonishing delight, beheld the ample plains, the beauteous tracts below. On the other hand, I surveyed the famous river Ohio that rolled in silent dignity, marking the western boundary of Kentucke with inconceivable grandeur. At a vast distance I beheld the mountains lift their venerable brows, and penetrate the clouds. All things were still.[28]

The thoughtful mood of Chapman's Boone fits the tenor of this passage and corresponds to many other descriptions of Boone's contemplative nature found in Filson's biography and in its many imitations in the late eighteenth and nineteenth centuries.[29] Clearly the image illustrates the romantic, Rousseau-ian Boone: the solitary, meditative hero absorbed in the beauty of his natural surroundings, the wilderness philosopher.

As I have suggested before, this romantic notion of Boone was not the sole interpretation available in the decade of the 1830s. On Longacre's banknotes, as we have seen, Boone posed as a symbol of the pioneering (hence progressive) spirit of Anglo-Saxon Americans. In the portrait by William Allen (Frankfort, Ky., Kentucky State Historical Society), Boone appears as the active man. Although the hero is again seated in a landscape setting, the scene has significantly shifted to a darkened forest. Rather than resting thoughtfully, Boone is alert and poised in readiness for action, his right hand touching the trigger of his rifle, his attention focussed on something beyond the boundaries of the picture. The contraposto pose of his body conveys greater dynamism and physical energy than Chapman's contemplative figure. Allen's interpretation presents Boone as the vigilant Indian fighter, responding instantly to warnings of danger.

The state of Kentucky purchased Allen's painting in 1840, choosing it over Chester Harding's original portrait which had already been hanging in the State Capitol for several years on loan from the artist.[30] Public taste at the beginning of the decade of Manifest Destiny preferred an image of Boone as an ever-ready frontiersman to an authoritative likeness painted from life which offered a less romantic interpretation.

Alonzo Chappell's portrait of Boone, engraved and reproduced in *The National Portrait Gallery of Eminent Americans* of 1861 (fig. 5), mediates between these two images of Boone as the active and the contemplative man. In Chappell's portrait Boone is seated on a rock, and leaning forward, and casually resting his arm on his knee; yet, as in Allen's painting, he turns his head alertly to his right to study something outside the pictorial field. For Boone's physical appearance, Chappell seems to have consulted Longacre's engraving of Harding's *Boone in a Fur Collar*. Boone has the same white hair curled close to his face, the same downward curving mouth, the same white shirt trimmed in fur at the collar and shoulders. As was previously noted, Longacre's engraving had appeared in the 1835 edition of the *National Portrait Gallery of Distinguished Americans*, and it

seems likely that Chappell, commissioned to produce a portrait for a similar collection of biographies, would have turned to this earlier image as a starting point for his own effort.[31]

While the motif of Boone seated with rifle on a rock in a landscape setting resembles the Chapman design discussed above, Chappell's image is not necessarily a deliberate imitation of Chapman. There are other examples of the motif which suggest that it was part of a visual tradition of depicting illustrious frontiersmen dressed in hunting regalia and placed in natural settings. A particularly fine and significant example, and one which Chappell might have known, is a portrait of the distinguished artist and naturalist John James Audubon (New York, Museum of Natural History) painted by his son John Woodhouse Audubon, probably sometime after 1840.[32] The elder Audubon is seated on a rock, holding his rifle, and accompanied by his horse and dog.[33]

Audubon and Boone were representatives of what C. W. Webber, a nineteenth-century author of books on hunting and sporting, termed the "Hunter-Naturalist," which he defined as:

> ...something of the Primitive Hunter and modern Field-Naturalist combined. The name best defines itself—since *Hunter*-Naturalist implies at once a rugged and free-booter intrusion into the realms of Nature, in which the nice mail of Science has exchanged its glitter and its polish for the greasy, powder-blackened, blood-stained buckskins of the rough, earnest wilderness.[34]

Webber even linked Boone and Audubon as kindred spirits in the following passage from his account of Audubon's career:

> Before and during this most erratic period of Audubon's long life of vicissitude and exposure, these same solitudes amidst which he wandered knew another shaggy presence even better than his own. The same earthquakes, the same hurricanes, and the same red foe had beset the path of Daniel Boone—and he, too,...was a Hunter-Naturalist! Though his deeds and aims were not after the manner of those of Audubon, yet were they as grand, and their lives, how much alike.[35]

Total absorption in nature of the wilderness was the common bond linking Boone and Audubon, and the motif of the seated hunter in a landscape setting was an appropriate visual statement of this characteristic. The frontiersman thus depicted again plays a dual role as the wilderness hunter and as the thoughtful student of nature.

Narrative Images

The portraits discussed above illustrate the versatility of Boone's reputation, which allowed him to be identified as an enlightened man of nature, as

a contemplative child of the wilderness , and as an ever-ready frontiersman. The remainder of this discussion will examine images—chiefly narrative—in which Boone appears as part of a larger program. Although the meanings of these images will necessarily be somewhat more complex, their depictions of Boone evidence the same variety of interpretations to be found in the portraits.

The earliest narrative image of Boone is an engraving published in 1812 as a frontispiece in Humphrey Marshall's *History of Kentucky* (fig. 6). It illustrates an attack of Indians upon Daniel Boone, his brother Squires, and their companion John Stewart. Rather than calling attention to Daniel's heroic deeds the illustrator has focussed instead on the savagery of the Indians, particularly on their practice of scalping, which constitutes the central incident in the illustration.

This image must be understood in reference to an entire set of attitudes regarding the Indian that grew out of the early colonial experience of the Puritans in the seventeenth century, and which persisted into the nineteenth century.[36] In the eyes of English colonists living in a hostile environment remote from the society and civilization to which they were accustomed, the Native Americans with their strange ways of life came to be regarded as the very personifications of the devil and of his dark and evil powers. The colonists, perhaps justifiably, regarded the Indian as treacherous and unpredictable. Therefore they feared him, attempted to subdue and control him, and then sought ways to rationalize their treatment of him (which was often as brutal as the deeds of the savages themselves). Narratives of Indian wars and captivities not only described the harrowing experiences confronting the colonists, but also tried to explain the deeper meaning of these experiences in terms of individual and collective salvation.[37] The more savage the deeds of the Indian, the more severe the trial to Christian faith, and therefore the greater the victory for those fortunate enough to survive the ordeal.

This American fascination for and preoccupation with savagism had found its most succinct expression in the visual arts early in the nineteenth century in illustrations of the murder of Jane McCrea, of which John Vanderlyn's painting of 1804 in the Wadsworth Atheneum in Hartford, Connecticut (fig. 11), is perhaps today the best and most widely-known example.[38] Book illustrations of the theme, however, were more readily available to the American public at this time, and the frontispiece to Marshall's book belongs to this tradition of illustrations depicting Indian attacks.[39] There were as yet no visual traditions for depicting themes of exploration, emigration, or pioneer settlement, nor had Boone's deeds and achievements attained sufficient significance on a national level to inspire or

warrant serious consideration in painting. In fact, there was not much history painting of any kind in the young Republic, much less an established tradition which would encourage the depiction of notable events from the lives of American heroes.[40]

Early in his career, around 1826, Thomas Cole painted an American landscape of a lake, rock formations, and wilderness forest which included in the lower left corner a depiction of the aged Daniel Boone seated on a rock outside the door of his cabin and accompanied by his dog (Amherst, Mass., Amherst College; fig. 7).[41] Epitomizing the romantic concept of Boone inherent in Filson's biography, the painting is one of the most significant renditions of the hero done in the nineteenth century. The immediate inspiration for Cole's depiction was not Filson's account, however, but the description of Boone found in Lord Byron's epic romance, *Don Juan.*

In view of Boone's popularity among European intellectuals (see above, p. 1), it is not altogether surprising to find the hero figuring in the poetry of the notorious English romantic. Byron evidently found in Boone the paragon of Rousseau's natural man, and in Canto VIII of *Don Juan,* he eulogizes Boone as a refugee from society, the solitary and reclusive child of nature:

> Of all men, saving Sylla the man-slayer,
> Who passes for in life or death most lucky,
> Of the great names which in our faces stare,
> The General Boone, backwoodsman of Kentucky,
> Was happiest amongst mortals anywhere;
> For killing nothing but a bear or buck, he
> Enjoy'd the lonely, vigorous, harmless days
> Of his old age in wilds of deepest maze.
>
> Crime came not near him—she is not the child
> Of solitude; Health shrank not from him—for
> Her home is in the rarely trodden wild...
> ...Boone lived hunting up to ninety...
>
> An active hermit, even in age the child
> Of Nature...
>
> (Stanzas LXI-LXII)

Byron's point was to contrast the virtues of the natural life, exemplified in Boone, with what he ironically terms the "great joys" of civilization: "War, pestilence, the despot's desolation,/ The kingly scourge, the lust of notoriety,/ The millions slain by soldiers for their ration" (Stanza LXVIII).

As an American artist seeking suitable American themes for his paintings, Thomas Cole would naturally have taken an interest in Byron's interpretation of the popular American hero. Cole read and admired the English poet and found himself in sympathy with Byron's attitudes towards nature and civilization. Several times during his career, in fact, he proposed subjects from Byron's poetry for his paintings.[42] His depiction of Daniel Boone probably visualizes the reclusive frontiersman described by Byron as living in "wilds of deepest maze" and active into advanced old age. But Cole was not merely illustrating Byron's verses. Drawing upon Christian iconographic traditions, the painter elaborated on Byron's interpretation by representing Boone as a modern-day wilderness saint.

Christian hagiography presents several instances of saints, such as Jerome or Francis, who withdrew themselves from society into the wilderness to ponder in solitude the meaning of the Scriptures. The outcome of their experiences was divine revelation. In the visual arts (and particularly in the Northern European tradition) these saints often appear in close association with a dead tree stump, as in Albrecht Durer's woodcut, *St. Jerome in Penitence* (fig. 8). Originally in the sixteenth and seventeenth centuries the tree motif carried theological significance, referring to the wood of the Cross and thus to the Crucifixion, or, in the case of a blossoming stump, to the Resurrection. However, the stump was also an appropriate emblem of a wilderness environment and of solitude in nature. It functions as such in Rembrandt's etching, *St. Jerome Beneath a Pollard Willow*.[43]

In Cole's painting of Daniel Boone, a storm-blasted, moss-laden tree stump, placed just to the right of the rock on which Boone sits, leans almost protectively over the elderly pioneer—an attribute of the solitary individual in the wilderness. Like the earlier Christian hermits, Cole's Daniel Boone is experiencing a type of spiritual revelation. His tense pose, with legs spread apart and hand resting firmly on the rock as if he were about to spring forward, and his expression of intense concentration, focussed on nothing outwardly visible in the painting, make him appear as if responding to an unexpected inner voice. Even his dog seems to sense an undercurrent of excitement. Furthermore, the lighting effects, which focus on Boone, the dog, and the tree, and set them off against the dim foliage behind, maybe intended as a visual metaphor of enlightenment.

Unlike the hermit-saints of Christian history, Cole's Boone receives his spiritual enlightenment not through scholarship nor through the study and contemplation of the Scriptures, but directly from nature herself. He is in fact a perfect illustration of Cole's own thoughts as he recorded them in 1825 or 1826, the very years in which he was painting his Daniel Boone: "Nature has secrets known only to the initiated. To him she speaks in the most eloquent language."[44]

The idea of a "religion of nature" evolving from a wilderness experience which leads to spiritual enlightenment or revelation accorded beautifully with romantic ideals and would naturally have appealed to Cole and to other American artists of romantic inclination. Prior to 1825 there were, in fact, numerous precedents in literature and the visual arts for treating this theme. As early as 1784 John Trumbull painted *The Religion of Nature*, a work now lost and known only through an ink and wash study (New York, Fordham University). In the drawing a man in a classical toga seated under a dead tree stump, lifts his head and hands in an expression and gesture of surprise or revelation. Under his left foot is a book with the inscription "Hobbes"—presumably the teachings of the philosopher James Hobbes, whose anti-Rousseau-ian ideas are here trampled underfoot. The drawing is inscribed on the back with a quotation from Alexander Pope's *Essay on Man*: "And look thro' Nature, up to Nature's God,"[45] an expression of the deistic concept of nature as the agent in the revelation of God.

Washington Allston's painting of 1818, *Elijah in the Desert*, illustrates the story of the prophet's miraculous deliverance in the wilderness, an experience which led to his greater understanding of God's sustaining power. A dead tree dominates the composition and plays an important iconographic role, alluding to the harsh environment in which the miracle took place. Cole himself painted his own version of the story in 1829 or 1830,[46] an indication of his preoccupation during the 1820s with the theme of the wilderness experience as religious experience.

Cole's keen interest in literature, especially in poetry, would also have exposed him to this theme. Soon after he had moved to New York in 1825, Cole joined a circle of intellectuals who met frequently to discuss matters of art and literature. Among the members of the group was the American poet William Cullen Bryant, with whom Cole formed a close and enduring friendship.[47] Bryant was largely responsible for introducing to Americans the ideas and poetry of the English Romantics, particularly William Wordsworth, whose verses proclaimed Nature to be man's moral teacher, leading him to eternal truths by action on his affective faculties—intuition, imagination, and sensibility. In one of his own early poems, *A Forest Hymn* of 1825 (the year in which he met Cole), Bryant expressed similar ideas, identifying nature as the first and most appropriate place to find and to worship God. "The groves were God's first temples," he says; and later, addressing Deity, he proclaims, "Thou art here—Thou fill'st / The solitude." In the poem's conclusion (which is especially pertinent to our discussion), Bryant alludes to the experiences of Christian hermit-saints, and then declares his desire to emulate them:

> There have been holy men who hid themselves
> Deep in the woody wilderness, and gave
> Their lives to thought and prayer, till they outlived
> The generation born with them...
> ...Let me often to these solitudes
> Retire, and in Thy presence reassure
> My feeble virtue...
> ...Be it ours to meditate
> In these calm shades, Thy milder majesty,
> And to the beautiful order of Thy works
> Learn to conform the order of our lives.[48]

Bryant, like Cole, believed that the American experience in the wilderness paralleled the revelations of earlier Christian saints, and it is not difficult to understand why this notion should have fit so beautifully with Americans' nationalistic ideals in the 1820s. If God did indeed reveal Himself in Nature, then Americans certainly had more ample opportunities than their European cousins to receive the word of God in their age, precisely because Nature was more abundant in their young nation.

A lengthy poem entitled *The Power of Solitude*, written by Joseph Story and published in 1804, provides yet another instance of the theme of a religion of nature, one that is again particularly relevant to our discussion of Cole's painting. The purpose of the poem, as stated by its author, was "to mark the influence of Solitude upon the passions and faculties of mankind." The hero of the work is "the good St. Aubin," a kind of modern-day St. Francis or St. Jerome, who passed his life alone in nature, "far from the world, its pleasures and its strife." The narrator, telling of his meeting with this hermit-sage, describes him as fired by a holy purpose to sing "the first Cause." The poem continues in a tone that fits the mood and setting of Cole's painting:

> The while he spoke, methought his spirit shed
> Some heavenly dew of mingled hope and dread;
> Mysterious influence seemed to haunt the shade,
> And round his face transfiguring brightness played.[49]

Even more pertinent to this discussion, however, is the engraved frontispiece to Story's poem (fig. 9), in which the hermit sits reading in a landscape outside the entrance to a cave. An inscription reads, "And muse with truth in Wisdom's sacred cell." The motif is so reminiscent of Cole's Boone as to suggest that it might have served as its source or inspiration. At the very least, it is further evidence of a visual tradition related to the notion of a religion of nature and solitude in the early nineteenth century. Certainly it can be said to be part of the same set of romantic notions that spawned Cole's image.[50]

Cole's Byronic interpretation of Boone as a representative of the solitary child of nature is unique in the corpus of pictorial images of the hero in American art. It was essentially a personal interpretation which appealed to the private thoughts and feelings of the individual, much as poetry can communicate intimately. The young American republic of the 1820s, however, had little use for a symbol of solitude and unspoiled nature when it was daily pouring its population into the landscape. It required instead an image in accord with its aggressive and self-confident energies, and such an image was supplied by Enrico Causici in a relief sculpture entitled *The Conflict Between Daniel Boone and the Indians* (Washington, D.C., Capitol Building; fig. 10), a work almost exactly contemporary with Cole's painting.[51]

The panel was one of four reliefs commissioned in the 1820s by the United States Government to decorate the Rotunda of the Capitol Building in Washington, D.C.[52] Although executed by three different artists, all four panels belong to a deliberate program whose theme is the white man's encounter with the Native American.[53] Causici depicted Boone subduing two Indians in hand-to-hand combat. Given the official nature of the commission, it is reasonable to assume that Boone was here meant to represent American (i.e., Anglo-Saxon) civilization, superior to and victorious over the Indian savages.

Causici, an Italian sculptor trained under Antonio Canova in the Neoclassical tradition, undoubtedly recalled his knowledge of ancient battle reliefs for the essentials of his composition. But he might also have consulted precedents in American art, such as John Vanderlyn's *Murder of Jane McRea,* previously mentioned (see above, p. 9), a well-known work which was one of several depictions of the theme (fig. 11). A comparison between Vanderlyn's painting and Causici's relief, however, is instructive. The attitude towards the Indian in both works is essentially the same: the Indian is a savage enemy and a threat. But in the painting of 1804 the savages triumph horribly (as they do in the 1812 illustration in Marshall's *History of Kentucky*), while in Causici's relief of 1826 they are the victims, overpowered singlehandedly by the heroic Boone. Thus in the earlier work we still detect vestiges of the colonial fear of the Indian, mingled with horror and revulsion at his brutality, while the later work expresses the triumphant self-confidence of a nation that was learning to cope with a hostile environment.

The American victory in the War of 1812 over Britain and her Indian allies had substantially reduced, for the time being at least, the Indian threat in the trans-Allegheny West. As settlers flowed into that area, Americans began to recognize the West as an area of almost unbounded potential for future development. Inevitably they began to regard the Indians, whose ancestral homes lay in the path of expanding settlement, as an annoying

hindrance to their dreams of advancing the empire.[54] Thus, even as the reliefs in the rotunda of the Capitol were being planned and executed, Congress in that very same building was debating the implementation of a policy which would force the Indians to cede their lands to the United States and move into territories farther West. The Congressional rhetoric of those debates provides a clue as to the way in which Congressmen, and probably a good portion of the rest of the American public, would have understood and interpreted the sculpted reliefs in the rotunda:

> ...So long as the Indian tribes within our settlements were strong enought to wage war upon the states, and to pursue their trade of blood with the tomahawk and scalping knife, it was neither the policy nor the duty of the Federal Government to consult their comfort, or to devise means for their preservation. The contest, then, was for the existence of our infant settlements, and for the attainment of that power by which a civilized and Christian people might safely occupy this promised land of civil and religious liberty. It was then to be regarded as a struggle for *supremacy,* between savages and civilized men, between infidels and Christians.[55]

Daniel Boone fighting the Indians epitomizes this struggle, and so Causici's image presents him in yet another guise—that of the valiant warrior in the cause of advancing civilization, subduing the dark forces of savagery.

Considered together, Cole's painting and Causici's sculpture concisely illustrate the dualism of attitudes which allowed Americans to perceive Daniel Boone as a child of the wilderness—a solitary, individual hero—and at the same time as a representative of their national experience—a symbol of their collective fears, struggles, and triumphs. We have repeatedly referred to this dualism, which appeared as early as 1784 with the publication of Filson's biography, and was symptomatic of a basic dichotomy in American thinking: the simultaneous appreciation and fear of the wilderness landscape.

The expansion into the trans-Allegheny regions that had necessitated Indian Removal continued in the 1830s, until much of that area had been cleared and settled and the frontier of settlement had moved across the Mississippi River into the Southwest.[56] Texas, colonized by American emigrants, won independence from Mexico in 1836, and, as mentioned above, immediately made overtures to the United States in hopes of joining the Union with the status of full statehood. In the meantime, the expansion of the fur trade during this same period had led to a greater interest in the Far West beyond the Rocky Mountains, and had contributed to a more accurate knowledge of these territories. By the opening decade of the 1840s, it appeared that American dreams of an empire stretching from the Atlantic to the Pacific Ocean were temptingly close to realization. Rhetoric centering on the issue of expansionism increased, offering a multitude of arguments supporting

the belief that it was the United States' Manifest Destiny to occupy the entire North American continent.[57]

Although there was by no means universal agreement on this issue, the expansionist policy eventually won the day and Texas was annexed in 1845. This precipitated the Mexican War, which ended the following year with the United States gaining even more territory in the Southwest. A treaty with Great Britain in 1846 gave the American republic sole title to the Oregon territory up to the 49th parallel. In that same year waves of American emigrants set out in wagon trains to cross the prairies, bound for the promised lands of California, Oregon, and Utah. The flow of emigrants continued unabated for several years, heightening to tidal wave proportions with the discovery of gold in California in 1849.

In the midst of this era of expansionism, in 1849, William Ranney, a New Jersey artist specializing partly in Western themes, painted *Daniel Boone's First View of Kentucky* (Oklahoma City, National Cowboy Hall of Fame and Western Heritage Center. The composition parallels a description from John Peck's *Life of Daniel Boone,* published in 1846:

> Towards the time of the setting sun, the party had reached the summit of the mountain range, up which they had toiled... Here new and indescribable scenery opened to their view. Before them, for an immense distance, as if spread out on a map, lay the rich and beautiful vales watered by the Kentucky River...The country immediately before them, to use a western phrase, was 'rolling,' and, in places, abruptly hilly; but far in the vista was seen a beautiful expanse of level country, over which the buffalo, deer, and other forest animals, roamed unmolested, while they fed on the luxuriant herbage of the forest. The countenances of the party lighted up with pleasure, congratulations were exchanged, the romantic tales of Finley were confirmed by ocular demonstration, and orders were given to encamp for the night...[58]

The choice of subject—Boone's first view of Kentucky—reflects the artist's personal interest in the American West. Born in Connecticut in 1823, Ranney grew up in the East, but in 1836 went to Texas as a volunteer in the Texan army in its fight for independence from Mexico. This experience on the southwestern frontier supplied Ranney with material for depictions of western themes, which he began to paint about ten years later. His first western themes depicted plainsmen, pioneers, and prairie settlers—all in the environment of the Great Plains west of the Mississippi River.[59] His 1849 painting of *Boone's First View of Kentucky* thus differed from his previous western themes not only in its setting—which was the trans-Allegheny West—but also in its intent: it was not, strictly speaking, a genre painting, but rather a depiction of a specific historical event. Nonetheless, as we shall see shortly, Ranney's treatment of the event was typical of the genre painter he was, and this approach significantly affected his interpretation of Boone.

Thematically Ranney's painting belongs to a group of paintings dating

from the decade of the 1840s, whose subjects include the Embarcation of Columbus, painted by Asher B. Durand (1843) and by Peter Rothermel (1844); the Landing of Columbus, by R. W. Weir (1823) or by John Vanderlyn (1837-47); and DeSoto Discovering the Mississippi, painted by Rothermel (1843) and William Powell (1847-55)—all themes of discovery and exploration, reflecting a desire to investigate pictorially the beginnings of the white man's destiny on the North American continent. Washington Irving's biography of Christopher Columbus, first published in 1828, inspired many of the earlier depictions of events in the life of that famous explorer; but by the late 1840s emigration to the West had awakened a parallel interest in Daniel Boone as an early explorer of western territories. It may be no mere coincidence that Thomas Cole, late in his career (about 1845 to 1848), proposed to paint "Daniel Boone looking from the eminence over the vast forest and seeing the Ohio for the first time—" although he never executed this project.[60]

Appropriately, in this context, the emphasis in Ranney's composition is on the thrill of discovery, a point noted by Henry Tuckerman, the art critic, in 1852. In an article on Daniel Boone, Tuckerman mentioned Ranney's painting and described it as follows:

> There hung, for many months, on the walls of the Art-Union gallery in New-York, a picture by Ranney, so thoroughly national in its subject and true to nature in its execution, that it was refreshing to contemplate it, after being wearied with far more ambitious yet less successful attempts. It represented a flat ledge of rock, the summit of a high cliff that projected over a rich, umbrageous country, upon which a band of hunters leaning on their rifles, were gazing with looks of delighted surprise. The foremost, a compact and agile, though not very commanding figure, is pointing out the landscape to his comrades, with an air of exultant yet calm satisfaction; the wind lifts his thick hair from a brow full of energy and perception; his loose hunting shirt, his easy attitude, the fresh brown tint of his cheek, and an ingenuous, cheerful, determined yet benign expression of countenance, proclaim the hunter and pioneer, the Columbus of the woods, the forest philosopher and brave champion. The picture represents Daniel Boone discovering to his companions the fertile levels of Kentucky.[61]

Tuckerman's comparision of Boone to Christopher Columbus reveals that by midcentury Americans had accepted the frontiersman as much more than just a local Kentucky or trans-Allegheny hero. It was now possible to place him into the larger context of the history of a nation and indeed of a continent. Boone had come to be regarded as a key figure in furthering the westward course of empire, which had begun when Columbus crossed the Atlantic and set foot on the shores of the New World. Further visual evidence of this broadened viewpoint is a remarkable image on the title page of a biography of Boone, published in 1865 (fig. 12).[62] A portrait of Boone in an oval medallion held by an Indian maiden—a traditional personifica-

tion of America[63]—appears with a classically dressed female writing in a book—most assuredly Clio, the Muse of History. On a scroll in the background are written the names of other great explorers: Columbus, Americus (Vespucci), Cabot, and Raleigh.

Tuckerman seems to have been somewhat confused in identifying Boone in the painting by Ranney. The figure pointing out the landscape is most likely John Finley, the only member of the exploring party who had previously been in the area. Boone is the hatless figure slightly to the right of Finley, more centrally located in the composition. The mistake is understandable, however, because no one figure in the painting is singled out for special attention. Ranney, in the spirit of democracy, points out the fact that Boone was just one of a number of hunters, frontiersmen, and pioneers whose deeds helped to open the West. Primarily a genre painter, Ranney tended to direct attention to the common man, or to a typical representative of a class, even when dealing with historical subjects. He frequently made the usually recognized hero share the limelight with lesser-known participants in a noteworthy event, as when he made Christopher Gist a hero who saved George Washington from the raging Allegheny River.[64]

This inclination to spotlight the unsung hero is again evident in a second Boone subject which Ranney painted in 1852, entitled *Squire Boone Crossing the Mountains With Stores for His Brother Daniel Encamped in the Wilds of Kentucky* (Boston, Mass., Coll. Miss Amelia Peabody). In this composition Ranney eliminated Daniel altogether and focussed attention exclusively on the brother. In the corpus of Boone imagery, this painting is a totally unique conception.

Biographies of Boone written in the nineteenth century invariably relate how, during his first exploring expedition into Kentucky, Daniel was once left entirely alone in the forests—the only white man in all of the Kentucky wilderness—while his brother Squire returned to the settlements to obtain more supplies. These accounts naturally follow Daniel's actions during the three months of his brother's absence, using the occasion to extoll Boone's fortitude by stressing the dangers and loneliness he had to face. Timothy Flint's account—one of the most widely read—describes the experience in these words:

> The character of Daniel Boone, in consenting to be left alone in that wilderness, surrounded by perils from the Indians and wild beasts, of which he had so recently and terribly been made aware, appears in its true light. We have heard of a Robinson Crusoe made so by the necessity of shipwreck; but all history can scarcely parallel another such instance of a man voluntarily consenting to be left alone among savages and wild beasts, seven hundred miles from the nearest white inhabitant. The separation came. The elder [sic] brother disappeared in the forest, and Daniel Boone was left in the cabin...entirely alone. Their only dog followed the departing brother, and Boone had nothing but his

unconquerable spirit to sustain him during the long and lonely days and nights, visited by the remembrance of his distant wife and children.[65]

Ranney's decision to spotlight Daniel's brother was an original approach to the treatment of the by now hackneyed story of Boone's exploration of Kentucky. In reminding us that Squire Boone's journey through the wilderness was just as dangerous as Daniel's situation and that it demanded as much courage and skill as were required of the older brother, Ranney does not so much debunk Daniel as a hero as call attention to the fact that there were many such heroes in the early history of the frontier. His depiction of Squire Boone is, however, low keyed and understated in action, lacking any dramatics to enhance the subject. The only hint at Squire's dangerous situation is his alert expression, "evidently listening around if any Indians are near," as one contemporary reviewer described it.[66] Again the painting is close in spirit to Ranney's genre subjects, such as his *Trapper Crossing the Mountains* of 1853 (Louisville, Ky., J. B. Speed Art Museum), the main figure of which has in fact on occasion been identified as Squire Boone.[67]

In spite of its lack of dramatic quality, Ranney's painting evidently made an impression on one of Boone's many biographers. One year after the painting was exhibited at the National Academy of Design in New York, W. H. Bogart published his *Daniel Boone and the Hunters of Kentucky*, in which he gave special emphasis to Squire Boone's role in Daniel's adventures. Of the episode depicted by Ranney, for example, he wrote:

> On May 1, 1770, Squire departed for the settlments on the Yadkin. What a journey for a man was that,—five hundred miles, and utterly alone! If the elder brother showed strength of character in remaining, not less the younger in daring this march. When the parting word was given, it must have been more like a farewell to each other forever, than the separation for a brief period. There were dangers on that road which needed no exaggeration. To pass five hundred miles without a companion to encourage, cheer, or defend, was a keen trial to the realities of courage...[68]

Ranney's interpretations of the Daniel Boone narrative are in keeping with the general tendency in nineteenth century art and literature towards the democratization of the hero. In elevating the commonplace activity to the significant, and in depicting momentous events as if they were done "all in a day's work," Ranney evened the differences between the common man and the hero; and this talent may explain his immense popularity at midcentury.

Two years after the appearance of Ranney's painting of *Boone's First View of Kentucky*, George Caleb Bingham, the frontier artist par excellence, offered to the American Art Union exhibition for 1851 a depiction of another

event in Boone's career, *The Emigration of Daniel Boone into Kentucky* (St. Louis, Washington University Art Gallery; fig. 13).[69] Bingham must have known Ranney's painting of 1849, which was hanging in the Art Union galleries at the time Bingham was in New York. It is even possible that Ranney's work may have inspired Bingham's own efforts, but the artist from frontier Missouri chose to represent not the discovery of Kentucky, but the immigration of settlers into its wilderness.[70] To Bingham, Boone's significance resided in his efforts to establish a pioneer community in the trans-Allegheny West. Bingham's pioneer, then, is not the unassuming "Columbus of the Woods" that Ranney had visualized, but a modern-day Moses leading the American Chosen People into the new Promised Land of the West; and the painting deserves to be considered the supreme expression of a nationalistic spririt in its interpretation of Daniel Boone.

Bingham's interest in Boone had probably begun in childhood. As a boy of eight in 1819, Bingham had moved with his family from Pennsylvania to Missouri, where he no doubt heard many stories about the old pioneer who resided there in the Femme Osage district. With the death of Boone in the following year (1820), legends about the hero probably circulated afresh to spark young Bingham's imagination. There is some evidence that very early in his career as an aritist, Bingham may have painted a sign that displayed a full-length portrait of Boone, possible derived from the Harding-Lewis engraving, which having been executed in St. Louis, was easily available to Bingham.[71] In 1844, at a time when Bingham was coming to artistic maturity and was also actively involved in Missouri politics, the artist proposed Daniel Boone as an appropriate theme for a political banner for Boone County, Missouri. In a letter to his friend James Rollins, Bingham wrote:

> ...I would suggest for the design as peculiarly applicable to your county, old Daniel Boone himself engaged in one of his death struggles with an Indian, painted large as life, it would make a picture that would take the multitude, and also be in accordance with historical truth. It might be emblimatical [sic] of the early state of the west, while on the other side I might paint a landscape with 'peaceful field and lowing herds' indicative of his present advancement in civilization.[72]

This concept of Boone as an emblem of westward expansion shaped his approach as it finally materialized seven years later in his full-scale painting in which Daniel Boone is indeed a heroic individual, but the painting considered as a whole sets forth a larger program that symbolizes the very process of civilization itself.

Boone and his family actually made two attempts at emigration into Kentucky, both of which were described in almost every nineteenth century biography of the hero. The first attempt in 1773 ended tragically when

Boone and his party were attacked by Indians. Six men were killed, among them one of Boone's own sons. Demoralized, the remaining members of the party gave up the attempt and turned back to the settlements they had left. A second, and this time successful, attempt took place in 1775. Boone led his own family to the newly constructed Fort Boonesborough, and shortly thereafter other settlers with their families followed.

Bingham's painting is a conflation of the two events. Certainly we cannot presume that the artist was depicting only the first attempt which was, after all, a failure. Yet many details of the composition—the size of the party, the depiction of the mountain pass, and the stragglers towards the rear of the party driving cattle—correspond to descriptions found in the various accounts of the first emigration which would have been available to Bingham.[73] Furthermore, the dark and threatening sky and the grimly alert expressions of the leading figures allude to the dangers of emigration which had been so vividly demonstrated in the tragic ending of Boone's first attempt.[74] The painting, then, is not so much the record of a specific event as a tribute to the courage and achievements of Daniel Boone and those other early pioneers who persevered in the face of danger and discouragment.

The makeup of the emigrant party in Bingham's painting included representatives of the several types of Americans who pioneered and established societies in the West. In the forefront are Boone and his two male companions, wearing buckskins and carrying guns. They are the hunters, explorers, and scouts who were the first to venture into new territories. The two female figures (Boone's wife Rebecca and their daughter) represent the first families who set up housekeeping in the wilderness and thus were signs of the coming of domestic society and civilization. Following them come woodsmen with their axes to clear areas for settlement; and then come farmers with their cattle to make farms from the newly cleared fields.

Among the cluster of men just behind the leading figures is a man beating his mule. His raised arm with the whip is prominently displayed against the background sky, calling attention to this rather disconcerting image of cruelty. Its inclusion in the composition may be explained as a representation of a less desirable element in the pioneer population—the so-called squatters. Bingham, an ardent Whig, distrusted this restless and landless class so often found on the fringes of a frontier society. In a letter to his friend James Rollins in 1846 Bingham described these people in rather disparaging terms:

> These illegitimate Loco focos, whose votes we wish to brush out of our way, have so scattered since the election, over our big praries [sic], that it takes a long time, with a good deal of pulling and hauling to get them up to the mark. Some of them have gone clear off to parts unknown.[75]

In 1850 Bingham painted *The Squatters*, which he sent to the American Art Union galleries in November of that year. Along with the painting he sent a letter which described the subject:

> The Squatters as a class, are not fond of the toil of agriculture, but erect their rude cabins upon those remote portions of the National domain, where the abundant game supplies their phisical [sic] wants. When this source of subsistence becomes diminished, in consequence of increasing settlements around, they usually sell out their slight improvements, with their *"preemption title"* to the land, and again follow the receding footsteps of the Savage.[76]

The painting itself presented the squatters in a none too complimentary light—as crude, indolent, and perhaps of a suspicious nature.[77] The figure of the brutal settler in the painting of Boone's emigration is a relative of these unlikeable people.[78] He is the antithesis of the type of frontiersman exemplified by Daniel Boone, who, according to Bingham's interpretation as evidenced in the painting, fulfills an important social function as a pioneer of settlement, contributing to the establishment of a permanent society and civilization in the wilderness.

The prominence which Bingham gave to Rebecca Boone and her daughter is in keeping with Boone's own proud statement, repeated in almost every biography of the hero, that his wife and daughter were "the first white women that ever stood on the banks of Kentucke River." Rebecca in particular appears as a Marianic figure. Seated on a white horse led by her husband, wearing a shawl draped over her head (an unusual headpiece for a frontier woman, and one which contrasts strikingly with the more typical bonnet worn by her daughter), Rebecca is so startlingly reminiscent of Mary in depictions of the Flight of the Holy Family into Egypt that the resemblance cannot be merely coincidental.[79] Through this device of visual comparison, Bingham in effect sanctifies Rebecca's role in the emigration to Kentucky, making her a symbol of the courageous spirit of all pioneering women, just as Daniel Boone had become the archetypal male pioneer.[80] The allusion to the Holy Family also carries with it the implication that pioneer emigration to the West was a divinely impelled venture, an idea which had been stated and restated in speeches, editorials, poetry, and essays written throughout the decade of the 1840s.[81]

Bingham's tribute to womanhood was recognized almost immediately by his audience in the nineteenth century. A lithograph made after the painting in 1852 bears the dedication: "To the Mothers and Daughters of the West this print from the original picture by George C. Bingham is respectfully dedicated..."[82]

Two other features of the painting are important to our interpretation

of the work: the setting and the observer's viewpoint. The setting functions metaphorically as the landscape of America across which the westward movement advances. The little band of pioneers marches from a serene and sunlit background (representing the security of eastern settlements which have been left behind), through a threatening landscape (signifying the dangers of the unknown), finally to emerge again into light (the hope of the future). The observer stands in front of the party, watching the pioneers advance towards him from the East. The viewpoint is unusual, but significant.[83] For a western artist like Bingham who had started his career in the frontier settlements of Missouri, it was perhaps natural to look back at history and to envision the pioneers of the eighteenth century advancing forward to meet him in the nineteenth century. Yet, *The Emigration of Daniel Boone* was not intended solely for a Missouri audience. Bingham actually painted the composition in New York City; and he submitted it to the American Art Union in that city, where his audience would consist primarily of Easterners, many of whom had probably never been further West than Buffalo, New York. Thus, when the artist placed the observer in the unsettled Kentucky forests to watch the advancement of civilization from the East, he implied that national history was to be viewed from the vantage point of the western territories. Perhaps no other visual device could have more emphatically identified the American national destiny with the West.

Bingham's painting of 1851 was not purchased by the American Art Union for its annual distribution of paintings, as Bingham had hoped it might be. Instead the artist sold reproduction rights to the work to the New York branch of the French firm of Goupil and Co., and proceeded with plans to dispose of the painting in a privately organized raffle;[84] however, Bingham continued to have a keen interest in the subject of Daniel Boone. In 1857 while working in Dusseldorf, Germany, he toyed with the idea of painting a second version of the emigration of Boone, "with the expectation of selling it to Congress and deriving also a profit from its exhibition."[85] In the following year, when he had begun to hope for a chance to paint a mural in the Capitol in Washington, D.C., he naturally thought of the Boone subject as particularly appropriate. In a letter of July 18, 1858, written from Dusseldorf to his friend Rollins (who at that time was a member of the committee which would award the commission for the mural) Bingham wrote:

> As there is yet no work of Art in the Capitol, properly illustrative of the history of the West, it seems to me that a western artist with a western subject should receive especial consideration from this Committee, and also from Congress in the first appropriations which may hereafter be made for such works.
>
> I would be very willing to undertake such a commission...I would be willing to present to a committee authorized to contract for such a work, a small and complete study for the emigration of Boone, or any other subject of equal interest, for their approval.[86]

Bingham, perhaps unfortunately, did not receive the government com-
mission he had hoped for. The task of painting a western subject in the
Capitol fell instead to Emanuel Leutze, whose mural, entitled *Westward the
Course of Empire Takes Its Way* (fig. 34), was painted in 1861-62, during
the troubled years of the Civil War.

Leutze's stated purpose in painting the mural was "to represent as near
and truthfully as the artist was able, the grand-peaceful conquest of the
great west...Without a wish to date or localize, or to represent a particular
event it is intended to give in a condensed form a picture of western emigra-
tion, the conquest of the Pacific slope..."[87] Elsewhere in this study (see
below, pp. 77–81) the full iconographic program of this most interesting
painting will be discussed in its appropriate context; here the author would
like to call attention to two portraits of men painted in rondels on the side
panels flanking the mural. Presiding over the central images representing
westward expansion and its ultimate goal, the Pacific Coast (as represented
in the predella panel of San Francisco Bay), these two men are evidently
those individuals who Leutze considered key figures in pioneering the
westward course of the American empire. They are William Clark, of the
Lewis and Clark Expedition, and of course our hero, Daniel Boone.[88] Thus,
in the American collective imagination Boone's spirit by the 1860s had
finally spanned the continent he had actually begun to explore in the late
eighteenth century, and that spirit travelled with the thousands of
Americans who went west to the Promised Land across the Rocky Moun-
tains.

In the 1860s the Civil War and its aftermath diverted national attention
from the frontier to the sectional conflicts between North and South which
plagued the Union. The fervor of Manifest Destiny subsided somewhat, and
with it, the originality of pictorial imagery related to Daniel Boone and his
career. Although biographies of Boone continued to be published in the lat-
ter half of the century, no new and significant depictions of the hero ap-
peared in the visual arts. For example, a lithograph published in the 1870s
entitled *Daniel Boone Protects His Family* is simply a two-dimensional ren-
dition of a sculpture by Horatio Greenough entitled *The Rescue*. Although
the association of Greenough's work with the Boone subject is significant
(for there is no evidence that the sculptor himself intended his group to
represent Boone and his family), the lithograph is simply a combination of a
borrowed composition and an already popular theme and thus introduces
no new intepretation of the subject.

In 1907 a sculpture of Daniel Boone by Enid Yanell, depicting the
pioneer in buckskins, fur cap, and carrying a rifle, was set up in Cherokee
Park in Louisville, Kentucky in commemoration of that state's illustrious

son. Thus, with the closing of the frontier in the last decades of the nineteenth century, Daniel Boone and his significance to the American imagination returned quietly to the sphere of local Kentucky history.

Today, of course, historians have reassessed Boone's importance and have clarified his role in the history of the West. The result has been a devaluation of his historical significance insofar as the actual events of exploration and settlement are concerned. His myth has been debunked, and other candidates for attention have been brought forward for study. One thing, however, remains incontrovertibly true: in the history of American thought of the nineteenth century, Daniel Boone was an unparalleled hero, symbolizing to Americans the pioneer spirit which they fancied was part of the very fabric of their national identity.

2

Civilization's Advance Men: Images of Fur Trappers and Traders

The true heirs to the romance and adventure of Daniel Boone's career as hunter and explorer of the wilderness were the fur trappers of the Far West, who flourished along with the American fur trade industry during the 1830s.[1] These men, who worked in the service of one of the largest and most prosperous of American enterprises in the first half of the nineteenth century, pursued their profession trapping beaver in the rivers and streams of the Rocky Mountains. They lived a nomadic existence in the open air, exposed to the elements and in danger of attacks by unfriendly Indians. They lived off the game they could hunt or trap, hording their precious supplies of coffee and tobacco—their only luxuries—until they could replenish them from some contact with civilization. Usually they travelled and worked singly or in pairs; but once a year they gathered together at a preappointed place in the mountains for the annual rendezvous. Here they sold or traded their year's catch of beaver pelts to representatives of the fur companies, who in turn sold to the trappers badly needed supplies for the coming year—usually at grossly inflated prices. Here too the mountain men found a rare opportunity to socialize—indeed, to dissipate; and the trappers, after so many months of deprivation, characteristically enjoyed themselves with gusto. The gathering became the scene of general debauchery: an incredible week-long orgy of drinking, gambling, and whoring with Indian women, described by Washington Irving as a "saturnalia among the mountains."[2]

These trappers or mountain men, graced with flamboyant personalities and unconventional lifestyles, provided much colorful material for the art and literature of the young American republic just at a time when it was searching for a distinct national identity. The trapper could appeal to many diverse elements in the American public. Romantics were intrigued by the adventure of the trappers' way of life; patriot and moralists admired their courage, resourcefulness, and self-possession—ennobling traits proudly identified with the American national character; and more pragmatic individuals were well aware that, in exploring unknown Western territories,

these mountaineers were clearing a path for the future growth of American commerce.[3]

In this appreciative climate a considerable body of literature dealing with the fur trade developed during the first half of the nineteenth century. Through the publication of narratives and journals of western travel in books, newspapers, and magazines, the reading public became familiar with the men and events of the Rocky Mountain fur industry. The first popular account of the fur trade to reach a wide audience was Washington Irving's *Astoria,* a history of John Jacob Astor's Pacific enterprise.[4] This account was so well-received upon its publication in 1836, that Irving followed it in 1837 with *The Adventures of Captain Bonneville,* a narrative of the Rocky Mountain fur trade. Irving's successes in this genre opened the floodgates, and for the next two decades narratives of the fur trade proliferated, along with travel accounts mentioning the trade and relating anecdotes about its participants. Notably popular and influential among these works were: Thomas J. Farnham's *Travels in the Great Western Prairies* (1843); W. A. Ferris's *Life in the Rocky Mountains* (1843–44); Josiah Gregg's *Commerce of the Prairies* (1844); David Coyner's *The Lost Trappers* (1847); George Frederick Ruxton's *Adventures in Mexico and the Rocky Mountains* (1847) and his *Life in the Far West* (1849); Francis Parkman's *The Oregon Trail* (1849); and Lewis Garrard's *Wah-To-Yah and the Taos Trail* (1850).[5]

Most of these accounts included, in some form or another, a fairly standard repertoire of elements describing unusual and impressive scenery, the hardships of travel in the West, the character, costumes and habits of Indians, trappers and other frontiersmen, and stories of thrilling incidents of life in the West gathered by the authors from hunters and trappers they had met in their travels. Interspersed among these fairly predictable descriptions, however, are also some revealing statements evaluating western life and interpreting its broader significance to the American public. They are valuable clues to nineteenth-century attitudes toward the men who lived beyond frontier societies, and will be used in interpreting the images of trappers discussed below.

Authors of the fur-trade literature clearly and repeatedly described to their readers the role of the trade in national expansion. Irving led off the chorus when he called fur traders, along with gold hunters, "the pioneers and precursors of civilization." He attributed "national character" to Astor's fur trade enterprise and to his desire to establish a colony which "would form the germ of a wide civilization; that would, in fact, carry the American population across the Rocky Mountains and spread it along the shores of the Pacific, as it already animated the shores of the Atlantic."[6] George Ruxton, in *Adventures in Mexico and the Rocky Mountains,* called trappers "those hardy pioneers of civilization,"[7] and in *Life in the Far West* he stated:

...Trappers and hardy mountaineers...were the men whose hardy enterprise opened to commerce and the plough the vast and fertile regions of the West. Rough and savage though they were, they alone were the pioneers of that extraordinary tide of civilization which has poured its resistless current through tracts large enough for a king to govern.[8]

Existing side by side with this view of fur traders and trappers as national heroes in the van of civilization, was another attitude which saw the trapper as a rebel living beyond the bounds and restraints of society. This latter attitude was within itself ambigious; for, while some observers admired the trapper for his freedom and self-sufficiency, they were also disturbed by the state of lawlessness this freedom implied. Written descriptions of the trappers' way of life thus often betray a disposition wavering between appreciation and disapproval. David Coyner, who could describe trappers as "precursors...(who) went in advance of civilization and discovered countries now occupied by the agriculturalists and mechanics," could also pen a much less savory description of them:

> On the outskirts of civilized society then, as now, on the frontier of the West, there has always been a certain motley class of men, trappers, traders, renegadoes, and refugees from justice, who seem to have become disgusted with the tameness and monotony of civilized life, and made exiles of themselves, by going where the restraints and security of laws are not felt.[9]

W. A. Ferris found it difficult to understand why trappers would chose to live as they did:

> Strange, that people can find so strong and fascinating a charm in this rude, nomadic, and hazardous mode of life, as to estrange themselves from home, country, friends, and all the comforts, elegances, and privileges of civilization; but so it is, the toil, the danger, the loneliness, the deprivation of this condition of being, fraught with all its disadvantages, and replete with peril, is, they think, more than compensated by the lawless freedom, and the stirring excitement, incident to their situation and pursuits.[10]

Perhaps the most frank statement of the pros and cons of the trapper's character and way of life is to be found in a passage from George Ruxton's *Adventures in Mexico and the Rocky Mountains:*

> The trappers of the Rocky Mountains belong to a "genus" more approximating to the primitive savage than perhaps any other class of civilized man. Their lives being spent in the remote wilderness of the mountains, with no other companion than Nature herself, their habits and character assume a most singular cast of simplicity mingled with ferocity...
>
> ...Of laws, human or divine, they neither know nor care to know. Their wish is their law, and to attain it they do not scruple as to ways and means...They may have good qualities, but they are those of the animal; and people fond of giving hard names call them revengeful, bloodthirsty, drunkards, gamblers...—in fact, 'White Indians.'

However, there are exceptions, and I *have* met honest mountain men. Their animal qualities, however, are undeniable. Strong, active, hardy as bears, daring, expert in the use of their weapons, they are just what uncivilized white man might be supposed to be in a brute state...[11]

In these descriptions one discerns a tension in operation between a respect for reason, law, and order, and an inclination towards individual freedom and impulsive action—between, in effect, the values of the Enlightenment of the eighteenth century and those of the Romantic era of the nineteenth. Within the context of westward expansion, this tension became a conflict between the values of civilization and those of the wilderness, a tension we have already identified as underlying Americans' interpretations of Daniel Boone. The trapper, as a "white man...in a brute state" represented a blending of civilization and savagery, and thus could serve as a mediator in reconciling the two.

The significance of the trapper's career was, then, open to a variety of interpretations; thus, like his predecessor Daniel Boone, the fur trapper became a versatile figure in American arts and letters. Depending upon which of his many qualities were to be highlighted, the trapper could appear as a romantic hero—colorful, individualistic, and even exotic—or as a national hero exemplifying stoic virtues.[12] He could even appear in genre paintings as a kind of democratic hero—that is, as a common man pursuing his profession, a role with which Americans could easily identify. In each of these guises the trapper could also fulfill his role as a mediator between the wilderness and civilization, thus helping to reconcile conflicts between romantic and nationalistic values that existed side by side in American thinking.

The following discussion will focus on the work of four American artists who produced the main body of trapper images during the period roughly between 1840 and 1860: Alfred Jacob Miller, Charles Deas, William Ranney, and Arthur Fitzwilliam Tait. Paintings and graphic works by other artists—some of them major figures, such as George Caleb Bingham—will be referred to in the appropriate contexts; but the major themes in the repertoire of trapper images occur in the work of the four artists named. Miller, Deas, and Ranney each contributed a distinct interpretation of the trapper corresponding, respectively, to the romantic, nationalistic, and democratic values mentioned above. Tait's importance lies primarily in the fact that his designs, reproduced as popular lithographs by Currier and Ives, reached a wide audience, making him largely responsible for the image of the trapper and plainsman held by the American public in the 1850s and '60s.

The Exotic American:
Trapper Images of Alfred Jacob Miller

Alfred Jacob Miller was one of several artists who had the opportunity to observe firsthand the activities of the fur trade during its halcyon days of the 1830s. Fur companies operating out of St. Louis, especially the American Fur Company under the direction of Pierre Chouteau, were eager to promote a favorable public image, and often allowed distinguished travellers to accompany trading expeditions into fur trapping territories.[13] George Catlin, Karl Bodmer, and John James Audubon were other artists who, at various times between 1832 and 1843, journeyed with the American Fur Company on expeditions into the frontier.[14] Of these four, however, only Miller gave much attention to the fur trappers and traders whom he met; and his sketches of his far western trip include records of their colorful appearance and way of life.[15] Miller was also the only one of the four who travelled overland in a fur company caravan, across the plains to the Rocky Mountains. Consequently he was able to observe the life of the mountain men and the activities of the mountain fur trade, including the exciting buffalo hunt and the infamous rendezvous. The other three artists, having travelled up the Missouri River on steamboats, observed a different phase of the fur trade which was less zestful and entertaining than the one Miller encountered.[16]

Miller went west as part of the retinue of William Drummond Stewart, a wealthy Scotsman who had already made several excursions onto the prairies.[17] Stewart was essentially a sportsman and adventurer. Thus when he employed Miller to make sketches of the scenery and life he observed on the trip, and later to paint finished canvases for the Stewart castle in Scotland, his hope was to have paintings which would convey something of the adventure and romantic flavor of the American West.[18] Miller fulfilled his duty much to Stewart's satisfaction,[19] and profited personally from the venture as well. He received numerous other commissions from American patrons to paint western scenes throughout the remainder of his career.[20]

Miller's most extensive commission (excluding the paintings for Stewart) was a set of two hundred watercolors that he produced for William T. Walters of Baltimore between 1857 and 1860.[21] Based on the notebooks and sketches of his 1837 trip, these watercolors depict the spectrum of western life which Miller had witnessed firsthand: Indian life, customs and costumes; western scenery; the activities and personalities of a fur company caravan; and, most important to this discussion, the life, costumes and manners of the fur trappers of the Far West. The artist wrote commentaries for each watercolor, explaining, describing or elaborating upon the theme presented in his image. These commentaries reflect the tone, spirit, and (at

times) the actual wording of key works of the fur trade literature, especially the writings of Washington Irving and George Ruxton.[22] This indicates that Miller's perceptions and interpretations of western life relied perhaps as much on literary sources as upon his own observations and experiences.

Miller's finished paintings—both the oils and the watercolors—are exhuberant and unabashedly romantic. He approached the task of recording life in the Far West with an eye for what was offbeat, thrilling, and exotic. Miller's romantic tendencies were, of course, a response to the pervasive influence of romantic thought in the first half of the nineteenth century, but much of his work owes a particular debt to Eugène Delacroix and to other French *orientalistes*. During a trip to Europe in 1833-34, Miller had spent some time at the Ecole des Beaux-Arts in Paris, where he studied paintings by contemporary French artists as well as those by the Old Masters which were to be found in the Louvre. Among the paintings he copied were Delacroix's *Inferno* and Decamps' *Arabs in Cairo*.[23] At this time Delacroix himself was in Morocco, and Miller undoubtedly heard gossip and reports of this celebrated trip in the artistic circles with which he associated. When a few years later Miller was to travel to a relatively unknown part of the American continent to record unusual scenes, he might have fancied himself "the Delacroix of the American West;" for certainly the images which resulted from his trip have all the flair and exoticism of Delacroix's oriental paintings.

Miller pictured the fur trapper and the western hunter as ideal romantic figures—admirably self-reliant, independent, and individualistic. Their most attractive traits were those that set them well apart from the norms of society: colorful costumes and habits, and a "wild, Robin Hood kind of life" (as Washington Irving described it).[24] A watercolor in the Walters Collection, entitled *Trappers Starting for the Beaver Hunt* (fig. 14), illustrates the romantic conception of the trapper not only by depicting the trappers' unique appearance, but also by conveying something of the nomadic freedom of their existence. Mounted trappers, carrying their trapping gear, ride off across an open plain towards a distant landscape of snow-peaked mountains. Significantly, they move away from the observer, who is stationed in the civilization of the East and, by implication, restrained by it. In his commentary to this image, Miller described the unusual costume and equipment worn and carried by these trappers. He then recited a verse which summarized his perception of the differences between the rovers of the West and men who remain in the comforts of civilization:

> [The] motives of action [of the trappers] have
> been happily described by the poet,—
> Let him who crawls enamoured of decay,

Cling to his couch, and sicken years away,
Heave his thick breast and shake his palsied head,—
Ours,—the fresh turf and not the feverish bed.[25]

Like Lord Byron, who saw in Daniel Boone the happy beneficiary of the healthful effects of Nature, Miller regarded the trapper as an embodiment of life, health, vitality, and of the freshness of a new nation and unspoiled environment—all of which were the antithesis of the "decay" of civilization.[26]

A spirit of individualism and untrammeled freedom characterizes the subjects of another watercolor in the Walters group, entitled *Trappers* (fig. 15). Beside a mountain pool or stream two trappers lounge casually in the open air. Unshaven and long-haired, they wear buckskins and moccasins and sport unusual headgear fashioned by the trappers themselves (as Miller explains in his commentary). Shadows cast by these peculiar hats fall across the trappers' eyes, giving them an exotic look reminiscent of Delacroix's Algerian women. To make sure the observer will not miss any important detail, the artist depicted two indispensable items of trapping gear—a powderhorn and bullet pouch—suspended from a tree branch above the trappers' heads. The image is thus something of a costume piece, intended to draw attention to the trappers' distinctive and somewhat outlandish outfits, which can be seen as clues to their equally individualistic natures.

Miller attempted to balance his romantic and exotic image of the mountain men by linking them to the destiny of American civilization. In the commentary accompanying *Trappers,* Miller points out the significance of these men to the exploration of the unknown regions of the West, using words reminiscent of other descriptions from the fur trade literature.

The trappers may be said to lead the van in the march of civilization—from the Canadas in the North to California in the South;—from the Mississippi East to the Pacific West; every river and stream, in all probability, have been at one time or another visited and inspected by them. Adventurous, hardy, and self-reliant—always exposed to constant danger from hostile Indians, and extremes of hunger and cold,—they penetrate the wilderness in all directions in pursuit of their calling.[27]

Again we encounter that philosophic double vision which could admire the trapper's unconventionality and distinctness from society's norms while appreciating his role in spreading the influence of that society and its conventions. Miller's image betrays romantic tendencies, while his written commentary expresses nationalistic sentiments.

A trapper's life drew much of its appeal and romance from the western environment in which he pursued his profession. The West seemed to

magnify by several factors the much admired, described, and painted qualities of the eastern wilderness: wildness, vastness, and pristine condition. The Rocky Mountain landscape was even more sublime by reason of its potential for hostility—its harsh climate, the deprivations men suffered when attempting to traverse it, and the dangers of attacks by Indians. Miller was as conscious of, and sensitive to, the affective power of the western environment as any artist, and in many of his watercolors of trappers, the landscape commands full atttention and determines the mood of the image.

The settings of the watercolors entitled *Trapping Beaver,* and *Trappers' Encampment on the 'Big Sandy' River,* are the banks of mountain streams lined with gnarled and twisted tree stumps and thick brush reminiscent of the vegetation of Thomas Cole's wilderness landscapes. The figures of the shaggy and uncouth trappers fit perfectly into this untamed and uncultivated scenery. Wading fully clothed in the water to set traps, or gathering firewood to make camp, the trappers act in easy harmony with their surroundings. Even more impressive is the scenery of two other watercolors, *Wind Scenery—Making a Cache,* and *Wind River Chain,* in which the figures of the trappers are dwarfed by the grandeur of the wilderness landscapes. In fact, the figures of the latter composition might easily be overlooked if Miller did not draw attention to them in his commentary:

> In the immediate foreground some trappers are galloping to join a party who are on the extreme end of the bluff, looking at the "promised land" which forms their mountain home; for at the base of these, they expect to meet large bands of their brother Trappers with whom they promise themselves a grand carouse and drinking bout;—in order to repay themselves for the abstinence they are compelled to observe in a military and well-governed camp.[28]

Miller's trappers, then, feel cramped by the disciplines of civilization and are much more at home in the open wilderness. The watercolor, stressing the vastness of the landscape and the freedom with which the trappers move through it, reinforces an interpretation of the trapper as essentially a child of the wilderness, even though linked to society through his background and profession.

No matter how much the American mind might value the freedom of wilderness environment, it remained painfully aware of its potential hostility. Constant exposure to danger was one of the quintessential conditions of life on or beyond the frontier, and trappers, in spite of their ability to adapt to the wilderness, were not immune to its dangers. The literature on the fur trade abounded in narratives of trappers harassed by sudden attacks by Indians or wild animals, of their facing starvation and exposure to harsh elements, and of their resourcefulness and self-possession in the face of such dangers. (Recall the passage from W.A. Ferris quoted above, p. 29) For

many writers, this perilous and thrilling existence of the trapper held a certain fascination. Miller, too, found in tales of trappers' hair-raising experiences much that appealed to his taste for romantic adventure, and several of his watercolors depict incidents of trappers narrowly escaping calamity. One of these, *Free Trappers in Trouble,* records an actual incident that occurred during Miller's trip West. The caravan with which he had been travelling came upon two trappers who were near starvation, having long since exhausted their food supply and ammunition. The composition, based on a sepia drawing of the two major figures which Miller presumably had done on the spot,[29] discretely relegates the caravan, which brought relief, to the background and focusses most attention on the pathetic figures of the trappers in the foreground.

A more lively image is *Shooting a Cougar*, which depicts a mounted trapper warding off an attack by an animal springing from an overhanging rock. Most probably Miller had heard of, but never actually witnessed, such an event; otherwise he would not have modelled his cougar on an enlarged tabby cat. Nonetheless, in its stated purpose, which was to "convey an idea of the Cougar's stealthy attack, and the reception he meets from a self-possessed and wily mountaineer,"[30] the sketch successfully illustrates the traits of courage and competence which earned the trapper respect among the American public.

The watercolor entitled *Escape from Blackfeet* illustrates the thrill of pursuit and escape. Two mounted trappers gallop across the foreground pursued by Indians in the distance.[31] The composition is typical of the arrangement generally used for such themes: it was used by William Ranney, A. F. Tait, and others, and became a familiar image of western life to the American public through its circulation in popular prints in 1850s and 1860s.

An experienced trapper would seldom have found himself in a situation like the one depicted in *Lost Greenhorn* (fig. 16), in which a newcomer to the prairies finds himself lost on a vast and seemingly undifferentiated plateau. His pathetic figure, mounted on his pony and scanning an endless horizon, conveys the futility of his situation. For the sophisticated patrons in the East for whom Miller painted this subject, the image may have had an intense psychological charge, suggesting an interpretation of the scene in terms of a personal inner crisis.[32]

Roger B. Stein, in his study of American seascapes, has suggested that western panoramas, particularly prairie-scapes, are akin to American marine paintings as expressions of the artists' "feeling for the vast, unmediated sublimity of the universe."[33] It would not be unreasonable to suggest that Miller's *Lost Greenhorn,* as well as other depictions of isolated figures in prairies settings, were the western equivalents of romantic

seascapes in which melancholy figures contemplate the vastness of the ocean. Viewed in this light the lone pioneer or trapper on the prairie would signify, on a conscious level, the individual struggling to find his way in an immense universe of which he is an insignificant part.

A conscious recognition of these feelings did exist in the nineteenth century, as indicated by a passage from George Kendall's *Narrative of the Texan Santa Fe Expedition*, published in 1844. Kendall describes a personal experience in which he was separated from his companions and found himself lost on the prairies—a situation almost identical to the one depicted in Miller's image. His reactions to his predicament are particularly revealing:

> Gentle reader, you have never been lost on a wide ocean of prairies, unskilled in border life, and little gifted with the power of first adopting a course to follow, and then not deviating from it. You must recollect that, there, as on the wide ocean, you find no trees, no friendly landmarks to guide you,—all is a wide waste of eternal sameness. *To be lost,* as I and others have experienced, has a complex and fearful meaning. It is not merely to stray from your friends, your path, but from yourself. With your way, you lose your presence of mind. You attempt to reason; but the rudder and compass of your reflective faculties are gone. Self-confidence, too, is lost; in a word, all is lost, except a maniacal impulse to despair, that is peculiar and indescribable.[34]

Just as Kendall's diction ("the rudder and compass of your reflective faculties") implies an analogy with ships on the ocean, so Miller's image invites a comparison with sailors at sea who are adrift in a foreign environment.

Allusion has already been made to the fact that although a romantic bias permeates Miller's images of the fur trapper, the artist also accepted the often-expressed view that the trapper was a representative of civilization expanding into the wilderness. Romantic in temperament (due to his artistic training), Miller might be expected to place a high value on nature and the wilderness environment; yet, as an artist living in an Eastern seaboard city and patronized by wealthy Easterners, he could not completely shun the promise of the rising glory of American civilization. Searching for a means by which to reconcile the demands of civilization and those of the wilderness in his imaginative view of the West, Miller evolved an interpretation of the trapper as a mediator between the two. The fur trade literature effected this reconciliation by describing the trapper as a white (i.e., civilized) man who had learned to live like the Indian and whose values and traits belonged to the wilderness. Miller embraced these ideas, but his images transcended rational arguments in their effectiveness as only imaginative in-

terpretations could. His image of *The Trapper's Bride* is one of the most trenchant visual statements of the theme of reconciling the wilderness and civilization to be produced on American art during the nineteenth century.

The composition is one of Miller's most appealing and popular images. He repeated it several times—in oil paintings, such as the one in the Joslyn Museum in Omaha, Nebraska (fig. 17), and in watercolors, such as the one in the Walters Collection.[35] The commentary accompanying the latter describes the essentials of the composition:

> The scene represents a Trapper taking a wife, or purchasing one...He is seated with his friend to the left of the sketch, his hand extended to his promised wife, supported by her father and accompanied by a chief, who holds the calumet, an article indispensable in all grand ceremonies...[36]

The event depicted is an Indian ceremony, taking place on Indian soil, as it were, beyond the jurisdiction of the white man's laws, customs, and traditions. The image is thus a superb example of the romantic taste for the exotic, in spirit and subject akin to Delacroix's depictions of a Jewish wedding in Morocco. However, we must not overlook its deeper implications, which operate on three different levels of significance.

On the first level, the theme of the trapper's Indian bride typifies racial intermarriage, and thus touches upon a critical issue in nineteenth century American social history: the nature of the relationships between races, and particularly between Indians and white men.

The question of marriage between Indians and whites arose almost as soon as Europeans had established colonies on the shores of the New World. Colonial reactions to the prospect of racial intermarriages were mixed. Puritan thought in the northern colonies generally found the idea abhorrent, fearing that such marriages would lead to racial degeneration. In the southern colonies, however, a more liberal attitude was able to rationalize such unions on the grounds that they were effective means by which Indians could be brought to Christianity and civilization.[37] This was the argument used by Virginia colonist John Rolfe to explain his marriage with the Indian princess Pocahontas in 1614.[38] This marriage became the archetype of all such interracial marriages and the ideal of harmonious Indian-White relations—an ideal which, unfortunately, was not to be realized in later generations. In spite of the example of Rolfe, however, the first law prohibiting miscegenation was enacted in a southern colony—in Maryland in 1663.[39] Concern over the issue persisted into the eighteenth century, when Virginian Robert Beverly and his fellow colonist William Byrd wrote their respective histories of Virginia in 1722 and 1729. Both argued that, had racial intermarriage been encouraged from the beginning of the white man's contact

with the Indians, the problems of Indian-White relations so apparent at that time would have been greatly alleviated.[40]

In the latter half of the eighteenth century, the issue was embraced by a larger scientific and philosophic debate over the nature of America as a human habitat.[41] There were articulate spokesmen on both sides of this debate, arguing in what were at the time the most advanced scientific terms. Generally speaking, European naturalists found the American climate and environment inferior to that of Europe and unsuitable for the support and prosperity of civilization. Naturally, Americans vigorously opposed this view. As proof of the inferiority of the American habitat, the Comte de Buffon in 1791 delivered a brief but devastating indictment of the American Indian in his *Natural History.*[42] His description of the Native American as little better than an animal provided grist for the mill of those who believed that miscegenation would lead to racial degeneration. To the calumny so ungraciously delivered by Buffon, Thomas Jefferson replied with a thorough rebuttal in his *Notes on the State of Virginia,*[43] in which he ascribed to the Indian physical equality with, if not superiority to, the European. Any seeming deficiencies in the Indian, argued Jefferson, could be attributed to his social state. Starting from Jefferson's premises, it was not difficult to advance to the notion that marriages between whites and Indians would result in elevating the Indian to the level of white society without impairing the physical well-being of either race; and Jefferson himself soon came to advocate racial intermarriage as a social policy.[44]

Thanks, perhaps, to the influence of Jeffersonian opinion, a favorable attitude towards racial mixture lingered into the nineteenth century, as the literature on the West and on the American Indian testifies. In 1826, for example, Timothy Flint wrote:

> In respect to Christianizing the savages, the leading men of the country say, in a tone between jest and earnest, that we can never expect to do it without crossing the breed. In effect, wherever there are half-breeds, as they are called, there is generally a faction, a party; and this race finds it convenient to espouse the interests of civilization and Christianity. The full-blooded chiefs and Indians are generally partisans for the customs of the old time, and for the ancient religion.[45]

Although marriages between white men and Indian women did occur, they did not take place on a scale wide enough to bring about the results that Jefferson and others had hoped for—i.e., full integration of the Indian into white culture. Actual circumstances in the nineteenth century were making the dream of peaceful assimilation of the races practically obsolete. The expansion of white civilization into Indian territories was too rapid to allow for a policy of gradual intermixing of whites and Indians. Instead, the United States government decided upon a more expedient policy with

regard to the Indian—Removal, which meant the transfer of all Indians to lands beyond the boundaries of the Union.[46] Thus, after the passage of the Indian Removal Bill in 1830, only those white men who lived and worked on the edge of the frontier and beyond—such as fur trappers and traders—would have any sustained contact with Indians. Yet, the dream of bringing the Indian to civilization persisted. David Coyner in 1847 described the "motley class of men" who inhabited the frontier as the instruments by which this civilizing of the Indian was to be achieved:

> ...For these men, who by the way are very numerous, savage life seems to have its peculiar charms. They take to themselves wives, and domesticate themselves among the different tribes in the west...The result of this intermixing and intermarrying, has been the springing up of a numerous hybrid race of beings, that constitute a medium, through which, it is hoped, at one distant day, the laws, arts, and habitudes of civilized life may be successfully introduced among the tribes of the west, and be the means of reclaiming them from the ignorance and barbarities in which they have been so long enthralled.[47]

Even the Superintendent of Indian Affairs in St. Louis, D.D. Mitchell, asserted as late as 1851 that "an intermixture with the Anglo-Saxon race is the only means by which Indians of this continent can be partially civilized."[48] Considered in this context, Miller's trapper taking an Indian bride represents the last hope for fulfilling the Jeffersonian ideal of a peaceful amalgamation of the races.

As a symbol of unity among races, Miller's image appealed to the nineteenth-century American poet Walt Whitman, whose use of the image indicates how some Americans interpreted the theme of the trapper's bride. In his poem, "Song of Myself," celebrating the universality of all life, Whitman included a description of the marriage between a trapper and an Indian maiden which is remarkably consonant with Miller's *Trapper's Bride*:

> I saw the marriage of the trapper in the open air
> in the far west, the bride was a red girl,
> Her father and his friends sat near cross-legged
> and dumbly smoking, they had mocassins to their
> feet and large, thick blankets hanging from
> their shoulders,
> On a bank lounged the trapper, he was drest mostly
> in skins, his luxuriant beard and curls
> protected his neck, he held his bride by the hand,
> She had long eyelashes, her head was bare, the coarse
> straight locks descended upon her voluptuous
> limbs and reach'd to her feet.[49]

Whitman's description of the trapper's marriage immediately precedes a brief account of a meeting between the narrator and a runaway slave. The poet proclaims his egalitarian doctrine in the concluding line of this section: "I had him [the slave] sit next me at table..." Together the two anecdotes—the marriage of the trapper and the Indian girl, and the hospitality of the white man towards the runaway slave—express Whitman's belief in a universal brotherhood based on the unity and equality of the races; and he must have seen Miller's image as a symbol of that unity.

The Indian Removal Bill was enacted in 1830; Miller painted his first version of *The Trapper's Bride* for Stewart in 1840, and the last version in watercolor for Walters sometime between 1858 and 1860.[50] The persistence of this theme in an era in which the dream of harmonious racial assimilation was no longer a viable policy indicates that a deeper level of interpretation is possible for the image. Marriage, of course, signifies union. To the American of the nineteenth century, the Indian embodied the values of the wilderness, while the white man represented civilization. *The Trapper's Bride*, then, can be seen as an expression of hope for the reconciliation of nature and society.

The key to the validity of this interpretation lies in the striking similarity between Miller's composition and European renditions of the Marriage of the Virgin, particularly Raphael's version of 1504 (Brera Gallery, Milan).[51] In Miller's painting the bride and groom face each other and extend their right arms, ready to join hands in symbolic commemoration of their union. The composition echoes Raphael's arrangement of Joseph and Mary, and in both paintings a third party officiates, the high priest in Raphael's depiction paralleled by the bride's father and the Indian chief in Miller's image. The proportions of Miller's painting and his placement of figures with respect to the backgrounds are also similar to Raphael's composition.

Miller's decision to use the visual tradition of a sacred theme is not so inappropriate as it might at first appear. Although we can scarcely assume that the artist seriously meant to compare the Indian maiden to the Virgin Mary, it is nonetheless possible that Miller did see a parallel between the sacred and secular events. The marriage of the Virgin to Joseph legalized a union which had already taken place: a union of the two distinct realms—the human and the divine. In a similar way the marriage of the trapper to an Indian woman can be seen as signifying the union of two worlds—civilization and the wilderness, represented by the two races that inhabited them.[52] Miller's allusion to the holy event in the Christian tradition was a deliberate effort to raise the significance of the trapper's marriage to this higher level of interpretation. The event takes on national significance, expressing the hope not only that the Indians might be

assimilated rather than exterminated, but that the ambitions of the American nation might be successfully reconciled with the American landscape. The trapper acts as mediator between the conflicting values of the wilderness and civilization, thus providing an imaginative solution to a dilemma which in fact was never resolved in the nineteenth century.

Miller's image is susceptible to interpretation on yet another level, and this interpretation helps to explain the popularity of *The Trapper's Bride* among the artist's eastern patrons. Because marriages between whites and Indians were forbidden by law in Miller's home state of Maryland (as well as in other states within the Union) the mountain man who married an Indian maiden represented a class of white men effectually outside the reach of such a law. Living in the Far West—in a land beyond the boundaries of the United States and its laws, and thus literally and figuratively beyond the trammels of civilized society—the trapper enjoyed an enviable freedom, unrestricted by legal prohibitions or social taboos. Perhaps it was this message that appealed subliminally to Miller's wealthy and erudite patrons who lived within the established social order and submitted themselves to the limits it placed on freedom of choice and action. Thus, at the same time that Miller's image expressed the hope of reconciliation between civilization and the wilderness, it could signify on a less conscious level the aspiration towards total escape from society's restraint into the freedom promised by the West.[53]

Miller's romantic inclinations may have clouded his observations of life in the Far West and produced as a result a description of the trapper that strayed from absolute accuracy in the direction of inflated thrills and exoticism. His images, however, are no less significant for being thus colored. They are, in fact, indices of what Americans thought about their national destiny in the West; and, as we have seen, in studying these images we confront once again the dualism of American thinking. The western wilderness could represent a land beyond societal restriction and the trappers could symbolize aspirations of escaping into unrestricted freedom. But the West could also represent the future of American civilization, and the trappers could serve as heralds and forerunners of its advancement. With the image of the trapper as a mediator between society and the wilderness, Miller happily hit upon a means of reconciling these seemingly conflicting aspirations.

Before leaving altogether the theme of racial intermarriage acting as a means of mediating between civilization and the wilderness, it is appropriate to discuss here George Caleb Bingham's painting of 1845, *French Trader and His Half-Breed Son,* better known today as *Fur Traders Descending the Missouri* (New York, Metropolitan Museum of Art; fig. 18).[54] The painting is deservedly popular and is widely known as one of

Bingham's most successful genre scenes of frontier life. Its mood of quiet harmony arises from Bingham's skillful integration of form and content. The traders in their canoe drift calmly with the unruffled current of the river. Compositionally all forms speak of balance and stability. The canoe glides easily with the horizontality of the river and its distant bank. The figure of the fur trader, sitting almost motionlessly in the rear of the canoe and guiding it with his oar, and the pet fox chained to the bow are two upright accents balanced around the figure of the son, who, leaning casually on the cargo of furs at the center of the canoe, forms a solid and nearly symmetrical triangle.[55] All three figures—fox, fur trader, and son—look directly out from the painting towards the observer, acknowledging his presence and establishing direct and immediate contact between painting and audience.

In 1845 when Bingham painted his fur traders on the Missouri, steamboat traffic on that river had taken over much of the job of transporting furs from trading centers downriver to St. Louis. A scene like the one Bingham depicted would no longer have been typical, but would have been found only in the more remote regions of the upper Missouri River. Furthermore, the fur trade industry itself had fallen into a slump and was no longer the busy enterprise that it had been a decade earlier.[56] Bingham's painting was a nostalgic piece evoking memories of earlier days before the advent of the steamboat. In light of the above discussion of racial intermarriage and the mediating role played by the fur trapper (and trader), however, another level of interpretation, in which the image functions as a metaphor of man's relationship to the wilderness , should be considered.

The starting point for this interpretation lies in the original title of the painting. Bingham identified the two figures in the canoe as a "French trader and his half-breed son,"[57] an identification which had more significance to his audience in 1845 than it has for us today. The literature on the fur trade, especially as written by American authors, carefully differentiated between French trappers and traders and Americans. The former participated in the fur trade of the Missouri River, where their activities included bartering with Indians for beaver pelts (the role of the trader), or transporting furs downriver to frontier settlements (the job of the voyageur). The American trapper or mountaineer, on the other hand, roamed the Far West of the Rocky Mountains trapping beaver. American commentators noted great differences in character and temperament between the two nationalities; and, as might be expected, American trappers were usually considered superior in their profession. Washington Irving, for example, described the French trapper as a "a lighter, softer, more self-indulgent kind of man...gay and thoughtless," and "less hardy, self-dependent and game-spirited, than the mountaineer."[58] Not all evaluations of the French were so disparaging, however. Charles Lanman, referring to

the French trader, described him as belonging "to the aristocracy of the wilderness."[59]

One trait generally associated with the French in the Mississippi Valley is of particular relevance to this discussion. There is some evidence that Americans regarded the French as more inclined to intermarry readily with Indians than were the Americans. Timothy Flint, for example, stated in 1826:

> I have already hinted at the facility with which the French and Indians intermix. There seeems to be as natural an affinity of the former people for them as there is repulsion between the Anglo-Americans and them...The French settle among them, learn their language, intermarry, and soon get smoked to the same copper complexion. A race of half-breeds springs up in their cabins...It would be an interesting disquisition, and one that would throw true light upon the great difference of national character between the French and Anglo-Americans, which should assign the true causes of this affinity on the one part, and antipathy on the other.[60]

Thus it was the French who, in the nineteenth century, set the example for the racial amalgamation advocated by Jefferson and others in the late eighteenth century.

Bingham's French trader and his son can thus be seen as symbols of the white man's integration with the Indian and, by implication, with the wilderness. The harmony and quietude that pervades the setting of Bingham's painting testify to the peacefulness and success with which this assimilation has taken place. Significantly, in Bingham's composition the half-breed son occupies a central position between his father (representing white society) and the fox (representing pure wildness); he is the embodiment of a new breed or new way of life that combines the traits of both civilization and the wilderness.

The river is an important motif in this interpretation, functioning as a kind of visual synecdoche of the wilderness—that is, as one part signifying the whole; yet it serves also as a line of demarcation separating that wilderness from civilization. The observer, standing on the east bank of the river (the side of civilized settlements) must look across the river to the opposite bank which, shrouded in mist, represents the unknown and unsettled trans-Missouri West. The river, by virtue of its uninterrupted flow, may also signify a process—specifically, the process of civilization's advancement; for, on its quiet surface, the river carries canoe, cargo, and passengers inexorably towards civilization and away from the frontier wilderness of the upper Missouri regions. For one eternal moment our fur traders drift effortlessly, suspended between east and west, between upstream and downstream, between civilization and the wilderness. Their presence on the river, flowing with it yet not touching either shore, signifies their role as mediators gliding between two worlds.

The Trapper as National Hero:
Images by Charles Deas

Miller made only one trip West: upon returning to Baltimore in 1837 he never again ventured onto the frontier, although he continued to paint Western subjects for his patrons in the East throughout the remainder of his career. Charles Deas, on the other hand, spent the most active years of his artistic career—the 1840s—in St. Louis, making periodic excursions onto the frontier.[62] Born in Philadelphia in 1818, he made his first trip West in 1840, and was evidently so enthralled with frontier life that he settled in St. Louis for the remainder of his brief career. By 1846 he had so thoroughly established himself as a painter of western subjects as to earn the praises of Charles Lanman:

> ...The bright particular star, who uses the pencil here (i.e., St. Louis) is Charles Deas...He makes this city his headquarters, but annually spends a few months among the Indian tribes, familiarizing himself with their manners and customs, and he is honorably identifying himself with the history and scenery of a most interesting portion of the continent. The great charm of his productions is found in the strongly marked national character which they bear.[63]

Deas so successfully adopted the dress and customs of the westerner—particularly of the trapper—that he earned the nickname "Rocky Mountains." A description of him written in 1844 gives some idea of his rather theatrical nature and hints at a commonly accepted view of the trapper as a man who obeys his own inclinations:

> Deas had a broad white hat—a loose dress, and sundry traps and truck hanging about his saddle, like a fur-hunter. Besides he had a Rocky Mountain way of getting along; for, being under no military restraint, he could go where he pleased, and come back when he had a mind to.[64]

Deas's depictions of fur trappers are tinged with strong nationalistic preconceptions of the trapper as a new American hero. Nowhere is this interpretation illustrated more cogently than in a composition of 1844 entitled *Long Jakes, or Rocky Mountain Man*[65] (illustrated here as it was engraved by W. G. Jackman, fig. 19), one of Deas's best-known trapper paintings. A trapper mounted on his horse dominates the pictorial field as a solid pyramidal form set close to the frontal plane. His pose, turning in his saddle and poised for action, conveys a sense of imminent, if unseen, danger. Like the Daniel Boone of Allen's 1839 portrait (see above, p. 7), Deas's mountain man is alert to something that has caught his attention outside the pictorial field, perhaps a noise that warns of nearby enemies.

In setting and monumental composition format Deas's painting strik-

ingly resembles Jacque-Louis David's *Napoleon Crossing the Alps* of 1800 (Versailles), a composition widely known and admired in the United States in the nineteenth century.[66] Both paintings belong to the tradition of the equestrian portrait, a tradition associated almost exclusively with military heroes or heads-of-state—in other words, with men who represented a nation.[67] Deas's use of this venerable tradition elevated his trapper to the status of national hero.

Deas's trappers could claim this status chiefly by virtue of their courage and self-possession, qualities widely admired and frequently described in the fur trade literature. Thomas Farnham, for example, wrote of the trappers in 1843:

> Habitual watchfulness destroys every frivolity of mind and action. They seldom smile: the expression of their countenances is watchful, solemn, and determined. They ride and walk like men whose breasts have so long been exposed to the bullet and arrow, that fear finds within them no resting place.[68]

And George Ruxton's comments, although postdating Deas's painting by a few years, could easily serve as a description of Long Jakes:

> The trapper must ever be in a state of tension, and his mind ever present at his call. His eagle eye sweeps round the country, and in an instant detects any foreign appearance...All the wits of the subtle savage are called into play to gain an advantage over the wily woodsman; but with the natural instinct of primitive man, the white hunter has the advantages of a civilized mind, and thus provided, seldom fails to outwit, under equal advantages, the cunning savage.[69]

Ruxton again saw in the trapper the blended traits of civilization and savagery—in this case, the "instinct of the savage" mingled with "a civilized mind." Evidently the art-viewing public that saw Deas's paintings understood his trapper images in similar terms. An art critic writing in *The Broadway Journal* in 1845 described *Long Jakes* as a blend of wildness and refinement:

> "Long Jake" comes to us from the outer verge of our civilization; he is a Santa Fe trader, and with his rifle in hand, his blazing red shirt, his slouched hat, long beard and coal black steed looks as wild and romantic as any of the characters in Froissart's pages, or Salvator Rosa's pictures. But "Long Jake" was not always a Santa Fe trader—there are traits of former gentleness and refinement in his countenance, and he sets upon his horse as though he were fully conscious of his picturesque appearance...[70]

Sometime in late 1846 or early 1847, Deas completed a composition entitled *The Trapper,* unfortunately now lost; but a description of the work published in the St. Louis *Reveille* recalls certain features of *Long Jakes* and suggests that *The Trapper* was an elaboration and variation on the earlier theme:

The picture represents a trapper on horseback upon a platform of the mountains, sketched at the moment, apparently, when some noise in his rear has awakened his attention. Resting his right foot in the heavy wooden stirrup, he has drawn the other out, and, with body turned in the saddle, is holding his rifle steady for any hostile surprise. The horse, his head turned on one side, is also listening attentively to the alarm. In the background is a cold, bleak sky, slightly tinged by the setting sun; and directly in the solitary wayfarer's path lies a skull, bearing in its cloven front the mark of savage murder. The whole picture conveys at a glance the lonely, perilous and daring character of the western trapper... There is no fear portrayed in the countenance—no surprise; but a calm, collected face, clear eye and firm mouth—the very personification of a mountain rover, used to danger and ready for the encounter.[71]

"Lonely, perilous and daring"—with these words the reviewer summarized the character and life of the fur trapper as Deas presented them in his paintings. His most dramatic—one might even say, melodramatic—presentation of this peril is his painting, *The Death Struggle* of 1844 (Shelburne Museum, Shelburne, Vt.; fig. 20), a depiction of a fight to the finish between an Indian and a lone trapper.[72] Unfortunately, in his effort to achieve high drama, the artist strains our credulity: it is difficult to accept the likelihood that two combatants, struggling with each other while still astride their horses, could accidentally plunge off a cliff. Nonetheless, although the action may seem extreme, the image of the death plunge was not unprecedented in art. The legend of Marcus Curtius, the Roman soldier who sacrificed himself for the good of Rome by leaping on horseback into an open chasm in order to appease the gods, had been illustrated in sculpted reliefs from antiquity and in paintings from the sixteenth and seventeenth centuries.[73] In the eighteenth century this theme appeared in an edition of Ripa's *Iconologia* as a vignette illustrating "Audacity."[74] American folk culture made use of the "daring leap" theme in at least two popular stories. Dating from the Revolutionary era is the amazing tale of Major Samuel McCullough, who escaped from an Indian attack by urging his horse to leap off a steep cliff above Wheeling Creek in Virginia[75] (Miraculously the fall of horse and rider was broken halfway down, and both managed to scramble down into the creek and swim to safety on the opposite shore.) A similar episode, adapted to the comic tradition, is part of the lore that grew up around the life and reputation of Davy Crockett. One tale credits Crockett with a miraculous leap from a cliff, again in order to escape attacking Indians. Davy's adventures were well known to the American public through the popular *Crockett's Almanac,* published in yearly editions.[76] A crude woodcut illustrating Crockett's leap appeared in the Almanac for 1844, the same year of Deas's painting (fig. 21). One should exercise caution, however, in suggesting that the woodcut was the inspiration for Deas's motif; for Deas's image was meant to be taken seriously (however exaggerated and ludicrous it may appear to us today), whereas the

comic overtones in the *Almanac* were unmistakable. Furthermore, the incident depicted in Deas's composition differs significantly from both Mc-Cullough's leap and Crockett's exploit: the feats of the latter two heroes were willful acts of daring, whereas, to judge from the expression on the face of Deas's trapper, his plunge is purely accidental and his struggle is a desperate and hopeless one. Nevertheless, the currency of two stories about thrilling leaps off high cliffs explains why Deas's audience in the 1840s might have been more credulous and predisposed than are we to accept the artist's depiction of such a melodramatic event.

From his vantage point in St. Louis, Deas was able to observe several aspects of the fur trade industry. Besides Rocky Mountain free trappers, the artist also depicted the *voyageurs* of the upper Missouri—men of French descent who were, in Charles Lanman's words, "the shipping merchant(s) of the wilderness."[77] As was pointed out above (p. 42), the fur trade literature described substantial differences between French-Canadian voyageurs and American free trappers. Washington Irving attributed these differences to the effects of the environment, but it is clear that his admiration belonged to the American mountaineer:

> ...The "Mountaineers," the traders and trappers that scale the vast mountain chains and pursue their hazardous vocations amid their wild recesses...move from place to place on horseback. The equestrian exercises, therefore, in which they are engaged, the nature of the countries they traverse, vast plains and mountains, pure and exhilarating in atmospheric qualities, seem to make them physically and mentally a more lively and mercurial race than the fur traders and trappers of former days...A man who bestrides a horse must be essentially different from a man who cowers in a canoe...[78]

In his paintings of voyageurs, such as the composition of 1846/47 in the Boston Museum of Fine Arts (fig. 22),[79] Deas avoids the common stereotype of these men as thoughtless, happy-go-lucky, and deficient in courage and resourcefulness. The figures of his painting are heroic in their efforts to control their canoe in the rushing torrent of river rapids. A reviewer in the St. Louis *Reveille* of February 1847 noted nothing tame about Deas's depiction:

> [The painting] represents three trappers in a "dug-out" passing through a canon among the hills. The attention of all three is engaged in directing the barque with Indian paddles, and from their fixed attention forward may be guessed the difficulties in their way, and the interest felt by all in their safe progress through the defile...The weather-worn *voyageurs* are painted true to life, in their rude habiliments, with unshaven chins, and their long hair hanging in disordered masses about their necks. The steersman is particularly striking, in figure and appearance. His hair is silvered by time, but his brawny and muscular frame, protected by the habits of simple mountain life, is a model of strength and vigor. The whole scene is wild and picturesque as nature itself in the solitary regions of the west.[80]

Deas did establish one significant difference between the character of the voyageur and that of the American free trapper. In his paintings voyageurs appear as social beings, travelling with their families, working cooperatively, facing challenges as a group; but his trappers are almost invariably loners, typifying the solitary American as a rugged individualist.

Although when judged from today's perspective Deas's paintings appear markedly idealized and melodramatic, audiences of the 1840s found them to be accurate representations of Western life. One contemporary critic described Deas's work as "purely American in...feelings" and praised it for having "an air of genuineness that impresses you with the feeling of truth."[81] Public response to Deas's paintings indicated that his images of fur trappers as heroic figures—alert, courageous, independent, and self-reliant— came as close as possible to presenting what might be considered a national interpretation of the trapper; that is, an interpretation which expressed the ideals and virtues which the American public identified with their national character.

The Democratic Image:
William Ranney's Fur Trappers

Deas's successor as a popular painter of western subjects was an artist who spent most of his artistic career in the environs of New York City, William Tylee Ranney,[82] whose two paintings of the Boone narrative were discussed above (pp. 16–19). It will be remembered that Ranney had spent some time in the Southwest in the mid-1830s, an experience that was undoubtedly responsible for his later interest in painting western themes, including depictions of the fur trapper of the Far West. Ranney's trappers are neither the exotic creatures pictured by Miller, nor the superhuman heroes fabricated by Deas; they are instead ordinary men pursuing their profession in an extraordinary environment. They appear almost always on horseback as nomads moving through the Rocky Mountain wilderness or travelling across the vast regions of the Great Plains. Occasionally Ranney depicts a dramatic incident, such as a trapper assailed by Indians; but for the most part the action of his trapper paintings is understated and unremarkable. The real power of these compositions lies in their skillful presentation of mood, which evidences the artist's keen perceptions of the psychological effects of the western environment.

Ranney's painting of 1850, *The Trapper's Last Shot* (illustrated here as it was lithographed; fig. 23), was both his first composition dealing with the trapper theme and his most heroic image of that breed. Close in spirit to Deas's paintings of just a few years earlier, its subject may indeed have been inspired by one of Deas's compositions of 1847 entitled *The Last Shot*. Un-

fortunately Deas's painting is now lost, but comments in a review of the American Art Union exhibition of 1847 suggest that the work was among Deas's more melodramatic compositions:

> The subject of the picture will, undoubtedly, find an occasional admirer, but we think the committee unwise to purchase it for a promiscuous distribution. They have much to answer for should it fall to the lot of some meek-minded individual...for the horror of the picture would curdle all the milk of human kindness in his breast. The hideous aspect of the dying "rancher" would haunt him like a night-mare, and the daily contemplation of it at breakfast-time would destroy his appetite, and his peace of mind.[83]

Ranney's composition produces a much different impression. Here we see a solitary trapper on horseback, twisting in his saddle to scan the prairie horizon. Tiny figures of mounted Indians barely visible in the background represent the danger he anxiously faces. The horizontality of the prairie setting intensifies our sense of his vulnerability. Surrounded by flat open space, our hero is left exposed to his enemy without a visible place of refuge. Our sympathy is aroused by our anticipation of the trapper's fate rather than by a lurid description of it. Thus Ranney shuns Deas's sensationalism in favor of a more subtle psychological tension to capture and hold our attention.

Many features of Ranney's composition correspond to the written description of Deas's *Trapper* (quoted above, p. 46)—note the trapper's alertness, his twisting pose, his rifle held in readiness, and the restiveness of his horse. Ranney probably knew the paintings Deas had exhibited at the American Art Union; and his own trapper painting, while inspired by Deas's work, may also have been motivated by a desire to correct Deas's excesses.[84]

Ranney made at least two versions of *The Trapper's Last Shot,* one for exhibition at the American Art Union in New York City, and the other for the Western Art Union in Cincinnati. The latter version was engraved for distribution to the members of the Western Art Union in 1850[85]. Currier and Ives published a lithograph of the image (which is undated), and at least five copies of the composition, probably derived from the prints, are known to exist.[86] Obviously, the image was widely known and very popular—understandably so, for it is the artist's most incisive image of the trapper as hero.

Perhaps because of his own firsthand experience on the southwestern frontier, Ranney was particularly sensitive to the uniqueness of the plains environment and especially aware of its affective power.[87] The barrenness of his prairie settings throws his trappers into relief, highlighting their isolation from society and intensifying the real or potential dangers they con-

front (hence the vulnerability of the hero of *The Trapper's Last Shot).* Even in a painting in which there is little or no dramatic action, such as *Halt on the Prairie,* the stark prairie setting surrounding two trappers creates a compelling image of their utter isolation and remoteness. Ranney's mountainous settings are equally evocative. In his painting of 1853, *Trapper Crossing the Mountains* (Louisville, Ky., J. B. Speed Art Museum), for example, the barren wintry landscape corresponds well with the mood of loneliness reflected in the trapper's introspective expression.[88]

Although he felt acutely this sense of isolation in the western landscape, Ranney perceived that this condition could actually foster a spiritual and psychological kinship among those who lived and worked within it—even a brotherhood that transcended distinctions of nationality. Thrown together in a lonely environment, trappers were forced to establish a unique sense of companionship in which they shared not only the dangers and anxieties of the western experience, but also its freshness and freedom. In a pair of paintings of 1851 Ranney illustrated the international character of this brotherhood. In *The Scouting Party* of ca. 1851 (Malvern, Pa., Coll.Claude J. Ranney),[89] three trappers converse in sign language. Two are Americans, identified as such by their brimmed felt hats; the third figure wears a fur cap traditionally associated with French Canadians.[90] In *The Trappers,* (Omaha, Neb., Joslyn Art Museum; fig. 24), two of the figures from the former painting—one American and the French Canadian—reappear in a quiet sunset landscape, mounted on their horses and fording the shallows of a mountain lake. As they ride they turn their heads to look each other fully in the face, a posture that betrays a mutual curiosity but which also establishes a tie between them. The tranquil landscape surrounding them extends its mood of harmony to the figures, so that we are inclined to see them as exchanging respect and acceptance rather than suspicion.

Ranney's interpretations of the fur trapper retreated a step from popular romanticism without sacrificing the degree of idealism needed to make his images appealing to the American public. The temperament of his representations of trappers is low keyed but dignified. They avoid the theatrics that give Deas's trappers an aura of Napoleonic heroics and the romanticizations that render Miller's western characters as exotic as Delacroix's Arabs. As his support of the American Art Union would indicate, Ranney espoused a belief in the close relationship between art and a democratic society. The spirit of his trapper paintings is consonant with that democratic outlook; and his characters were perceived as fundamentally from the same stock as the American tradesmen, artisans, and professionals who comprised his audience at mid-century.

The Popularization of the Trapper Image:
A. F. Tait

Images of trappers reached a broad segment of the American public in the 1850s and '60s through a series of lithographs published by Currier and Ives after paintings by Arthur Fitzwilliam Tait and others. Tait's images, being among the earliest to be published, were probably the models for similar designs that followed.

Tait was a self-trained English artist who came to the United States in 1851, soon establishing himself as a painter of sporting life scenes and achieving a popularity that he probably never would have enjoyed in his homeland.[91] Unlike Miller, Deas or Ranney, Tait never travelled in the American West. Nonetheless, he seems to have succumbed to the romance of the frontier, for several of his better-known paintings have as their subjects the hunters, trappers, and plainsmen of the trans-Mississippi West. Purchased and reproduced by Currier and Ives, these images circulated widely among the American public as sets of lithographs under the titles "American Frontier Life" and "Life on the Prairie."[92] Tait's interpretations of the American frontiersman, readily available through these prints, undoubtedly played a part in shaping the image of westerners and western life held by many Americans in the 1850s and '60s. This image focussed primarily on the dangers of conflict with Plains Indians, prophetically anticipating the great prairie wars of the 1870s between the United States military and the Plains Indians.

Tait's earliest painting of frontier life reproduced by Currier and Ives is entitled *The Prairie Hunter/"One Rubbed Out"* (Omaha, Neb., Joslyn Art Museum; fig. 25), and dates from 1852. A companion piece, also lithographed by Currier and Ives under its title, *A Check/"Keep Your Distance,"* dates from the following year. Precedents for both compositions may be found in Ranney's *Trapper's Last Shot.* The first image represents a plainsman fleeing hostile Indians who pursue him across an open prairie. His twisting pose is reminiscent of the hero of Ranney's painting; but Tait's hunter, having just "rubbed out" one of the Indians, seems to have a better chance of escaping his pursuers. In the companion print, *A Check,* a mounted hunter faces an onslaught of Indians while his companion gallops to safety to the left.

The Last War-Whoop, lithographed by Currier in 1856, brings the Indian into the foreground and presents him in direct confrontation with a white man. The title of the print is again derived from Deas's and Ranney's "last shot" paintings, and the situation depicted is similar as well: a critical moment when a combatant makes his last effort against the enemy. In this case it is the Indian warrior who is about to meet his fate at

the hands of the white hunter. The Indian, having fallen to the ground and awaiting the death-blow, raises a defiant Indian war cry, a display of indomitable spirit which visibly impresses his adversary.

There are many other examples of images depicting Indian-White conflict dating from the late '50s and '60s, most of which are variations of the formats used by Deas, Ranney, and Tait. One print, however, entitled *The Last Shot,* designed by Louis Maurer and published by Currier and Ives in 1858, is worth mentioning because it illustrates yet another preconception (or misconception) which Americans held about the Indian and about his future prospects. Maurer's composition borrows its title from Deas and Ranney, and its theme and format from Tait's *Last War-Whoop.* Indian and white man directly confront each other, but the white man has fallen from his horse and is at the disadvantage. The Indian, having dismounted and thrown aside his shield and weapons, approaches his enemy, prepared to deal a fatal blow with his tomahawk in hand-to-hand combat; but the hunter surprises the Indian with a "last shot" from his revolver.

Maurer's hunter escapes death because of his superior weaponry. In addition to the rifle, which could be used effectively for shooting at distances, the plains hunter also utilized the revolver, which could fire up to six shots in succession. Colt invented his revolver in the 1830s, but it did not become popular in the United States until after 1845.[93] The Texas Rangers had been the first to recognize its usefulness, for the weapon perfectly suited the demands of plains warfare. The plainsmen needed a weapon that could be fired repeatedly from horseback while moving at a rapid gallop. The rifle was unsuitable for this task, because it could fire at most just two shots and was difficult to reload. When the Texans skillfully demonstrated the effectiveness of the revolver during the Mexican War, the United States military was finally convinced of its possibilities, and its use in the United States soon became widespread.

The Indians themselves had appropriated the use of the rifle by the 1840s;[94] yet in popular prints of hostile encounters between whites and Indians the latter almost invariably use their traditional weapons—the bow, lance, tomahawk, and rawhide shield. Maurer's print draws particular attention to the Indian's weapons scattered conspicuously in the foreground, contrasting them to the hunter's small yet deadly revolver. The tendency to stereotype the Indian as a savage wielding primitive weapons reflects an opinion popularly held among Americans that the Indian, brave and cunning as he might be, was doomed to extinction because his technology was inferior to that of Anglo-Saxon civilization.

Although these popular prints of the 1850s and '60s undoubtedly contain large dosages of romanticism and stereotypification, they nonetheless reflect to a degree the changed conditions of the fur trade and the deterior-

ating status of Indian-White relations during the same period.[95] The drop in the demand for beaver pelts and the drastic depletion of the supply of beaver due to indiscriminant trapping practices of the 1830s virtually brought an end to the Rocky Mountain fur trade; while the fur companies of St. Louis merely redirected their efforts to supplying a growing market for buffalo robes. The scene of the fur trade industry shifted from mountains to plains, and likewise the personnel changed from trappers to hunters. In the meantime, the presence of emigrant trains passing through Indian territories was beginning to annoy the tribes who occupied the Plains regions and who had been guaranteed by the United States government that their tenure of prairie lands would not be violated. At first the Indians granted safe passage across the prairies to the emigrant parties. However, when the pioneers began to wreak havoc on game supplies and to encroach on lands reserved to the Indians, the Indians lost patience and began to retaliate with attacks on wagon trains and on parties of white trappers and hunters. Incidents of Indian harrassment of emigrants were the exception rather than the rule, but they were frequent enough to be cited by Congressmen as one reason for organizing the Kansas-Nebraska territory, an issue debated in Congress in 1854. As the Currier and Ives prints of the 1850s illustrate, Indian warfare was seen by the American public of that period as an accurate and authentic representation of life on the plains.

In their careers in the American visual arts, the fur trader, trapper, and hunter, like their predecessor Daniel Boone, managed to represent the values of the wilderness and those of white man's society at the same time. At first trappers tended to be identified more with the romance of the wilderness, but after midcentury, when the theme of the trapper was increasingly popularized, it took on greater nationalistic character and the trapper came to represent the vanguard of civilization, subduing the savages who would block the westward progress of American society. By the 1850s and '60s, however, the situation in the west had changed considerably. The tide of emigration to Oregon and California that had begun in the 1840s had virtually ended the dominance of the mountain man in the Far West, and had opened a new era—one of wagon trains and pioneers, of homesteads and newly cultivated fields, and of budding settlements that were growing into towns and eventually into cities. America's destiny in the West was to be the advancement of civilization to the Pacific Coast, but ironically the trappers who had facilitated that destiny were to find their way of life doomed by it. Nevertheless, their images lingered as a reminder to the American public of how its West had been won.

It is fitting that this chapter conclude with a painting that illustrates the relationship between the trapper and civilization most successfully. It is

William Ranney's composition of 1853, entitled *Advice on the Prairie* (Paoli, Pa., Coll. Mr. and Mrs. J. Maxwell Moran).[96] The setting of the painting is the prairie in the early evening. A pioneer family is making camp for the night, but most of the party has gathered around a trapper or scout seated on his saddle and pack in the midst of the group. The trapper's animated gestures and expression, and the rapt attention given to him by his audience, recall George Ruxton's description of trappers telling stories around the campfire:

> Nothing can be more special and cheering than the welcome blaze of the campfire on a cold winter's night, and nothing more amusing or entertaining...than the rough conversation of the single-minded mountaineers, whose simple daily talk is all of exciting adventure....The narration of their everyday life is a tale of thrilling accidents and hairbreadth 'scapes, which...appear a startling romance to those who are not acquainted with the nature of the lives led by these men, who, with the sky for a roof and their rifles to supply them with food and clothing, call no man lord or master, and are free as the game they follow.[97]

Campfire scenes were frequent in the American visual arts, for in many respects (as Ruxton's comments suggest) they epitomized the freedom and unconventionality of life in the Far West. The campfire scene was a popular image with Alfred Jacob Miller, and later with Frances Bond Palmer, who designed western themes for Currier and Ives without ever having been near the frontier. Albert Bierstadt also painted an occasional trapper's campfire into his western landscapes.[98] Ranney, however, introduces a new theme by including the pioneer family in his campfire scene: the trapper encountering the emigrant party. Scenes like the one Ranney depicted were frequently enacted on the prairies in the 1850s and '60s. Even with the decline of the Rocky Mountain fur trade, several veterans of the trade remained in the Far West to serve as scouts and guides for emigrant trains and for government exploring and survey expeditions.[99] Their expertise was invaluable to the safety and success of these parties. On one level Ranney's painting illustrates an anecdote from contemporary western history, but on another level, his image of the meeting between a seasoned trapper and the pioneer family typifies an important transition in American history—the moment in which the western wilderness, along with its representatives, the fur trappers, yielded to the future of the West.

3

The New "Chosen People": American Pioneers and Homesteaders

Late in 1839 *Niles' National Register,* a weekly summary of national news, reported the following item from the Cleveland *Herald:*

> The tide of the past season has been setting toward the west stronger than ever, according to the newspaper sources on the various lines of travel towards the "land of promise." The upper Mississippi is no longer the utmost verge of that undefined territory [the West]—residents beyond talk of a still farther west, and but a few years before the swelling wave will break over the Rocky Mountains, and the quiet vales of the Columbia will teem with a people whose progenitors dwelt in rugged New England, and looked upon the Alleghanies as the impassable boundary of the western world.[1]

The report was indeed prophetic, for less than four years later *Niles' Register* was reporting the fulfillment of its predictions in the departure of large groups of emigrants for the Oregon territory:

> A short time since [,] the Oregon company left our neighborhood...They seem to be in high spirits, and go out with joyous expectations. The aged and young—the hardy, virtuous pioneer—the timid and the wealthy, have each braced themselves up for the trip in anticipation of the glorious harvest that awaits them at their new home in the west.[2]

The mass migration to the Pacific Coast that took place in 1840s was actually the second such phenomenon to occur in America in the nineteenth century. An earlier migration had taken place between about 1816 and 1820, when the flow of settlers from North Carolina and Virginia moving into the Mississippi Valley was so great that many Easterners feared the total depopulation of the Atlantic seaboard by "Alabama fever."[3] Nonetheless, the circumstances of this earlier migration differed significantly from the later treks to the Far West during the 1840s.[4] Emigration into the Mississippi Valley was undertaken chiefly by individual families moving a few hundred miles at most, along crude but well-travelled roads. By contrast, the distance to be traversed on the overland routes to California or Oregon was

almost two thousand miles through difficult and inhospitable terrain—over uncultivated prairies and across formidable mountain ranges. The trails, such as they were, were poorly marked at first and later they became so full of wheel ruts and mud holes that they were more of a hindrance than a help to pioneer wagons. The emigrants who undertook the journey organized for mutual aid and protection into parties consisting of several wagons. Estimates of the numbers who set out each year sometimes exceeded 7000 persons.[5]

Contemporary public thought had different response to the migration of the 1840s than to the earlier population shift. Instead of fearing depopulation of the East, Americans of the 1840s welcomed the prospect of seeing their fellow citizens building settlements on the far western coast of the continent. To those Americans living in the era of Manifest Destiny and excited by the spirit of expansionism, pioneering assumed patriotic and political significance. It came to be regarded as a characteristic activity of the American people—indeed, as the very essence of Americanism[6]. Americans used the pioneering enterprise as a ploy in international politics, justifying their claims to the Oregon territory with the argument that the settlement and cultivation of the land by American pioneers gave the United States a more legitimate right to the territory than the claims of Great Britain based only on the rights of discovery.[7] Congressmen debating the Oregon question waxed eloquent over the national significance of emigration. Thomas Hart Benton, the distinguished Senator from Missouri and champion of the West, in a speech of June 3, 1844, asserted:

> It is the genius of our people to go ahead, and it is the practice of our government to follow, and eventually to protect and reward the bold pioneers who open the way to new countries, and subdue the wilderness for their country.[8]

A Congressman, speaking in 1845 described pioneers as carriers of American culture to the Far West:

> There to Oregon your ever active population will press forward with intelligent and unconquerable energy. Your arts, your manufactures, your industry, your capital, whatever is American will go with them.[9]

Corresponding to the increased attention focussed on emigration, images of pioneers proliferated in the American visual arts after the mid-1840s. Western emigrants were depicted in numerous paintings and prints—crossing rivers, plains, and mountains in wagon trains moving west; encountering the dangers of Indian attacks and prairie fires; gazing out at newly found homelands from Pisgah-like mountain tops; and chopping down trees and building cabins for the establishment of settlements in the

wilderness. These images appeared for the most part after the United States had acquired Texas, New Mexico, California, and Oregon, and after the issue of expansionism (which had aroused so much debate in the early 1840s) had been decided; they cannot, therefore, be considered mere propaganda for the expansionist point of view. On the other hand, these images are more than mere genre depictions of American life, for Americans have always been too self-conscious of the uniqueness of their experience to treat any part of it casually. The following discussion will attempt to demonstrate that, in addition to depicting the pioneering spirit—the significance of which was just mentioned—these images reflect a complex set of ideas that had been conditioned by over two hundred years of exposition and argument concerning the nature of the Anglo-Saxon's experience on the North American continent. Briefly, these ideas may be summarized under three headings: the concept of America's redemptive mission in relation to the rest of the world; the belief in the continuous progress of civilization; and the debate over the nature of the trans-Mississippi West as an arid desert or as a new Garden of Eden.

The Ideological Backgrounds

Almost from the very first moment they set foot on the Atlantic shores of North America, Puritan colonists in the New World felt compelled to justify their "errand into the wilderness" and to show just cause for having forsaken English civilization to live in a wild and uncultivated land. They accomplished this task by comparing their venture to the wanderings of the Israelites in the wilderness preparatory to the attainment of a Promised Land; in other words, the colonists viewed their experience as a trial period in which their faith was to be tested and purified. Various apologiae written in the New England colonies envisioned these wilderness communities as accomplishing a holy purpose—to preach the gospel and convert the heathen, and thus to serve as an example of Christian faith to the rest of the English-speaking world.[10]

Actual experience, coupled with the changes in the moral and intellectual climate over the next 150 years, significantly altered the prevailing attitudes of American colonists as to their purpose and responsibilities in the grand scheme of world history. However, vestiges of the older concept of the special mission of the Anglo-Saxon inhabitants of the New World still remained in American thinking. After the American Revolution this mission loomed as a political as well as a moral one—to extend the blessings of liberty and a federal republican government to the rest of the world. In the infancy of the Republic this purpose was thought to be accomplished by the United States setting an example for other nations, but by 1840 Americans

had begun to think in terms of actually extending the boundaries and jurisdiction of their government over the entire hemisphere.[11]

Closely connected to the idea of mission was the concept of inevitable progress as the pattern of history, and as the pattern of American history in particular.[12] The theory of progress, first formulated by European thinkers in the late eighteenth and early nineteenth centuries, came to replace the cyclical theory of history which held that all civilizations evolve through a "life cycle" of birth, growth, maturity, decline, and finally death.[13] In the 1840s Americans conveniently found uses for both theories in their justifications of expansionism on the North American continent. Invoking the cyclical theory, they attempted to show that European civilization was in decline, and that the torch of civilization had been passed westward across the Atlantic Ocean to America. Here the theory of progress took over to prove that continual advancement was the inevitable future of the United States. Happily, by extending civilization to the Pacific Ocean and beyond, the United States would complete the westward course of the empire by bringing civilization full circle back to its early origins in the Orient. Thus there was to be no fear that America's star must wane in order that another may rise. A poem published in the *United States Magazine and Democratic Review* in 1849 articulates this proposition:

> Westward, ho! since first the sun
> Over young creation shone
> Westward has the light progressed.
> Westward arts and creeds have tended.
> Never shall their march be ended,
> Till they reach the utmost West.
>
> Europe's noon hath long been past;
> All her vain insignia cast
> Length'ning shadows on her brow;
> Soon she'll mourn, in darkness shrouded,
> For her blue sky, dimly clouded,
> Ev'n as Asia mourneth now.
>
> Westward, ho! the morning breaks;
> Lo! a younger world awakes;
> There the day-god long shall rest;
> Nor can wild Hesperian dreams
> Dreams of golden earth and streams,
> Lure him to a further west.[14]

The third issue which played a role in shaping Americans' attitudes towards westward expansion was the "Garden-Desert" debate,[15] involving Americans' differing perceptions of the far western environment. Reports

of early expeditions to the Far West in the first decades of the nineteenth century had characterized the plains regions beyond the Missouri River as a desert devoid of any potential for settlement or cultivation. By 1830 the concept of the Great American Desert—a barren and monotonous wasteland—had been firmly established in American thinking.[16] After midcentury, however, promoters of trans-Missouri regions (chief among them William Gilpin) hoping to encourage settlement on the prairies began to paint a much different picture of the Great Plains as a land potentially able to rival the Garden of Eden in its richness.[17] Thus during the 1850s and 60s two generalized preconceptions of the Great West prevailed: the paradisiacal garden, or the harsh and forbidding desert. Popular images dating from this period tend to depict the West as a garden; but paintings done by artists who actually travelled beyond the frontier often seem to be preoccupied with the austerity and difficulty of the western environment.

The images to be discussed in this chapter are so diverse that it is almost impossible to discuss them logically without imposing a preconceived structure upon them. For clarity's sake, these images have been divided into five broad thematic categories. Initially, depictions of individual pioneer families as representatives of the American pioneering spirit will be examined. The second topic will focus on images of wagon trains, which in some cases functioned as symbols of the progress of American civilization. Images of the third category—the dangers encountered by emigrants and pioneer settlers (including Indian attacks, Indian captivities, and prairie fires)—express the anxieties and fears Americans had about their relationship to the western environment. The fourth category will be a discussion of homesteaders on the frontier, which represent the final phase of the pioneering process. The last category will treat a group of works which attempt to summarize westward expansion. Most of the works belonging to this last group bear the title, "Westward the Course of Empire Takes Its Way," or some variation thereof—a line taken from Bishop George Berkeley's poem, "Verses on America."

The Pioneer Family

Fur trappers—restless, unsettled, and having neither families nor permanent homes—may have been the harbingers of the advance of civilization into the west, but the true representatives of civilization itself were the pioneer families who emigrated westward to establish permanent homes. For the Congressmen who debated the admission of western territories to the Union as States the presence of permanent settlements became a criterion for determining the stability of a territorial population, and hence the validity of its requests to become a part of the United States. Opponents

of the bill to admit California as a state in 1850, for example, argued that the population of the territory was shiftless and unstable:

> ...It is not to be denied that the population of California is of the most heterogeneous composition...A very large portion of them are mere sojourners, adventurers, and wayfarers, roaming over a wild, uninhabited expanse in quest of treasure with which to return to their countries and their homes. The great majority have no ties to the country, no families nor settlements, and are literally tenants by sufferance, if not trespassers on the domain of the United States. The right of such a population...to sovereignty, and inherent power...can surely not be gravely maintained by any.[18]

Congressmen who favored admission denied these aspersions, but they did not question the basic assumption that only a stable population deserved the privileges of statehood:

> There have been various reproaches cast on the people of the territories...The people have been denominated squatters and vagabonds, and almost every opprobrious epithet has been cast upon them. But who are they who have gone to that land, and are thus vilified?...They are intelligent, worthy men, who have gone there to build a Republic, and to make it one of the marts of commerce, which shall connect us with the far-distant East. They have gone there to adorn that land, and make it bud and blossom as the rose.[19]

Visual images of emigrant families, then, in addition to serving as obvious symbols of the midcentury phenomenon of migration westward, also signified the legitimacy of American claims to western lands. While depictions of fur trappers may have appealed to romantic tendencies in Americans (and to their not-so-well-concealed desires to shuck off restraints of civilization in favor of the lawless freedom and adventure of the frontier), the strong social instincts of the American population identified more closely with the pioneer families whose intent was to settle the west and build secure and prosperous communities.

The earliest images of emigration to the west pertain to the early migrations to the Mississippi Valley between 1816 and 1820. They depict single families encamped by the road on their journeys to their new homes. Examples of this type of image dating from before 1830 include a plate from Joshua Shaw's *Picturesque Views of American Scenery of 1820*, and Alvan Fisher's *The Emigrants*, known through an engraving published in the gift-book *The Token* for 1829. They are essentially images of displacement, depicting snatches of domestic life in an alien, wilderness environment and bearing some resemblance, in theme at least, to images of the Holy Family resting on the Flight into Egypt.

This motif of the emigrant family camping on their journey persisted well into the nineteenth century, appearing again in book illustrations,

prints, and paintings such as Benjamin Reinhart's *Emigrant Train Bedding Down for the Night* (1867; Washington, D.C., Corcoran Gallery of Art.

Reinhart focuses on the domestic activity of two or three pioneer families preparing the evening meal in the open air on the prairies.[20] The composition is divided into two tiers. In the lower half the emigrants are making camp by a stream; in the upper half stand their wagons, horses, and oxen. The two tiers are separated by the horizontal of the wagon trail, leading from right to left. A group of two wagons and a coach looms silhouetted against the sky in the center of the upper tier, presiding over the rest of the composition like some kind of protective presence and acting as a symbol of the overland trek. Significantly this group rises directly over a group of women and children in the lower tier of the composition. These figures, located at the center of the composition, are highlighted by the light that enters from its left, presumably from the setting sun—the torch symbolizing the promise of the future to be found in the west.[21] In linking the symbol of overland migration with representatives of family life, the image emphasizes the pivotal role of the family unit in the settlement of the west and echoes in visual terms the appreciative language of Congressional orators who sang the praises of pioneer women and children:

> All we had to do was to let our women and children go there (to the Oregon territory), and, without assistance from any one, they would take possession of the country, as Daniel Boon [sic], Rogers, Clarke [sic], and other early pioneers had done—men of wonderful character, peculiar to the American soil...[22]

Recalling the prominence given to the figure of Rebecca Boone and her daughter in George Bingham's *Emigration of Daniel Boone* of 1851 (see above, p. 22), we see that by midcentury the identification of the chief agent in the civilizing process of the west had begun to shift from the intrepid hunter and explorer to the hardy pioneer family.

One of the most striking images of a pioneer family is William S. Jewett's composition of 1850, *The Promised Land* (Evanston, Ill., Terra Museum of American Art, fig. 26).[23] This remarkable painting makes explicit use of biblical imagery (both visual and semantic) in a curious amalgam of Old and New Testament traditions. The title alludes to the story of Moses and the Israelites, God's chosen people, who, after wandering forty years in the wilderness, finally arrived at the "land of milk and honey" promised to them by the Lord. Like Moses, who viewed Canaan from Mount Pisgah, the family in Jewett's painting rests on an elevated mountain ledge from which they look out on their own "promised land,"—probably California, for Jewett had recently moved there in 1849.[24]

There are also strong visual similarities between Jewett's composition and representations of the Holy Family resting on the Flight into Egypt. The mother is seated on the ground under a tree and her child, here considerably older than the infant Jesus, is climbing into her lap. A saddle rests at her side, and a horse grazes peacefully in the background. As a sample comparison we might cite Claude Lorraine's landscape entitled *Rest on the Flight* in the Doria Gallery in Rome, a composition which had been engraved in the eighteenth century and thus might have been known to Jewett through reproductions.[25] Like Joseph resting on his staff in Claude's painting, the pioneer father in Jewett's composition stands a little to one side of his family leaning on his rifle as he surveys the land in front of him. In the background lies the body of a freshly slain stag, the equivalent of the grapes of Eschol in the story of Moses and the Israelites—i.e., a sign of the abundance of the Promised Land.[26] The most curious feature of Jewett's painting, however, is the ermine cloak worn by the child. This peculiar costume, so inappropriate to a frontier American setting, must allude to the divine royalty of the Christ Child, and offers further evidence that Jewett consciously modelled his pioneer family on the Holy Family of Christian tradition.

Jewett's painting reflects contemporary American thinking, in which the destiny of the United Stated was described in terms borrowed from both the Mosaic and Messianic biblical traditions. Americans regarded their land and themselves as being especially favored by God and destined by Him to occupy a special place in world history.[27] Because the American experience consisted in large part of emigration into and settlement of new and unknown wilderness territories, sparsely occupied by often hostile Indians (heathen), a specific comparision between Americans and the Children of Israel emigrating from Egypt to the land of Canaan seemed especially appropriate. As we have seen, the idea was as old as the Puritan settlements in New England, and it had been consciously developed in the exuberant period of patriotism following the American Revolution. "We are a people peculiarly favoured in Heaven," said Thomas Barnard in a sermon preached in 1795,[28] echoing Ezra Stiles's extended metaphor of the citizens of the United States as "God's American Israel."[29] Later in the 1840s the idea resounded in expansionist rhetoric delivered in Congress:

> ...Nothing can be more interesting than the narrative given of the travels, from day to day, of the thousands who are marching over barren plains and sandy deserts to Oregon...
>
> These accounts constantly remind us of the travels of the partriarchs of old; and looking back through the dim vista of time to the days of primitive simplicity, we see Abraham and Lot pitching their tents in the land of Canaan and the plains of Jordan...; when Moses and Aaron, following the "pillar of cloud by day and fire by night," conducted the children of Israel in the pilgrimage through the wilderness...[30]

Also implicit in expansionist rhetoric—which can be considered symptomatic of widely accepted beliefs among the American population—was the idea of America's messianic mission, an idea which was discussed briefly above (pp. 57). Americans believed they were not only to establish democracy and equality on the North American continent, but were also to act as an example for the rest of the world. The most avid proponents of Manifest Destiny in the 1840s could envision Americans pushing ever westward, crossing the Pacific Ocean, and so bringing to the Orient—where civilization first began—the virtuous influences of freedom, Christianity, and republican institutions. Again, debate over the Oregon question elicited some of the most eloquent expressions of this concept:

> Civilization and intelligence...started in the East; they...travelled, and [are] still travelling westward, but when they...have completed the circuit of the earth, and reached the extremest verge of the Pacific shores—when they [have] realized the fable of the ancients, and the bright sun of truth and knowledge...[has] dipped his wheels in the western wave—then might we enjoy the sublime destiny of returning these blessings to their ancient seat....It [is] our duty to do it.

> [The Oregon question] is the embodiment of the great American principle of progression, extension and expansion....It is the form of a new impulse called into action by free institutions operating upon the restless and daring spirit of the Anglo-Saxon blood. Glorious, divine impulse. Let it exert its sway until the world shall become a common republic, and mankind a united brotherhood.[31]

In the context of this rhetoric and of the popular sentiments of the era of Manifest Destiny to which it gives evidence, Jewett's allusions to the Promised Land and to the imagery of the Holy Family seem highly appropriate. His family represents the American "chosen people" entering the new "promised land"; and the child, representing a future generation of Americans, is clearly meant to be seen as a saviour and redeemer of the world—as the youth of a nation destined to proclaim the gospel of freedom and republican government to the Pacific shores and beyond.

Wagon Trains in the Western Landscape

We have seen how, in the visual arts, the image of the pioneer family as a representative of the basic unit of American society could signify the values of American civilization coming to the frontier. Another group of closely related images depicting wagon trains moving through the western landscape functioned in a similar way as representations of the pioneering impulse—the dynamics, as it were, of emigration and the process of settlement.

Perhaps the classic image of a pioneer wagon train is the Currier and Ives lithograph of 1866, entitled *The Rocky Mountains—Emigrants Crossing*

the Plains (fig. 27). It was designed by Frances Bond Palmer, an English woman who had come to the United States in the early 1840s. Although Palmer had never travelled on the frontier, she eagerly embraced America's enthusiasm for its western lands and for the westward migration of its citizens. Her visualization of an emigrant caravan was therefore primarily shaped by popular preconceptions about westward emigration rather than by firsthand observation or knowledge. The setting of the lithograph, for example, resembles the Alpine scenery of European romantic landscapes. Mountains rise precipitously at the edge of a green prairie grassland which symbolizes the lush western garden rather than the barren desert. A wagon train makes its way across this Elysian field, moving from background to foreground. On the opposite bank of a stream two mounted Indians watch the advance of the wagons, and one even waves in friendly greeting. The mood of the image is purposeful and optimistic, expressing Americans' confidence in their western enterprise.

A similar optimism pervades Albert Bierstadt's painting, *The Oregon Trail* (Youngstown, Oh., Butler Institute of American Art; fig. 28), thought to date from the late 1860s.[32] The painting is a generic image of emigration which attempts to convey something of the spirit of hope which motivated the pioneering enterprise. Emigrants make their way towards sundown through the grand scenery of a western river valley, carrying with them the appropriate accoutrements of settlement—cattle, sheep, farming implements, household belongings—and leaving behind them the signs of the hardships and disappointments of their journey—the skulls and bones of livestock that have died along the way. The pioneers proceed hopefully towards the West, from which emanates a golden light indicative of the bright promises of their future homeland.

For Bierstadt and Palmer, and presumably for other Americans in the late 1860s, the locus of hope for the future of the American nation lay in the West. This idea was, of course, nothing new in American thinking. We have seen its earlier manifestations in the 1840s in the analogy which compared the West to the Promised Land of the Israelites. Perhaps Ralph Waldo Emerson had most cogently articulated the sentiment in 1844, in his well-known essay, "The Young American":

> The land is the appointed remedy for whatever is false and fantastic in our culture. The great continent we inhabit is to be physic and food for our mind, as well as our body. The land, with its tranquillizing, sanative influences, is to repair the errors of a scholastic and traditional education, and bring us into just relations with men and things. . . . Luckily for us, . . . the nervous, rocky West is intruding a new and continental element into the national mind, and we shall yet have an American genius. . . . I think we must regard the *land* as a commanding and increasing power on the American citizen, the sanative and Americanizing influence, which promises to disclose new powers for ages to come.[33]

While the tensions in American society and politics which culminated in the Civil War had for a time diverted attention from the western enterprise and obscured the bright prospects which Emerson had described, there seems to have been a period of renewed interest in the West in the late '60s. Americans began to reexamine the trans-Mississippi West as a land in which the bitter past could be purged and forgotten. The optimism of Bierstadt's painting and Palmer's lithograph signalled a reawakening of the faith in the redemptive power of the West which had been temporarily eclipsed during the Civil War.

Not every response to the West expressed so confident an attitude as that evident in the two works just discussed. Whereas those images are oriented towards man and his achievements, there are other examples in which man's presence is almost totally subordinated to the western environment. We observe this attitude in George Douglass Brewerton's painting of 1854, *Crossing the Rocky Mountains* (Washingon, D.C., Corcoran Gallery of Art), or Samuel Colman's painting of around 1870, *Covered Wagons Crossing Medicine Bow Creek* (North Bennington, Vt., Coll. Hall Park McCullough).[34] The tiny covered wagons making their way through the expansive landscapes in these compositions provide an indication of scale whereby to measure the spaciousnes of nature and, by implication, the smallness of man and the inconsequence of his activity. In Brewerton's painting the wagon train at the left is a mere string of white dots, dwarfed into insignificance by the massive mountain range looming in the distance. In Colman's image, the line of covered wagons approaching the fording spot of the stream is just another layer in the strata of horizontal landscape elements, as if nature had forced man to conform to her patterns. The wagons make hesitant progress: the lead wagon, which has already ventured into the stream, is literally afloat on the prairie, while the second lists uncertainly to the side as it makes its way along the river bank. Within the seemingly limitless expanses of the plains, the efforts of the emigrants appear awkward, tentative, and ultimately insignificant.

Although the completion of the transcontinental railroad in 1869 did not end migration to the west in covered wagons by individual families, it did open a new phase of easier and quicker travel to the Pacific coast. Popular images of "going West"—specifically lithographs published by Currier and Ives around 1870—reflected this advance in communications and transportation by substituting the passenger train for the wagon train. *The Great West,* for example, echoes the format of Palmer's *Emigrants Crossing the Plains.* Palmer's own design for the 1868 lithograph, *Westward the Course of Empire Takes Its Way* (fig. 35)—to be discussed in greater detail below (pp. 83)—includes a railroad line and a train as key elements in the composition. *Through to the Pacific,* dating

from 1870, is clearly derived from this latter design by Palmer. From a bird's eye view we watch a San Francisco-bound passenger train in the foreground pass an active and prosperous frontier settlement. In *The Route to California* of 1871 the black and red train engine coming around the bend on the Truckee River shares the spotlight with the Sierra Nevada landscape in the background. For a brief moment in these images, at any rate, technological progress and the western environment appear to have existed together without conflict.[35]

Pioneers Confronting Danger

Both Bierstadt and Palmer acknowledged the presence of the Native American in the landscapes through which their wagon trains passed. In Palmer's composition, two Indians in the foreground watch the progress of the pioneers from the opposite bank of a prairie river. In Bierstadt's painting the presence of Indians is implied by the teepees faintly visible in the hazy distance of the valley through which the emigrants travel. In both cases the pioneers proceed peacefully, avoiding confrontation. Apparently these confident visions of westward emigration from the post-Civil War period could not tolerate the inclusion of signs of conflict; but other images made the conflict between the Indian and the white man their primary focus.

In the discussion of images of combat between Indians and plains hunters (see above, pp. 51–53), it was suggested that such depictions were intended to display the courage and resourcefulness of the white man. Images of Indian attacks on frontier settlers and emigrant parties had broader implications, however. Such acts of aggression were to be interpreted as attacks on the progress of civilization itself.

From the days of the Pilgrims, the fear of Indian attack haunted settlers in the wilderness and on the frontier, and throughout the nineteenth century this threat had contributed to the white man's anxiety about his advance into the West. Although the danger to life and property was in some situations very real, it was perhaps not so great as the many images and tales of Indian attacks and captivities might lead us to believe.[36] Such images may in fact reflect a need to depict the white man in distinct opposition to the values of the wilderness which are represented by the Indian. Like the Puritan colonists of the seventeenth century, who harbored a fundamental doubt about the wisdom and righteousness of their venture into the wilderness,[37] Americans of the nineteenth century may also have questioned the wisdom of leaving civilization in the eastern states to emigrate to the West and to live in an environment inhabited by savages. Images of pioneers staving off Indian attacks therefore offered some assurance that western pioneers would indeed resist savage life.

The starting point for our discussion will be Horatio Greenough's sculptural group, *The Rescue* (fig. 29), commissioned in 1837 for the United States Capitol building.[38] Greenough's intentions, as well as contemporary interpretations of the work, are well-documented; and the evidence clearly indicates that for Americans of the nineteenth century, the image represented the combat between savagery and civilization and the ultimate triumph of the latter.

A few months after receiving the commission for the work, Greenough sent to Secretary of State John Forsyth a letter which included a design for the proposed sculpture and a brief description of the artist's intent:

> I herewith enclose the design of a second group which I have composed for the platform in front of the Capitol—in which I have endeavoured to convey the idea of the triumph of the whites over the savage tribes, at the same time that it illustrates the dangers of peopling the country.[39]

Greenough worked on the group intermittently over the next thirteen years; and although he made changes in composition and detail, they did not significantly alter his original intent. It also appears that interpretations of the work by his contemporaries did not change much over the years. In 1848 a report in the New York *Literary World*, describing the still-unfinished sculpture, predicted that when completed it would "illustrate the history of our country, and...the progress of humanity from barbarism to civilization."[40] In 1859, Edward G. Loring, a close friend of Greenough's, described the finished work in these words:

> The mother and child were before the Indian and she, in maternal instinct was shielding her child from his grasp, to prevent which the husband seized both arms of the Indian, and bears him down at the same time; so the group told its story of the peril of the American wilderness, the ferocity of the Indians, the superiority of the white man, and how and why civilization crowded the Indian from his soil, with the episode of the woman and infancy and the sentiments which belong to them.[41]

Finally, Henry Tuckerman, describing the group in his memorial to Greenough, stated that the work "illustrates a phasis [sic] in the progress of American civilization, viz., the unavoidable conflict between the Anglo-Saxon and aboriginal savage races."[42]

Greenough's imagery is a conflation of two prototypes in American art, both of which were mentioned above in Chapter 1 (see above, pp. 9, 14): Vanderlyn's painting, *The Murder of Jane McCrea,* and Causici's relief sculpture, *The Conflict Between Daniel Boone and the Indians.* The latter work, located in the Capitol Rotunda, is an obvious precedent for Greenough's group, but hardly one whose quality could have inspired him. Greenough was undoubtedly aware that his sculpture would be compared with

Causici's; and he may even have chosen the Indian theme out of a desire to prove that he could improve on Causici's work—a goal which he accomplished easily enough.[43] Greenough expanded the basic theme presented in the relief by the inclusion of the woman and her child, who were added as personifications of goodness, innocence, and gentility, and serve as contrast to the Indian's brutality. This dramatic juxtaposition of the white female with the savage Indian was inspired by the tradition represented in Vanderlyn's painting.

Images of white women taken captive by Indians were, at least in part, variations on the theme of the conflict of civilization with savagery. Such images also reveal some of the complex attitudes which the white population held not just towards the Indian, but towards the frontier environment as a whole. While the frontiersman, who out of necessity adopted Indian methods of warfare and survival in the wilderness, was often perceived as a "white Indian" who had abandoned the habits of civilization for the life of the savage,[44] the frontier woman was thought to be less susceptible of succumbing to Indian ways. She could therefore more clearly represent the values of civilization threatened by savagery. Placed at the mercy of Indian captors, she also represented the plight of Anglo-Saxon culture in an alien and hostile environment.

This conflict of values is dramatically depicted in George Caleb Bingham's painting of 1848, *Captured by Indians* (St. Louis City Art Museum, fig. 30),[45] which borrows its imagery from Christian themes and visual traditions. The Indians guarding the captive mother and her child invite comparison with the Roman soldiers who kept watch at the tomb of Christ; and the pioneer woman is strongly reminiscent of the Virgin Mary of Pièta images.[46] This mother, loosely robed in a long gown, holds her child on her lap while she glances upward in an appeal for help from a heavenly power. By linking the pioneer mother to the "Mother of Christianity," Bingham firmly established the frontier woman as a representative of the values of Christian civilization. The Indians, on the other hand, represent the opposing values of heathen savagery, while the nighttime setting signifies the moral darkness of their savage state.

Carl Wimar painted several versions of the theme of the white female held captive by Indians. Two of them, painted in Dusseldorf in 1853 and 1855 and known as the "canoe picture" and the "raft picture" respectively, are identified today as *The Abduction of Daniel Boone's Daughter by the Indians.*[47] (It is questionable whether this title belongs to both paintings.) The "canoe picture" (St. Louis, Washington University Art Gallery), may in fact illustrate the Boone narrative;[48] but for the "raft painting" (Fort Worth, Amon Carter Museum; fig. 31), this author prefers the title assigned to it in *Ballou's Pictorial Drawing Room Companion: Comanches Carrying Off a Captive White Girl.*[49]

Of the two paintings, the "raft picture" presents a more mature conception of the captivity theme. In the "canoe painting" three Indian captors have beached their canoe and are preparing to take their prisoner ashore. The composition is therefore enclosed on the left by the trees and foliage of the shoreline. The captive girl is clearly frightened, but the Indians, too, show signs of apprehension—fearful, perhaps, of a counter-attack by the girl's rescuers. A detailed delineation of the setting—the trees, plants, and river—competes for attention with the main action.[50]

In the raft painting, by contrast, all attention is focussed on the raft which bears five Indians and their female captive along on the currents of a broad river. The Indians, although alert, appear assured and in control of the situation, while the girl's fearful expression hints at her utter helplessness. The distant shore, clouded in haze, provides a strong horizontal accent suggestive of the river and its steady flow; but the setting does not otherwise intrude on the central image. The raft itself—stable and large enough to easily accommodate all six figures—functions almost as an environment unto itself, suspended between the terra firma of the two shores. The female captive thus finds herself separated from the comfort and security of her accustomed society and surrounded by a hostile environment in which she is completely helpless.

As Lorenz Eitner has demonstrated, the image of the boat (or raft) on water can be interpreted metaphorically in nineteenth century romantic painting.[51] The exact meaning of the motif differs according to its context, but traditionally the boat has been identified with man's fate, and the natural universe has usually been seen as man's adversary. In Wimar's painting, however, nature itself is not threatening but is, in fact, extremely quiet (though working in consort, as it were, with the white girl's adversaries, the Indians). These Indians represent not only the wilderness, but a culture so alien and little understood by the white man as to be fearsome to him. The raft cannot be identified with the protagonist, for it is literally her prison and the vehicle of her separation from secure and familiar surroundings. The image, then, may signify the white man's feelings of divorcement from his accustomed values when he ventures into the wilderness.

Wimar's teacher and close associate in Dusseldorf was another German-born American painter, Emanuel Leutze, whose composition, *Indians and Captive* (Tulsa, Ok., Gilcrease Institute of Art and History),[52] is related to Wimar's images of Indian captivities in its use of the boat motif. In Leutze's painting, the white female captive is imprisoned in a boat which her Indian captors are beaching on the shore of a lake, and a rescue party is visible in the background. A significant feature of Leutze's composition is the wintry landscape, with blocks of ice floating on the river and snow covering the shore. Nature itself is bleak, barren and inhospitable, corre-

sponding apropriately to the cold plight of the captive. One is reminded of Caspar Friedrich's painting, *The Wreck of the Hope,* of 1824 (Hamburg, Kunsthalle), in which massive blocks of ice in an arctic landscape completely overpower and submerge a shipwrecked vessel in a symbolic representation of man's hope foundering in a hostile environment. Unfortunately, in Leutze's composition the narrative elements somewhat diminish the impact of the setting; but, like Friedrich's imagery, the character of the landscape implies the hostility of the surroundings and expresses an anxiety about man's relationship to the wilderness.

The classic images of wagon trains attacked by Indians are Carl Wimar's two paintings of the theme, traditionally dated 1854 and 1856 respectively.[53] The version dated 1856 was published as a lithograph in 1860 and became a widely circulated popular image.[54] The chief characteristic of both images is their heroic quality, achieved through the artist's choice of a close viewpoint and his treatment of individual figures. Especially in the version of 1856, the distribution of figures across the frontal plane, with their sculptural bodies and carefully determined poses, are reminiscent of ancient battle reliefs. This classic quality is especially evident in comparison with other images of the theme, such as Seth Eastman's watercolor of an attack on a wagon train, dating from the 1840s (St. Paul, Minn., James Jerome Hill Reference Library). Eastman views the attack from outside the protective circle of defense formed by the wagons, at a distance great enough to take in the entire scene. Wimar's focus on the heated efforts of the beleaguered pioneers combatting the Indians at close range results in an intensification of the emotional content of the composition and an increased sense of the imminent peril of the situation.

In Wimar's earlier version of 1854 several major figures compete with each other for attention. The lower right is a group of three figures modelled after fifteenth-century Italian depictions of the Deposition: a white-haired and bearded pioneer (the equivalent of Joseph of Arimathea) holds in his arms the limp body of a wounded youth, while a distraught sister or wife (the counterpart of Mary Magdalene) holds one of the injured man's hands. All around them rages the frenzied action of the combat: women and children rushing for cover and men warding off Indians with their rifles. One figure in this melee attracts particular attention: a black man, reaching for a rifle.

Black people appear rarely in images of the frontier, probably because the presence of Blacks was not welcomed in western territories. Racial prejudice was evidently very strong on the frontier, for economic as well as social reasons.[55] Most of the white settlers in the trans-Mississippi West—particularly in the Northwest—were not slaveholders, and they opposed the

extension of slavery into western territories from the fear of unfair competition from wealthy slaveowners. However, these settlers were also repelled by the prospect of a population of freed Blacks mixing with white society. It was this latter fear that motivated several attempts in western states and territories to prohibit free Blacks and mulattoes from emigrating into these areas. At first the slaveholding population there was small enough to forestall the possibility of antagonism or conflict; but with the introduction in Congress in 1854 of the Kansas-Nebraska Act, which would give to individual territories the right to determine whether to admit or prohibit slavery within their boundaries, the entire issue blazed into national attention. The bill generated four months of Congressional debate before its final passage in May 1854; but the controversy that it provoked continued to aggravate the nation throughout the remainder of the decade.

The black man in Wimar's painting should be considered in this context. Missouri, Wimar's home state, was a border state which allowed slavery, but which was not dominated by slaveholding interests. Nothing is known of Wimar's personal views on the slavery question, but we can assume that his contact in Dusseldorf with Emanuel Leutze, whose democratic and egalitarian views are well-documented,[56] exposed him to antislavery sentiments. Wimar in fact painted his 1854 version of *Attack on an Emigrant Train* in Dusseldorf under Leutze's supervision; and teacher and pupil may have discussed at some length the significance of the figure of the Black man.

The image is definitely sympathetic towards the Black man. He joins gallantly with his white companions in the defense of the wagon train. Because he is distinguished from the white men by his clothing and by the fact that he had no weapon of his own, he is probably to be identified as the modest slave-property of the emigrant pioneers. Although placed in a subordinate position to the two white men in the central group of which he is a part, the Black man nonetheless shares in their heroism against the common enemy. Wimar's message appears to be that on the frontier the Negro is equal to the white man in the most pressing emergencies.

The painting created a "considerable sensation" in Europe before being sent to America,[57] but it would be difficult to determine how much of this interest was generated by the figure in question and by the issues raised by his presence. We do know, however, that when the painting arrived in America, it was purchased by Hamilton R. Gamble, a recently retired justice of the Missouri Supreme Court.[58] Gamble, a moderate Whig who later became provisional governor of Missouri from 1861 to his death in 1864,[59] presumably was sympathetic to the antislavery sentiment, which is implied in Wimar's painting, but which is so tactfully and subtly treated as not to offend either side in the slavery controversy. In 1852 Gamble had won wide

recognition as one of the justices who heard the appeal of the Dred Scott Case before the Missouri Supreme Court. Gamble delivered the dissenting opinion, in which he upheld earlier precedents which had recognized a slave's right to freedom in nonslaveholding territories. For him, the noble quality of the black figure in Wimar's painting may have seemed a vindication of the moral basis for his opinion.

Another hazard that threatened travellers on the prairies—the prairie fire, which could be as horrifying and devastating as an Indian attack—will be discussed only briefly in this study. Apparently begun by lightning or spontaneous combustion when grasses were thick and extremely dry, a fire would sweep across the open plains, endangering everything in its path. Artists and writers alike attempted to describe this awesome phenomenon and to convey something of its terrifying drama. James Fenimore Cooper's description from his novel *The Prairie,* is typical, if, in this case, fictional:

> Huge columns of smoke were rolling up from the plain and thickening in gloomy masses around the horizon, the red glow which gleamed upon their enormous folds now lighting their volumes with the glare of the conflagration, and now flashing to another point as the flame beneath glided ahead, leaving all behind enveloped in awful darkness and proclaiming louder than words the character of the imminent and approaching danger. [Chapter 23]

Alvan Fisher, George Catlin, Alfred Jacob Miller, Charles Deas, William Ranney, and Carl Wimar, to name just a few artists, all painted prairie fires threatening Indians, trappers, pioneers, and even buffalo. The theme, with its apocalyptic overtones, was sufficiently dramatic to appeal immensely to an audience hungering for images of sublime terror; yet these images also betray an uneasy awareness of how hostile the western environment could be.

Homesteading on the Frontier

If we are to believe the popular images of western homesteads and homesteaders published by Currier and Ives and others in the 1860s and 1870s, we must conclude that the pioneers had indeed reentered the Garden of Eden to lead peaceful, contented, prosperous, healthy, and virtuous lives amidst an idyllic wilderness environment.[60] The facts, of course, were actually rather different; but the American public which purchased these prints and hung them in their eastern homes apparently believed that homesteading in the West was the ideal of the "good life."

Frances Palmer's design for Currier and Ives, *The Pioneers Home: On the Western Frontier* (1867; fig. 32), epitomizes the Edenic vision. Two hunters are returning from the hunt to a log cabin in a forest clearing. It is a

colorful autumn day, and in the background a field of neatly stacked sheaths of wheat signify a bountiful harvest. A mother and her children await the return of the menfolk, who approach with the spoils of their hunt hanging from a pole carried between them on their shoulders. This latter motif—carrying the bounty on a pole—derives from a visual tradition which originated with the biblical story of the Israelite spies, sent by Moses to search out the land of Canaan:

> And they came unto the brook of Eschol, and cut down from thence a branch with one cluster of grapes, and they bare it between two upon a staff; and they brought of the pomegranate, and of the figs. [Numbers 13:23]

Nicholas Poussin used the biblical theme and the motif of the grapes appropriately to symbolize an abundant harvest in his landscape, *Autumn—The Spies with the Grapes of the Promised Land* (Paris, Louvre)[61] from his series *The Four Seasons*. In Palmer's image the motif (which, as we shall see below, may have been borrowed from a painting by Thomas Cole) likewise signifies the abundance of the western wilderness, which in her visualization obligingly conforms to the Jeffersonian concept of the West as the Garden of the World.[62]

Other popular images of the frontier or wilderness homestead share one or more features in common with Palmer's design: a rough log cabin, a pioneer family, a hunter with a deer, or treestumps and logs somewhere in the landscape. Life in these images is simple, virtuous, and above all as fresh as it must have been for Adam and Eve in the Garden before the Fall.

Closely related in theme and design to these popular images of homesteading are two paintings by Thomas Cole: *The Hunter's Return* of 1845, and *Home in the Woods* of 1845/46.[63] Cole's paintings strictly speaking do not depict western homesteads, for he modelled his landscapes on the scenery of wilderness areas in the East. But his concern with the theme of man's settlement of the wilderness—whether east or west of the Mississippi —does pertain to this discussion. Throughout this study we have encountered evidence of a basic duality in American thinking toward the wilderness environment. For some Americans the wilderness seemed a region of danger and hardship to be subdued and transformed by advancing civilization. For others the wilderness was to be valued and preserved—and ultimately mourned, when it became clear that preserving it in its entirety was out of the question. Cole's two paintings, when considered as a complementary pair, present two successive phases in the process by which man's settlement of the wilderness transforms nature; and Cole seems to have had reservations about the ultimate effects of this process and transformation. Created in the early years of the great migrations to the Far

West, this pair of images sounds a quiet warning against the possible conse-
quences of indiscriminate encroachment on nature.

Unfortunately, *The Hunter's Return* has been lost; but it is known to-
day through an oil sketch (Catskill, N.Y., Coll. Mr. and Mrs. L. H. Boice),
and through a description of the finished composition written by Henry
Tuckerman (a description that corresponds remarkably with the design by
Palmer discussed above):

> It is a composition, with the exception of one noble mountain in the background, which
> is copied from a remarkable spur of the White Hills. The scene is an opening in the
> forest, where, beside a transparent lake and beneath the impending hillsides, appears a
> settler's log-hut, with its adjacent cabbage-garden. From the opposite thicket approach
> two bluff hunters, with a deer slung on a pole, and borne on their shoulders. One waves
> his cap to the wife, who stands by the hut door and holds up her infant to greet his
> return. In advance hurries the eldest son, with the dog. There is a rustic bridge, the
> stumps of a clearing, two or three prostrate birch trunks, and all the objects incident to
> such a scene; while around tower the evergreen firs, maples, oaks, and beeches,—their
> foliage kindled with all the splendid dyes of an American autumn; and far above, serene-
> ly arching the misty hilltops, spreads the clear blue sky, mottled with gold. It is altogether
> a beautiful and most authentic illustration of American life and nature.[64]

In dimensions, composition, and subject matter the painting was quite
similar to *Home in the Woods* (Winston-Salem, N.C., Reynolda House
Collection; fig. 33).[65] In the latter work the setting is also a forest clearing
by a lake, with a mountain in the background. To the right is a cabin, at the
door of which stands a mother and children welcoming the return of the
father. The latter approaches from the left, carrying over his shoulder, in
place of the deer, his fishing pole and the day's catch. Like his counterpart
in *The Hunter's Return,* he waves to his family in greeting.

Even without having the original painting of *The Hunter's Return* for
comparison, the available evidence allows us to establish some key dif-
ferences between the two compositions which are perhaps more significant
than their similarities. The first of these differences is the size of the forest
clearings in each painting. Judging from the oil sketch of *The Hunter's
Return,* the open area around the rustic cabin was smaller than the clearing
in *Home in the Woods,* which has been enlarged, perhaps a sign of the con-
tinuing expansion of man's settlement in the wilderness. The cabin in the sec-
ond painting likewise shows evidence of refinements in the addition of win-
dows, sawn boards for the roof, a brick chimney, a lean-to at the side, and a
climbing vine adorning the front—all in contrast to the rude log hut in-
dicated by the oil sketch of *The Hunter's Return.* A cow or two—animals of
a sedentary, domestic life—wade near the shore of the lake in *Home in the
Woods;* and in place of the hunter's crude buckskins, the father wears a
farmer's homespun clothes. No longer does he roam the forests in search of
food, but enjoys instead the rural pastime of fishing.

Cole intended the differences between the two compositions to reflect the process of settlement advancing from the wild to the pastoral states.[66] But Cole seems to have harbored some doubts about the ultimate end of this process. He feared that the impetus which led man from the wild to the pastoral would eventually lead, as it did in his vision of *The Course of Empire,* to corruption and downfall. His *Hunter's Return* and *Home in the Woods* depict two early phases of man's progress, with the latter composition representing an ideal pastoral state in which peace and harmony prevail. The moment depicted is a fleeting and precarious one, however, and there are signs that hint of future developments.[67]

In the wild or rustic state, depicted in *The Hunter's Return,* nature is characterized by abundance, represented by the motif of the hunters carrying a deer slung over a pole, a motif whose derivation has been discussed above. Cole's use of this motif (which precedes Palmer's by over two decades) adds a certain irony to its meaning. In place of the gigantic bunch of grapes Cole substitutes the carcass of a deer which represents the wildlife which is easily driven from settlement or diminished by the hunter's gun. Thus the motif functions as a symbol of the precarious state of nature's abundance, which is yet vulnerable to man's usage.

Even more telling as signs of Cole's misgivings are the tree stumps and logs to be found in each of the two compositions. In *Home in the Woods,* an axe, the tool used to clear away forests, is prominently displayed in the foreground, a symbol of man's encroachment on the natural environment.[68] A disorderly array of domestic accoutrements occupies the lower right corner of this composition; and the hanging laundry is as out-of-place in the wilderness setting as Cole seems to imply that man is himself. The signs of man's carelessness (at best), or of his violation of nature (at worst), are placed opposite the serenity of the distant lakeshore to the left of the composition; but this view of undisturbed nature remains in the distant background, as if pushed there by man's unstoppable advance.

At least one of Cole's contemporaries would have agreed with this interpretation, which sees the evidence of man's activity in *Home in the Woods* as an intrusion on nature. A reviewer of the American Art Union exhibition of 1847, writing in *The Literary World,* described Cole's painting in these words:

...This scene of exquisite repose will recall the feeling of calm and quiet happiness that has stolen over him, when at the close of some summer day he has sat down to watch the sunny clouds float up in the western sky. *We almost feel as if the cabin and its occupants were intruders. We want to get further into the picture and take them at our backs.* (Italics added)[69]

Cole's immediate concern was probably with the disappearance of the eastern wilderness, which he could have witnessed from year to year on his sketching trips to the Catskill and Adirondack Mountains. But the issue was one that certainly applied also to the wilderness regions of the trans-Mississippi West, which after 1843 were being traversed and settled by thousands of emigrants yearly. Cole's interest in the theme coincides with the national attention being focussed on westward migration in the mid-1840s; and the feelings of misgiving which lie hidden in his imagery could have pertained as much to the Far West as to his beloved wilderness areas in the East.

Life on the frontier, alas, was not so idyllic as popular images of western homesteading led the public to believe; but the accuracy of these images was probably seldom questioned, because they corresponded so well to the popular preconceptions of the West as the Garden of the World. William Ranney, however, did not make concessions to those preconceptions. His image of a pioneer family on their prairie homestead is a vivid image of the harsh realities of frontier life. The theme of his *Prairie Burial* of 1848 (Paoli, Pa., Coll. Mr. and Mrs. J. Maxwell Moran) is, as the title implies, death: a pioneer family mourning at the graveside of one of its children.[70] Every detail of the surrounding setting suggests the difficulties of existence on the prairie fringes of Missouri or the southwest. The horse nibbling on a few short blades of grass calls attention to the sparse vegetation. The adze in the foreground—used to break ground for the tiny grave—shows that the soil is hard, rocky, and difficult to dig. Death has visited the family once before, as witnessed by the gravestone in the background, possibly marking the grave of the missing grandmother. The family cabin, which might ordinarily signify warmth and comfort, is a tiny building barely visible in the background, much removed from the family group. There are no indications of cultivated fields or herds of livestock, the signs of prosperity so pervasive in later images of homesteads. Ranney's pioneers appear instead to eke out an existence as best they can from an inhospitable land. Even the climate is harsh. A large dark shadow cast over the background signals the approach of a storm cloud that will soon put an appropriate end to the funeral.

The real subject of Ranney's painting, however, was not so much the harshness of frontier life as the patience and perseverance of the Americans who endured it. In his own understated way Ranney created a compelling image of the true heroism of the pioneer families who gave up the security of their homes in the East to seek a new but more difficult life in the West. He found in the solidarity of the family unit the foundation on which future communities in the West were to be firmly built.

Westward Ho!

Westward the Course of empire takes its way;
The four first Acts already past,
A fifth shall close the Drama with the day;
Time's noblest offspring is the last.

When Bishop George Berkeley penned this stanza as the conclusion of his "Verses...on the Prospect of Planting Arts and Learning in America" (1752),[71] he provided in its first line a motto for American westward expansion in the nineteenth century. So appropriate was this line as a succinct statement of America's vision of its manifest destiny, that it was adopted (and adapted) as the title of four images of the 1860s summarizing the westward movement. Conveniently these four images divide themselves into two pairs bracketing the decade. From 1861-62 date two mural paintings depicting emigrants traversing plains and mountains on their journey west: one by Carl Wimar for the St. Louis Courthouse, and the other by Emanuel Leutze for the Capitol Building in Washington, D.C. By the end of the decade the anticipated completion of the transcontinental railroad had effected a change in the visualization of "the course of empire," as evidenced by Andrew Melrose's painting of 1868 and Frances Palmer's design for a Currier and Ives lithograph of 1869, in which the railroad is the central feature of each composition.

In the change of focus illustrated by these two pairs of images we may read a more significant change in American thinking about the West. The old romantic notion that the West, as a locality, was to be the decisive influence in America's future gives way to the glorification of technology as the agent of progress.

With the possible exception of Carl Wimar's paintings for the old St. Louis courthouse (to be discussed below, p. 81). Emanuel Leutze's mural in the Capitol Building in Washington, D.C. (fig. 34), was probably the most ambitious attempt in the visual arts of the nineteenth century to summarize the westward movement. The mural was officially commissioned in 1861[72] and executed in 1862 during the troubled years of the Civil War. Measuring twenty by thirty feet, it occupies the west wall of the west staircase in the House of Representatives. According to the rather extensive notes written by Leutze himself to identify and describe the various parts of the painting, it was intended to be one of four large murals which were to decorate the four grand staircases in the Capitol, and which were to represent "four great causes of the prosperity of the country."[73] Of the projected paintings only the one depicting "Emigration to the West" was actually executed; and Leutze's plan even for this one subject was not carried out in full, for he originally had hoped to include other paintings on the side walls of the staircase to complement the mural on the west wall.[74]

Leutze's intention, as stated in his notes, was:

> To represent as near and truthfully as the artist was able the grand peaceful conquest of the great west...Without a wish to date or localize, or to represent a particular event, it is intended to give in a condensed form a picture of western emigration, the conquest of the Pacific slope...

It is clear from this statement, and from the mural itself, that Leutze considered the "conquest of the great west" to be the strenuous achievement of America's common people, rather than the result of military victory (such as that of the Mexican War) or diplomatic negotiation (such as that of the Oregon Treaty). The location of the mural in the House of Representatives, the legislative chamber most directly representative of the people, was therefore particularly appropriate.

In his notes Leutze also described the central action of the composition:

> A party of Emigrants have arrived near sunset on the divide (watershed) from whence they have the first view of the Pacific slope, their "promised land" "Eldorado," having passed the troubles of the plains, "The Valley of darkness" & c.—The first are pressing eagerly forward...

As implied in this description, the mood of the painting is exuberant and triumphant. The composition builds to the peak of a rocky outcrop, upon which two figures are planting an American flag—an appropriate sign of conquest. The discovery of the distant ocean is made simultaneously by four groups of emigrants: the trapper to the left, the young boy, the Tennessee farmer and his family, and the flag bearers. These figures are arranged on an ascending diagonal that creates a dynamic movement upward which climaxes in the planting of the flag. Elsewhere in the composition, however, there is evidence of the difficulties and dangers the pioneers have had to overcome during their journey. Leutze described in his notes, for example, a "suffering wife," who "had folded her hands thanking for escape from dangers past;" also "a lad who has been wounded, probably in a fight with the Indians;" and a young woman "in doubt whether there be not more troubles ahead." We also find pioneers toiling with their wagons up the divide, and the bones of livestock which had died on the way. Thus the arrival of the emigrants on the Great Divide has been achieved only at the expense of a long and arduous struggle.[75]

The painting is enclosed by ornamental margins at the top and to either side (the side panels being painted on the flanking walls), and by a predella painting beneath. The side margins consist of a vine motif forming arabesques and rondels, in which are depicted various biblical and mythological

episodes described by the artist as "a playful introduction from earlier history as a prelude to the subject of the large picture," but remaining subordinate to it. The episodes depicted include a child watching the flight of herons (identified by Leutze as signifying "migratory emotions"); Moses leading the Israelites through the desert; the spies with the grapes of Eschol (a by-now-familiar motif signifying abundance); Hercules dividing the pillars of Gibraltar and opening the way westward to the Atlantic Ocean; the Argonauts in search of the golden fleece (the "first search for gold"); and the Magi following the star to the west. The upper margin contains, in addition to the words of the motto, "Westward the course of Empire takes its way," the figures of advancing pioneers (including a missionary) and retreating Indians. Presiding over all in the center of this margin is an eagle, shielding under its wings the symbols of union and liberty, which Leutze considered the "influences of superior intelligence" characteristic of the American nation. The predella beneath the mural is a long narrow landscape identified in the notes as the Golden Gate of San Francisco harbor. Referring to the predella scene, Leutze stated, "The drama of the Pacific ocean closes our Emigration to the West." His choice of the Golden Gate to represent the ultimate goal of emigration is particularly significant in view of its associations with Eldorado, suggesting not only a land of gold, but a "golden land" for a new golden age.

Although the painting is primarily secular with a secular and patriotic theme, its religious overtones are undeniable—from the layout of the scheme, which is reminiscent of an altarpiece, to the allusions to the Israelites of the Exodus, to the reference to American missionary activity in the margin. Like the expansionists of the 1840s, Leutze saw westward emigration as a divinely impelled phenomenon. The program of his painting reiterates a theme familiar from an earlier decade: the American people, a new Israel, fulfilling their historical and moral destiny by entering their Promised Land in the West. When Leutze planned and executed his mural in the early 1860s, however, expansionist ideologies were somewhat outmoded, especially in view of the new and pressing issue occupying national attention—civil conflict. In the context of the Civil War, Leutze's painting assumes an overlay of meaning which is best understood in relation to the intellectual climate of the war, and particularly in relation to what may be termed a "millennialist spirit" forming part of that climate.

As defined by Ernest Tuveson, millennialism is a "belief that history, under divine guidance, will bring about the triumph of Christian principles, and that a holy utopia will come into being."[76] This belief, having existed in one form or another since the time of the Puritans, has characterized one way in which Americans have always thought about their role in history. The common analogy comparing Americans to the Israelites, the "chosen

people" of the Old Testament, was symptomatic of the idea in the nine-teenth century that Americans had been chosen as God's agent in bringing about a millennium on earth. Even the Civil War, which may have seemed to contradict these millennial expectations, was interpreted contemporaneously in terms of biblical prophecies of the millennium—that is, as the battle described in the Apocalypse in which the forces of good (liberty and Union) combatted the powers of evil (slavery and secession) prior to the institution of the millennial state.[77]

Leutze's mural, then, belongs to a period in which the inauguration of the long-prophesied millennium was thought to be imminent. Interpreted in this context, his vision of westward emigration presents the West as the locality in which the millennial Golden Age was to be instituted in the aftermath of the War. Supporting this interpretation is the presence in the mural of a black boy, clearly a reference to America's black population. The millennium predicted by American abolitionists promised America's slaves freedom and social justice; and, in Leutze's mural, the black boy is about to enter his promised land along with his Anglo-Saxon companions.

We have evidence that this interpretation was indeed part of Leutze's intention. Anne Brewster, writing about Leutze in *Lippincott's Magazine* in 1868, described a meeting with the artist in which she questioned him specifically about the group of figures that included the black boy:

> "Did you not mean this group [she asked Leutze] to teach a new gospel to this continent, a new truth which this part of the world is to accept—that the Emigrant and the Freedman are the two great elements which are to be reconciled and worked with? The young, beautiful Irish woman, too, is she not your new Madonna?" The artist's face glowed and a grim smile gleamed out under the rough mustache...In the first flush of his pleasure he told me I was the first American that had understood his picture.[78]

True to millennialist expectations, Brewster saw in Leutze's subject the promise of a new era, in which gospel of reconciliation between races was to be preached to the world. To be sure, her interpretation—especially its emphasis on reconciliation as the new gospel—reflected the postwar era in which she was writing, a period in which the need to heal wounds was particularly urgent. Her perception of the painting's promise of a brighter future, however, apparently did get to the core of Leutze's intent.

The essential optimism of the painting was evident to Leutze's contemporary audience. In the *Atlantic Monthly* of July 1862, Nathaniel Hawthorne described Leutze's mural, which he had seen "in process" during a recent trip he had made to the Capitol. About the painting and its effects on his morale, Hawthorne wrote:

> [The painting] looked full of energy, hope, progress, irrepressible movement onward, all represented in a momentary pause of triumph; and it was most cheering to feel its good

augury at this dismal time, when our country might seem to have arrived at such a deadly stand-still...It was delightful to see [Leutze] so calmly elaborating his design while other men doubted and feared, or hoped treacherously, and whispered to one another that the nation would exist only a little longer, or that, if a remnant still held together, its center and seat of government would be far northward and westward of Washington. But the artist keeps right on, firm of heart and hand, drawing his outline with an unwavering pencil, beautifying and idealizing our rude material life, and thus manifesting that we have an indefeasible claim to a more enduring national existence. In honest truth, what with the hope-inspiriting influence of the design, and what with Leutze's undisturbed evolvement of it, I was exceedingly encouraged.[79]

What Hawthorne saw and described was a vision of a better world to come, a vision offered by a prophetic artist to a troubled nation as a hopeful alternative to the grim reports arriving in the capital from Fort Sumter, Bull Run, Richmond, and Antietam.

The history of Carl Wimar's paintings for the dome of the old St. Louis Courthouse is somewhat confused, and their study is rendered even more difficult by the fact that today they are in complete ruin.[80] The entire project included four elliptical panels in the dome, four allegorical figures placed between them, and the portraits of four famous Americans in the panels beneath the dome.[81] Dr. William Tausig, one of the members of the committee responsible for selecting Wimar for the commission, described the selection of the subjects of four dome panels in a letter of 1886:

The themes of the four main pictures were most carefully selected and [it was] decided they should symbolize the discovery and development of the far West. In the east side the discovery of the Mississippi and on the north and south historical events of St. Louis, from the time when it was a small fort. On the west side the words of Benton "Westward the star of Empire takes its course," were to be interpreted by a group of immigrants moving over the Rockies toward the setting sun.

Later in the same letter he elaborated on the description of the west panel:

The picture on the west side whose theme was also treated by Leutz [sic] is his celebrated painting in the Capitol in Washington, made several consultations necessary, but finally the artist's individual conception prevailed. While in the picture by Leutz the wild, adventurous side of the group of immigrants is brought out, it was the pathetic side that appealed to Wimar more, whose immigrant group showing the fatigues of travels, toils along in a winding line through some cañon farther onwards towards the beautifully setting sun.[82]

There is some evidence that Wimar's original design included a herd of buffalo retreating before the emigrants, but in an early restoration this part had been painted out.[83] Presumably Tausig had forgotten about it by the time he wrote his descriptions in 1886. A buffalo herd as a sign of the

retreating wilderness would not have been unusual or out-of-place in Wimar's work.[84] The artist had made the buffalo the frequent subject of his paintings. He depicted small groups of buffalo as well as massive herds, and among his best and most popular compositions are his paintings of the buffalo hunt by Indians. If we accept the inclusion of a retreating buffalo herd as part of Wimar's original concept for the courthouse panel, then we must see in his interpretation of westward expansion a slight pang of regret over the disappearance of the wilderness and its noble animals. Considering the element of pathos described by Tausig, we find his vision of emigration a rather melancholy one, much in contrast to Leutze's hopeful treatment of the theme. The reasons for the difference in approach are not difficult to postulate. As we have tried to demonstrate, Leutze's mural was a patriotic affirmation of an improved future for a nation embarking on a "holy war," designed by an artist-patriot whose paintings often expressed his political ideologies. Wimar, on the other hand, was more truly a western artist whose firsthand experiences on the frontier gave him a more realistic view of the West. As a partisan of the wilderness and the frontier, he was more likely to be disturbed at the changes it was undergoing.

Following the Civil War a new emphasis on technology as the force responsible for furthering and consolidating the westward movement appeared in imagery relating to the West and to expansionism. Railroads and telegraph lines, for example, were pictured prominently as forming the bands that linked the East with the far West. Andrew Melrose's painting *Westward the Star of Empire Takes Its Way—Near Council Bluffs, Iowa* commemorates the role that the railroad played in furthering the course of the American empire. The "star of empire" seems to be quite literally the headlight of a locomotive emerging from a dim background and headed straight toward the observer. Deer—representing the receding wilderness—leap across the tracks, silhouetted against the glare of the locomotive light. To the left sits a log cabin in the midst of a clearing and surrounded by tree stumps sawn or axed by homesteaders, a scene typifying man's advance into the wilderness. The locale, as the title tells us, is near Council Bluffs, Iowa, the western terminus of the Chicago and North-Western Railroad, whose route from Chicago to Council Bluffs was completed in 1867 (the probable date of the painting.)[85] Just across the Missouri River from Council Bluffs was Omaha, Nebraska, where the beginning of the Union Pacific Railroad, the eastern branch of the transcontinental railroad which was to link the East to the Pacific Coast was located. The completion of the Chicago and North-Western Railroad in 1867 was heralded as the first connection from the East to the Union Pacific. Melrose's painting, then, commemorates not only the linking of the eastern regions of the United States with the frontier settlements on the

Missouri River, but also projects the eventual linking of East and Far West via the transcontinental railroad. Its celebration of this event echoes the enthusiasm of men like Thomas Hart Benton, Asa Whitney, and William Gilpin for a transcontinental railroad to link Western farmers with Eastern markets. These men presented the building of such a railroad as the most significant achievement of the American nation, one which was to assure its continuing greatness and prosperity.[86]

Similar in theme, purpose, and spirit to Melrose's painting is Frances Palmer's design for the well-known Currier and Ives lithograph of 1868, *Across the Continent: Westward the Course of Empire Takes its Way* (fig. 35). Like Melrose, Palmer applauded the role of the railroad in the progress of the American nation and in the settlement and development of the West. A prominent place is given to the railroad tracks cutting diagonally across the picture plane of her composition; in the lower section a train is leaving the frontier settlement for the Far West. Mrs. Palmer undoubtedly had in mind the transcontinental railroad, which in 1868 was nearing completion. Her train bears the name, neatly lettered on the side of its passenger cars. "THROUGH LINE—NEW YORK-SAN FRANCISCO."

The lithograph does not celebrate the railroad exclusively, however; it is an image summarizing the westward movement as seen through the eyes of someone who had never been on the frontier. It therefore describes Eastern impressions of the settlement of the trans-Mississippi West. Accompanying the railroad tracks receding towards the western horizon are the poles and wires of another technological wonder that facilitated communication between East and far West—the telegraph. Emigrants in their prairie schooners are also represented, perhaps in the spirit of Thomas Otter's *On the Road* of 1860 (Kansas City, Mo., William Rockhill Nelson Gallery; fig. 36), to contrast with the speed and efficiency of the railroad.[87]

The frontier town in the foreground is a prosperous settlement with several small cabins, a church, a schoolhouse, and well-dressed families—all signs of the establishment of a stable community. The church and school house in particular symbolize the advancement of civilization to the frontier, for they signify the refinements of religion and education.[88] In the lower left corner are busy woodchoppers which serve as pervasive symbols of the restless, enterprising, and industrious spirit of Anglo-Saxon settlers in pioneer communities.

The railroad tracks significantly separate the image into two halves. On the left are situated the signs of settlement and civilization—town, people, telegraph, homes, emigrants; while on the right are the symbols of the American wilderness. A river, its banks lined with virgin forests, winds its way into the distance. A herd of buffalo, driven back by the invasion of the white man and his technology, retreats towards a mountain range rising im-

pressively from the flat prairie. In the foreground two Indians mounted on their ponies look on as the white man's iron horse belches smoke into their faces—perhaps an unintentional but also an accurate prefiguration of industrial pollution—which here signifies how the white race has outstripped the Indian in progress.[89]

As a popular Currier and Ives lithograph, Palmer's design reached a wide audience and became a key image of expansionism in the late 1860s and 1870s. It probably inspired John Gast's paintings, *Westward Ho!* of 1872 (Orange, Va., Coll. Harry T. Peters, Jr.), which in turn was reproduced as a lithograph in 1873 under the title *American Progress*. An explanatory text accompanying the lithograph describes the image and its allegorical meaning:

> In the foreground the central and principal figure, a beautiful and charming Female, is floating Westward through the air bearing on her forehead the 'Star of Empire.' She has left the cities of the East far behind, crossed the Alleghanies and the "Father of Waters," and still her march is Westward. In her right hand she carries a book—Common Schools—the emblem of Education and the testimonial of our National enlightenment, while with the left hand she unfolds and stretches the slender wires of the Telegraph, that are to flash intelligence throughout the land. On the right of the picture is a city, steamships, manufactories, schools and churches, over which beams of light are streaming and filling the air—indicative of civilization. The general tone of the picture on the left declares darkness, waste and confusion. From the city proceed the three great continental lines of railway, passing the frontier settlers' rude cabin, and tending toward the Western Ocean. Next to these are the transportation wagons, overland stage, hunters, gold seekers, pony express, the pioneer emigrant and the war-dance of the "noble red man." Fleeing from "Progress," and towards the blue waters of the Pacific, which shows itself on the left of the picture beyond the snow-capped summits of the Sierra Nevadas, are the Indians, buffaloes, wild horses, bears, and other game, moving westward—ever Westward the Indians, with their squaws, papooses, and "pony lodges," turn their despairing faces towards, as they flee from the presence of, the wondrous vision. The "Star" is *too much for them.*[90]

Ten years separate the dates of Leutze's mural and Gast's composition; but because a minor revolution in American thinking was completed, during that decade the two paintings present divergent interpretations of the American West. Both artists saw America's westward progress as a conquest. However, for Leutze that conquest was the moral and spiritual victory of America's common people over the disappointments and hardships of the past, while for Gast the conquest was the victory of civilization over the wilderness. Leutze envisioned the West as a land of light and opportunity for downtrodden peoples; for Gast it was a dark wilderness awaiting the light of American enterprise. Leutze's image seeks salvation and renewal in a virgin land, and as such belongs to an earlier era; Gast's painting is the product of an industrial age, in which technology held the key to the future and material improvement was the standard of success and prosperity.

4

The Wonders of the West: Images of Western Wild Animals

The colonization and settlement of the New World in the seventeenth and eighteenth centuries coincided with the rise of scientific curiosity in the western world.[1] As settlements in North America became securely established and began to prosper, and as the exigencies of life in the new land lessened, men of curiosity with an inclination for the study of natural history began to look to the interior wilderness regions as a treasure trove of new plants, birds, and animals waiting to be discovered, observed, described, and classified. The motivation for these studies, according to the naturalists who undertook them, was pious—to demonstrate the existence of God and to discover the nature of His attributes through the study of His creations.[2] Mark Catesby, for example, expressed this sentiment in the dedication to Queen Caroline of his *Natural History of Carolina, Florida, and the Bahama Islands* (1732), a work which contained illustrations and descriptions of the birds, quadrupeds, and plants observed and studied by the author during a visit to the Americas:

> I hope Your Majesty will not think a few minutes disagreeably spent in casting an Eye on these leaves; which exhibit no contemptible Scene of the glorious Works of the Creator, displayed in the New World....[3]

With the progress of the Enlightenment came other, less theologically oriented reasons for studying the flora and fauna of America. Thomas Jefferson's energetic compilation and analysis of data comparing the animals of America with those of Europe, for example, was done in the service of a major philosophical issue: the nature of the American environment as a human habitat. Jefferson's detailed discussion, which appeared in his *Notes on the State of Virginia,* was in fact a thinly veiled reply to the theory of the famous French naturalist, Georges Louis LeClerc, Comte de Buffon, that the climate of the American continent was inimical to life and caused degeneracy in human and animal inhabitants.[4] Apparently Jefferson's

rigorous efforts were able to convince the Frenchman of his erroneous judg-
ment on this point, but the shadow of the debate lingered into the nine-
teenth century.[5]

For Jefferson and other Americans, a knowledge of the animal in-
habitants of the New World was essential to a full understanding and even-
tual mastery of that environment. Underlying the curiosity about fauna and
flora which motivated the work of America's early naturalists lay a broader
concern with the land over which they travelled, and with the effects that
the land and its human inhabitants had on each other. To these careful
observers of the American wilderness environment, it soon became evident
that as American civilization spread westward in the nineteenth century, the
original character of the environment was irreversibly altered. Thus
naturalists—men of the infant sciences—came to sound a theme similar to
that reiterated by artists and writers of romantic tendencies: the conflict be-
tween civilization and the wilderness. John James Audubon, for example,
wondered at the rapidity of change, but tactfully refrained from uttering an
explicit condemnation:

> When I think of these times, and call back to my mind the grandeur and beauty of
> those almost uninhabited shores; when I picture to myself the dense and lofty summits of
> the forest....unmolested by the axe of the settler;...when I see that no longer any
> Aboriginies are to be found there, and that vast herds of elks, deer and buffalo which
> once pastured on these hills and in the valleys,... have ceased to exist; when I reflect that
> all this grand portion of our Union, instead of being in a state of nature, is now more or
> less covered with villages, farms, and towns, where the din of hammers and machinery is
> constantly heard; that the woods are fast disappearing under the axe by day, and the fire
> by night;...when I see the surplus population of Europe coming to assist in the destruc-
> tion of the forest, and transplanting civilization into its darkest recesses;—when I
> remember that these extraordinary changes have all taken place in the short period of
> twenty years, I pause, wonder, and, although I know all to be fact, can scarcely believe
> its reality.[6]

In the first half of the nineteenth century, then, the naturalists' interest
in American wildlife, originally a manifestation of scientific curiosity and
of a desire to comprehend the totality of the American environment, even-
tually led to a deeper issue—to the struggle to establish the proper relation-
ship between man and his environment. Studied in this context, the imagery
of the animals of the American West is potentially rich in meaning beyond
the zoological accuracy with which they were (or were not) depicted, and by
which they were often judged.

The variety of western animals depicted in the visual arts was great, a
fact which perhaps reflects the catholicity of American curiosity but also
demonstrates a belief that an abundance and diversity of life was a measure
of the worth of a land and therefore also a promise of its future greatness.[7]

The individual species were of interest to Americans for different reasons. The comical prairie dog was a delightful curiosity; the beaver was prized for its pelt and because for years it was the staple of the lucrative fur trade industry; the deer became a symbol of forested wilderness. To some degree those associations accompany depictions of these animals, whether they are the main subject of paintings or prints or whether they appear as incidental parts of larger compositions.

This author has chosen to consider in depth the imagery of three western animals: the grizzly bear, the prairie mustang, and the plains bison (or buffalo, as it is more commonly known).[8] These choices were not predicated solely on the frequency of the images (although, in the case of the buffalo, this factor is certainly an index to the importance of the animal in American thinking and thus an indication of the potential richness of its interpretation). Rather, they were chosen because these images may be interpreted on several levels, and these meanings may be related specifically to American concepts about the nature and significance of the West, about its effect on man, and about the effect of man and his civilization upon it.

The Grizzly Bear

"A large, fierce, formidable animal, the most sagacious, most powerful, and most to be feared of all the North American quadrupeds," was the way one western traveller, W. A. Ferris, described the grizzly bear in 1844.[9] For most Americans this animal served as a symbol of the wild and untamed wilderness of the West; it also epitomized the dangers of western life. Its bestial ferocity fascinated Karl Bodmer, the Swiss artist who accompanied the amateur naturalist Prince Maximilian von Wied in his journey up the Missouri River in 1833.[10] One of the plates from Maximilian's travel narrative records Bodmer's impressions of the grizzly bear. His image of two beasts ripping apart and devouring the carcass of a buffalo is an awesome study of the harsh realities of an untamed environment. Ironically, the two bears in Bodmer's image are at the same time predators and prey; for they are about to fall victims to another enemy—man. The vultures hovering over the scene are further reminders of the savage law of the wilderness in which various species prey upon one another in their perpetual struggle for survival.

Because of the ferocity of the grizzly bear, any encounter between man and the beast entailed danger. A bear hunt was therefore considered a highly perilous undertaking, and perhaps for that reason it was all the more attractive to adventure seekers. Bear hunts were the subject of three watercolors painted by Alfred Jacob Miller for William Walters in the late 1850s. In the commentaries accompanying each painting, Miller stressed the

danger of this sport, as, for example, in the following description of the watercolor entitled *The Grizzly Bear:*

> Hunters are in full tilt after the most formidable of all animals met within the journey. It is no child's play, but downright dangerous sport. Strange that this should be its greatest charm to the reckless trapper and Indian. To hunt and capture the Grizzly bear is a signal honor, and is considered a great *coup*...[11]

In each watercolor mounted hunters chase exuberantly after a lumbering bear. The example illustrated here (fig. 37) is the watercolor entitled *Hunting the Bear.*[12] The excitement of the pursuit, the exhilaration of speed, and the thrill of recklessness provide the dominant theme. As the commentary suggests, the bear hunt exemplified for the artist the brash and daring behavior of western characters who were tempted by the promise of excitement to undertake foolhardy adventures. In the western environment, Miller seems to imply, adventure is easily pursued and found, but to the ruination of discretion.

Frontier stories of hand-to-hand combat between men and grizzly bears were not uncommon. There were popular tales about the adventures of mountaineers who had been attacked by grizzly bears and hopelessly mauled, but who had managed to survive. Such stories were told by Ruxton, among others, and were known to Miller who repeated one in the commentary to one of the watercolors mentioned above.[13] An anonymous lithograph (in the Bancroft Library in Berkeley, California) illustrates a bear attack on a trapper named Hollister. The mountaineer, almost as wild and hairy as his adversary, strikes the pose of a classical warrior, with one hand holding a long knife, the other hand caught in the bear's mouth. The image demonstrates the currency of such stories and suggests that their popularity was due to the fact that they so aptly illustrated the hazards of life on the frontier.

James Walker's depiction of *Roping a Wild Grizzly* of 1877 (Tulsa, Ok., Gilcrease Institute) depicts a scene from frontier California life.[14] The action, placed close to the frontal plane, involves mounted vaqueros who have roped a bear and are attempting to subdue him. The grizzly, struggling fiercely to free himself from the ropes that bind him, dominates the center of the composition. His long claws and sharp teeth receive special prominence and emphasize the formidable nature of the beast. Walker's painting vividly conveys the desperate fury of a cornered animal, but it fails to involve the human participants fully in the struggle. The vaqueros, flanking the bear at the edges of the composition, are just slightly more than interested spectators; and thus the image is chiefly one of bestial ferocity rather than a study of human and animal passions.

Images of the bear hunt in American painting invite comparison with the wild animal hunts depicted by Peter Paul Rubens or Eugene Delacroix. American treatments of the theme fall short of the passionate conflicts visualized by these European painters; however American artists who painted the bear hunt (most notably Miller) were interested primarily in either the ferocity of the bear or the recklessness of its pursuers. They seldom, if ever, allowed the human participants to display the intense passions one would expect in a fierce struggle. The demarcation between man and beast always remains distinct. Recklessness as a quality related to daring and enterprise was a trait acceptable to American romantic notions; but the abandonment of reason to unbridled passions was anathema. American hunters depicted in the visual art virtually never give themselves over to pure instinct in the fury of combat.

One of the most haunting images of a grizzly bear in American painting can be found in Albert Bierstadt's *Wind River Country* of 1860 (Wichita, Ks., Coll. Britt Brown). The composition is a Rocky Mountain landscape, impressive and seemingly serene; but in the left foreground lies a grizzly bear chewing on the carcass of an antelope—evidence of trouble in a wilderness paradise. The motif is reminiscent of the left panel from Hieronymous Bosch's triptych, *The Garden of Earthly Delights,* where, in the foreground of the Garden of Eden, animals prey upon one another in a scene that grimly foreshadows the state of the world after the Fall. Bierstadt's use of the image is less sinister than Bosch's; but its inclusion in the painting is no less deliberate as a commentary on the natural order of the world as perceived by philosophers of natural history in the first half of the nineteenth century.

As mentioned above, prevailing theories of natural history up to mid-century saw in the natural world and its phenomena the evidences of a grand design attributable to a divine Creator. Most educated people in the nineteenth century were familiar with this argument through its popular statement in a widely read book on natural history, Paley's *Natural Theology,* first published in 1802.[15] The grand design of nature included the concept of a Chain of Being in the universe, a concept dating from the seventeenth century but which was still widely accepted as late as the 1840s. Another popular text, John Ware's 1832 edition of William Smellie's *Philosophy of Natural History,* included a chapter entitled "Of the Progressive Scale or Chain of Being in the Universe," which opens with these remarks:

> To men of observation and reflection, it is apparent that all the beings on this earth, whether animals or vegetables, have a mutual connexion [sic] and a mutual dependence on each other. There is a graduated scale or chain of existence, not a link of which, however seemingly insignificant, could be broken without affecting the whole...

The conclusion summarizes the philosophy of natural history as it was understood in the nineteenth century:

> Thus the whole universe is linked together by a gradual and almost imperceptible chain of existence both animated and inanimate. Were there no other argument in favor of the UNITY OF DIETY, this uniformity of design, this graduated concatenation of beings... seems to be perfectly irrefragable.... Let man therefore... study the world of nature, and find in the contemplation of all that is beautiful, curious, and wonderful in them, proofs of the existence and attributes of his Creator.[16]

Although natural history was undergoing significant changes in the century,[17] and was eventually to be replaced by the natural sciences, the outlook expressed in Paley's and Smellie's writings died hard. Even Louis Agassiz, the respected naturalist whose researches added significant contributions to the study of geology, zoology, and embryology, continued up to his death in 1873 to adhere to the concept of a Creator's design in nature.[18] Bierstadt, himself an amateur naturalist and a friend of Agassiz,[19] presumably had more than a passing acquaintance with the philosophy Agassiz espoused. The artist's *Wind River Country* may consciously set forth this philosophy depicting the grandeur of the universe designed by the Creator, and the links in the Chain of Being which give evidence of the "unity of Deity."

The Wild Mustang

Of all the animal images pertaining to the West perhaps the richest is that of the wild horse or prairie mustang. The horse has always been a meaningful symbol in the legends and myths of numerous cultures of both east and west, and its image carries implications derived from well-developed literary and visual traditions. American artists who painted the prairie mustang would naturally have been most familiar with the traditions of Western Europe stemming from Greek mythology, in which the winged horse Pegasus appeared as an important motif in several episodes: as the offspring of Poseidon and Medusa, as the wondrous creature spawned from the Gorgon's blood after Perseus had slain her, as the steed on which Bellerophon slew the chimera, and as the creator of Hippocrene, the spring on Mount Helicon considered the source of poetic inspiration. By virtue of his association with Hippocrene and also his ability to soar above earth, Pegasus became in some literary contexts a symbol of creativity.[20]

In America the wild horse or prairie mustang won a reputation of its own early in the nineteenth century as a representative of a life of freedom. Descriptions of mustangs sighted on the prairies and accounts of their capture by Indians or white men appeared frequently in narratives of Western

travels. Washington Irving's descriptions of wild horses, found in his *Tour on the Prairies* published in 1835, were among the first, and happily the most poetic, of such narratives. In one episode he described the sudden sighting of a wild horse on his journey through prairie country:

> It was the first time I had ever seen a horse scouring his native wilderness in all the pride and freedom of his nature. How different from the poor, mutilated, harnessed, checked, reined-up victim of luxury, caprice, and avarice, in our cities!

A few pages later he elaborated on this comparison between wild and domesticated horses in his musings on the capture of a mustang:

> I could not but look with compassion upon this fine young animal, whose course of existence had been suddenly reversed. From being a denizen of these vast pastures, ranging at will from plain to plain and mead to mead, cropping of every herb and flower, and drinking of every stream, he was suddenly reduced to perpetual and painful servitude, to pass his life under the harness and the curb, amid, perhaps, the din and dust and drudgery of cities. The transition in his lot was such as sometimes takes place in human affairs, and in the fortunes of towering individuals:—one day, a prince of the prairies—the next day, a pack horse![21]

Obviously for Irving the wild horse was a rich symbol from which he could extract a wealth of meaning. He saw the natural state of the mustang as one of freedom, one intimately connected with the prairie environment. Then, in Byronic fashion, he contrasted that state of freedom to the oppression and degradation of civilization. Finally, in comparing the fate of the mustang to the changing fortunes of man, he found a moral lesson for human experience.

After about 1830 there arose a legend about a special wild horse—the "White Steed of the Prairies"—which became the subject of dramas, poems, sermons, and novels.[22] By the time George Wilkins Kendall joined the Texan Santa Fe Expedition in 1843, this legend had become quite familiar to travellers on the plains and prairies. In his narrative of the expedition, Kendall related the legend as it was told to him:

> Many were the stories told...in camp, by some of the older hunters, of a large white horse that had often been seen in the vicinity of the Cross Timbers and near Red River. That many of these stories...were apocryphal or marvelously garnished, I have little doubt; but that such a horse has been seen, and that he possesses wonderful speed and great powers of endurance, there is no reason to disbelieve. As the camp stories ran, he has never been known to gallop or trot, but paces faster than any horse that has been sent out after him can run; and so game and untiring is the "White Steed of the Prairies,"...that he has tired down no less than three race-nags, sent expressly to catch him....
> ...Large sums had been offered for his capture, and the attempt had been frequently made; but he still roamed his native prairies in freedom, solitary and alone. The fact of

his being always found with no other horse in company was accounted for, by an old hunter, on the ground that he was far too proud to be seen with those of his class, being an animal far superior in form and action to any of his brothers. This I put down to a rank embellishment, although it is a fact that the more beautiful and highly-formed mustangs are frequently seen alone.[23]

Kendall's reports, first published in the New Orleans *Picayune* before the author gathered them into book form, apparently inspired a poem by one J. Barber, published in 1843 in the *United States Magazine and Democratic Review*.[24] The poem is centered on the legend of the White Steed, and like Kendall and Irving, its author treated the mustang as a symbol of pride and freedom:

> Mount, mount for the chase! let your lassos be strong,
> And forget not sharp spur and tough buffalo thong;
> For the quarry ye seek hath oft baffled, I ween,
> Steeds swift as your own, backed by hunters as keen.
>
> Fleet barb of the Prairie, in vain they prepare
> For thy neck, arched in beauty, the treacherous snare;
> Thou wilt toss thy proud head, and with nostrils stretched wide,
> Defy them again, as thou still hast defied.
>
> Trained nags of the course, urged by rowel and rein,
> Have cracked their strong thews in the pursuit in vain:
> While a bow-shot in front, without straining a limb,
> The wild courser careered as 'twere pastime to him.
>
> Ye may know him at once, though a herd be in sight,
> As he moves o'er the plain like a creature of light—
> His mane streaming forth from his beautiful form
> Like the drift from a wave that has burst in the storm.
>
> Not the team of the Sun, as in fable portrayed,
> Through the firmament rushing in glory arrayed,
> Could match, in wild majesty, beauty and speed,
> That tireless, magnificent, snowy-white steed.
>
> Much gold for his guerdon, promotion and fame,
> Wait the hunter who captures that fleet-footed game;
> Let them bid for his freedom,—unbridled, unshod,
> He will roam till he dies through these pastures of God.
>
> And ye think on his head your base halters to fling!
> So ye shall—when yon Eagle has lent you his wing;
> But no slave of the lash that your stables contain
> Can e'er force to a gallop the steed of the Plain!

His fields have no fence save the mountain and sky;
His drink the snow-capped Cordilleras supply;
'Mid the grandeur of nature sole monarch is he,
And his gallant heart swells with the pride of the free.

It is little wonder that the legend of the wild mustang, described in terms such as those above, should become so popular with Americans in the 1840s. It took little imagination to turn the marvelous animal into a patriotic symbol; yet, the significance of the wild horse and his legendary fame does not remain on this relatively superficial level. No less a thinker and author than Herman Melville found in the legend more profound implications. In his masterpiece, *Moby Dick,* first published in 1851, Melville described the White Steed as symbol of an uncorrupted world. His reference to the legend comes in one of the novel's key chapters, "The Whiteness of the Whale," in which the author attempted to explain the awesome yet elusive quality of whiteness:

> Most famous in our Western annals and Indian traditions is that of the White Steed of the Prairies; a magnificent milk-white charger, large-eyed, small-headed, bluff-chested, and with the dignity of a thousand monarchs in his lofty, over-scorning carriage. He was the elected Xerxes of vast herds of wild horses, whose pastures in those days were only fenced by the Rocky Mountains and the Alleghanies. At their flaming head he westward trooped it like that chosen star which every evening leads on the hosts of light. The flashing cascade of his mane, the curving comet of his tail, invested him with housings more resplendent than gold and silver beaters could have furnished him. A most imperial and archangelical apparition of that unfallen, western world, which to the eyes of the old trappers and hunters revived the glories of those primeval times when Adam walked majestic as a god, bluff-bowed and fearless as this mighty steed. Whether marching amid his aides and marshals in the van of countless cohorts that endlessly streamed it over the plains, like an Ohio; or whether with his circumambient subjects browsing all around at the horizon, the White Steed gallopingly reviewed them with warm nostrils reddening through his cool milkiness; in whatever aspect he presented himself, always to the bravest Indians he was the object of trembling reverence and awe. Nor can it be questioned from what stands on legendary record of this noble horse, that it was his spiritual whiteness chiefly, which so clothed him with divineness; and that this divineness had that in it which, though commanding worship, at the same time enforced a certain nameless terror.[25]

While Melville's interpretation, shaped as it was to fit the context of his novel, may be exceptional, much of the symbolic meaning he perceived in the legend of the White Steed was also inherent in the descriptions of wild horses on the prairies given by Irving, Kendall and others. The prairie mustang was clearly an image with a wealth of associations which were reflected in some degree not only in American literature but in the visual arts as well.

Alfred Jacob Miller painted two watercolors of wild horses for William Walters. *Wild Horses* depicts a band of mustangs, described by Miller in his commentary:

> The sketch will give you some idea of a band of wild horses engaged in their rough amusement and frolicsome pastime of biting and kicking, while some are rearing and striking with their forefeet...
> Their hot and fiery blood causes them to take alarm at the slightest movement,—so that when they start a general stampede takes place, and in a very few minutes the prairie is bare and not one of them is to be seen.[26]

There is little of the mystique of the wild horse in either the sketch or the commentary; but the watercolor entitled *Stampede of Wild Horses* seems deliberately designed to convey something of the spirited freedom of these animals. Miller described the scene in his commentary, which echoes Washington Irving's descriptions of wild mustangs:

> Among the wild animals of the West, none gave us so much pleasure, or caused such excitement, as the bands of wild horses that at intervals came under our view. The beauty and symmetry of their forms, their wild and spirited action,—long full sweeping manes and tails—variety of color, and fleetness of motion,—all combined to call forth admiration from the stoical....
> ...The sketch will convey to the observer some idea of this glorious scene,—but it is impossible to catch such magic convolutions and secure the spirit of such evanescent forms under the excitement and difficulties that may be readily imagined to transpire at the moment.[27]

The setting of the watercolor is a prairie landscape with mountains rising in the background. The emphatic horizontal emphasis stresses the sense of a spacious and limitless environment which was also a part of Ranney's images. The horses, grouped in a band in the lower part of the composition, rush forward toward the foreground and the observer; but around the periphery of the band, individual horses are beginning to veer off in scattered directions, creating a centrifugal effect. As in his other images of the western environment, Miller found in the prairie mustang an image of free and undisciplined energy.

The capture of the wild mustang, so poignantly described by Irving, is the theme of two paintings by William Ranney, both dating from 1846: *The Lasso* (Malvern, Pa., Coll. Claude Ranney) and *Hunting Wild Horses* (Omaha, Neb., Joslyn Art Museum; fig. 38).[28] Each composition depicts the moment of capture in which a plainsman has roped a white mustang and has abruptly checked its flight. *The Lasso* focuses exclusively on this scene, but in the second painting Ranney included other horses and proportionately expanded the pictorial space. The dynamic forms of these additional horses, racing about their captured companion, contrast tellingly with the

sudden captivity of the white mustang and with the trained discipline of the plainsman's horse.

Ranney almost certainly must have known of the legend of the White Steed, either from his days as a volunteer in the Texan army in the southwest, where the legend was especially popular, or from the literature that described it. Although his paintings are not literal illustrations of the myth, any interpretation of what they may have meant to Ranney and to his audiences must take into account the legend and its implications. If the white horse in either painting does refer to the legendary White Steed, then his capture represents a significant departure from the myth. One way to view the capture is to see it as a tragic reversal of fortune, such as Irving described—the end of wild freedom and the submission to servitude and degradation; but if we see this event from the point of view of the captor, it becomes an exhilarating event, metaphorically interpreted as the mastery of a free and, by implication, creative spirit. For a young painter like Ranney who was just reaching artistic maturity, the theme would have been especially appropriate, translating the Greek myth of Bellerophon taming Pegasus into an American context.

Albert Bierstadt's interest in western landscape also included the image of the wild horse, which is the subject of three of his oil studies and one finished painting. Two of the oil sketches (Boston Museum of Fine Arts) are simply studies of horses, lacking backgrounds or settings.[29] The third example, an oil study on paper entitled *White Horse in the Sunset* (Cody, Wyoming, Buffalo Bill Museum), is a highly unusual image. The background is a vivid prairie sunset, against which is placed, very close to the frontal plane, a horse viewed in profile. Occupying the entire pictorial space, the figure is altogether out of scale with the background and its low horizon. The horse was not originally part of the design, having been painted over the landscape, which is still visible in places beneath the white overpaint. The effect is visionary; perhaps is deliberately so by referring to the legendary White Steed which, it will be remembered, had been described by Melville as an "archangelical apparition."

With this remarkable image in mind, we may turn to a consideration of Bierstadt's finished painting, *Horse in the Wilderness* (Washington, D.C., Priv. Coll.), and find in it similar intimations of a transcendent theme. The setting of this painting is a broad river valley at the foot of an impressive range of mountains, the very tops of which are concealed by a cloud cover. To the right of the composition is a solitary black horse—a proud and regal creature which calls to mind at once the spiritual attributes of the legendary mustang. To the left the clouds are breaking and sunlight is pouring down dramatically to illumine the grassy plain.

The motif of the break-up of a storm over mountains appears often in Bierstadt's work, perhaps because its sudden passages from dark to light provided dramatic effects.[30] The motif may also have iconographic significance, denoting revelation. In the traditions of western culture, the mountain top has always been associated with the presence of deity (or deities); and in the Christian tradition in particular, it has been the setting for revelatory experiences: Moses receiving the Ten Commandments on Mt. Horeb; Jesus transfigured on a mountaintop; and St. John "carried... away in the spirit to a great and high mountain" at the culmination of his vision on the Isle of Patmos. In Greek mythology, when a mortal was apotheosized, he was carried to Mt. Olympus, home of the Gods; and representations of these events in the seventeenth and eighteenth centuries almost invariably involve the hero ascending while clouds break apart to allow him passage.[31]

The degree to which Bierstadt consciously drew upon these traditions is problematic; but that his intention in the painting in question may have been to suggest a transcendent or revelatory experience is by no means unlikely. The magnificence of western scenery was frequently described by writers throughout the nineteenth century in terms of its spiritual or religious significance, and among the most eloquent of these descriptions are those offered by Fitz Hugh Ludlow in his *Heart of the Continent* of 1870. Ludlow was a close friend of Bierstadt who travelled with the artist on one of his trips west in 1863.[32] *Heart of the Continent* is his published account of this western journey. At one point, describing his first distant view of the mountains from the plains, Ludlow rhapsodizes:

> It cannot be described by any Eastern analogy; no other far mountain view that I ever saw is at all like it.... It is impossible to imagine [the mountains] built of earth, rock, anything terrestrial.... They are made out of the air and sunshine which show themI confess....that my first view of the Rocky Mountains had no way of expressing itself save in tears. To see what they looked, and know what they were, was like a sudden revelation of the truth, that the spiritual is the only real and substantial; that the eternal things of the universe are they which afar off seem dim and faint.

Later he reiterates the transcendent quality of the scene:

> The mountains seemed hopelessly apart from us, like the glories we try to grasp in a dream; yet this very hopelessness gave them all a dream's grandeur, and made them seem rather great thoughts than great things. To see the Rocky Mountains in bright sunlight, to drink from the vast, voiceless happiness which they seem set there to embody, is one of the strangest mixtures of pleasure and pain in all scenery.[33]

Bierstadt probably shared many of the attitudes and sentiments expressed in Ludlow's descriptions; and his paintings of the Rocky Mountains reflect this outlook.

It is in this context that we must interpret *Horse in the Wilderness.*[34] If we accept the horse as an embodiment of freedom and a symbol of the creative spirit, then the sudden influx of light signifies the exaltation of the creative spirit to inspiration and revelation. The cause of this inspiration is the wilderness environment—the vastness of the plains and the grandeur of the mountains. The painting may even be interpreted as a personal statement about the artist's experience with the western landscape, expressing his responses to the magnificence of the Rocky Mountains which inspired him to new artistic achievement.

The American Buffalo

Described by one nineteenth-century commentator as "the universal theme of prairie travelers,"[35] the American bison was indeed the Western animal par excellence. No western travel narrative was complete without a description of the impressive sight of a herd of buffalo or an account relating the thrills of a buffalo hunt. So numerous did such descriptions become, both in travel narratives and in fiction, that by 1860 Horace Greeley felt obliged to apologize for including an account of the animals in his *Overland Journey:*

> I would rather not bore the public with buffalo, I fully realize that the subject is not novel—that Irving and Cooper and many others, have written admirably upon it.... Yet I insist on writing this once more on buffalo, promising then to drop the subject....[36]

In the visual arts, too, the buffalo was a common theme of images pertaining to the West. Artists visualized the buffalo hunted by Indians and White men, migrating or grazing in enormous herds and occasionally isolated singly or in small groups in an expansive prairie landscape. On the surface these images appear merely to express Americans' fascination with the West and its wildlife; but on another level they indicate the white man's anxieties about his relationship to the Western environment. And because the buffalo was closely associated with the Indian, some of these images also pertain to the fate of the Native American as perceived by the white man.

The earliest images of the American bison were illustrations accompanying narrative accounts of the discovery and exploration of the New World which were done by artists with vivid imaginations but no first-hand experience with the animal.[37] Most of these images produced in the seventeenth and eighteenth centuries follow the format of descriptive animal images as exemplified by those of Albrecht Durer: the animal seen in profile dominating the pictorial field, its head turned slightly to render a frontal view of the "face." Generally these images make only minimal attempts to

depict a setting or to place the animal in the context of his natural environ-
ment. In the nineteenth century, however, there was a greater interest in
depicting the buffalo in the western landscape, and particularly in an expan-
sive prairie setting—a shift in emphasis reflecting the American preoccupa-
tion with the western wilderness.

Early explorers in the New World had found the sight of buffalo herds
particularly awesome because of their incredible numbers. Eyewitness ac-
counts described these herds as "seas" of buffalo stretching to the
horizon.[38] The force of the impression did not wear off even in the nine-
teenth century: time and again Western travel narratives described immense
herds sighted on the prairies and spoke of the peculiar thrill such sights
evoked. Consider, for example, John Fremont's enthusiastic account:

> A few miles brought us into the midst of the buffalo, swarming in immense numbers over
> the plains....In the sight of such a mass of life, the traveler feels a strange emotion of
> grandeur. We had heard from a distance a dull and confused murmuring, and when we
> came in view of their dark masses there was not one among us who did not feel his heart
> beat quicker....Indians and buffalo make the poetry and life of the prairie; and our
> camp was full of their exhilaration.[39]

Horace Greeley estimated the size of buffalo herds in terms of the number
of square miles they covered:

> I know a million is a great many, but I am confident we saw that number [of buffalo]
> yesterday. Certainly, all we saw could not have stood on ten square miles of ground.
> Often, the country for miles on either hand seemed quite black with them....[40]

Pictorial images of buffalo herds grazing on or migrating across the
prairies likewise tried to convey some idea of the awesomeness of the sight.
This occurs, for example, in John Mix Stanley's lithograph of 1855, *Herd
of Bison Near Lake Jessie* (fig. 39). Published in the *Pacific Railroad
Reports,* the image illustrates the following description from the report:

> About five miles from camp we ascended to the top of a big hill, and for a great
> distance ahead every square mile seemed to have a herd of buffalo upon it. Their number
> was variously estimated by the members of the party—some as high as half a million. I
> do not think it any exaggeration to set it down at 100,000. I had heard of the myriads of
> these animals inhabiting these plains, but I could not realize the truth of these accounts
> till today, when they surpassed anything I could have imagined from the accounts which
> I had received. The reader will form a better idea of this scene from the accompanying
> sketch, taken by Mr. Stanley on the ground, than from any description.[41]

Just a few years later, in 1861, William Jacob Hays painted one of the
most impressive images of a buffalo herd produced in the nineteenth cen-
tury. His *Herd on the Move* is one of several works which resulted from a
trip the artist had made up the Missouri River in the summer of 1860.[42]

As an amateur naturalist, Hays was particularly interested in the wildlife he observed on his trip; and like most other Western travellers, he found the sight of buffalo herds moving across the prairies especially impressive.

Hays himself described his painting as follows:

> By the casual observer this picture would with hardly a second thought, be deemed an exaggeration, but those who have visited our prairies of the far West can vouch of its truthfulness, nor can canvass [sic] adequately convey the width and breadth of these immnumberable [sic] hordes of bison, such as are here represented coming over a river bottom in search of water and food, their natural instincts leading them on, constantly inciting them to this wandering life.... As far as the eye can reach, wild herds are discernible; and yet, farther behind these bluffs, over which they pour, the throng begins, covering sometimes the distance of an hundred miles.... They form a solid column, led by the strongest and most courageous bulls, and nothing in the form of natural obstructions seems ever to deter their onward march, they crossing rivers and other obstacles from which a horse would shrink.[43]

As an image of irresistible movement governed by animal instinct, Hays's composition is singularly effective. The immense herd, blackening the low hills in the distance with their numbers in an almost solid mass, advances across the broad valley towards the center foreground, converging at a point directly in front of the observer.

Hays further developed the theme of animal instinct in a companion painting entitled *The Stampede* (Calgary, Glenbow-Alberta Institute), a drastic image of self-destruction, described and explained by Hays as follows:

> The immense herds of bison which roam over the prairies are sometimes seized with fright, from some real or imaginary cause, and the panic, beginning perhaps with but few, is at last communicated to the whole herd, when, with headlong fury, they dash and drive each other on, in wildest fear. The picture represents the arrival of a herd, during one of these panics, upon the brink of one of the small canons, or ravines, which everywhere intersect the prairies, and are generally invisible until their edge is nearly approached. The foremost animals, despite their fear, discover their danger and frantically struggle to retain their foothold, but the immense pressure of the terror-stricken creatures in the rear renders it impossible; they are forced forward, and plunge into the ravine, their bodies serving as a bridge for the rest of the herd, which continues its mad career until exhausted.[44]

There, is however, another theme underlying these two paintings—the inevitable destruction of the buffalo as a species. The more dramatic statement of the theme is made in *The Stampede,* in which the crazed herd rushes madly towards its immediate destruction. No less effective, however, is the metaphorical treatment of the idea presented in *Herd on the Move.* One of the details of this composition is a buffalo skull prominently displayed in

the grass in the lower right foreground. One of the leaders of the herd has stepped out of the main column and pauses to eye the skull curiously. The juxtaposition of the multiplicity of life with the symbol of inevitable death is a poignant allusion to the probability of the herd's extinction.

While it may seem improbable that a species whose numbers had once seemed to observers virtually infinite should within a few decades become nearly extinct, this is in fact exactly what happened to the buffalo in the nineteenth century. From the herds of millions that roamed the prairies in the early 1800s, the number of buffalo dwindled to a few hundred by the mid-1880s. This was due, in large part, to the massive slaughters of the animals which took place in the 1870s, when white hunters decimated the bison population in an obsessive greed for buffalo hides.[45] As early as the 1830s Americans had recognized the possibility that the species would become extinct due to the indiscriminant hunting practices of both white men and Indians. Even while they were describing the innumerable herds of buffalo on the prairies, Americans were lamenting their dwindling numbers and foretelling their eventual disappearance. George Catlin first sounded the warning in 1841.[46] Josiah Gregg predicted the total annihilation of the American bison; George Frederick Ruxton lamented the wholesale destruction of the species; and Horace Greeley concluded sadly that the buffalo "are bound to perish."[47] George Kendall's comments are typical of these laments:

> It would seem impossible, especially to one who has seen the buffalo numerous as the sands of the seashore, on their immense natural pastures, that the race can ever become extinct; but when he reflects upon the rapid strides civilization is making westward upon the domain of the buffalo, he is brought to feel that the noble race will soon be known only as a thing of the past.[48]

Hays himself echoed this concern over the disappearance of the buffalo, as well as of other species, in a paper he delivered before the New York Lyceum of Natural History. His purpose was to demonstrate the extent to which the range of various species of animals on the North American continent had been altered and reduced. Like many of the earlier commentators, Hays attributed the changes to the advance of white civilization:

> In the present condition of this country, since civilization has reached half way across the continent, few persons think of the prodigious changes that have taken place in the animal life in the comparatively short time since the discovery of the country. At that time the whole country was an unbroken wilderness, through which roamed the Indians and countless numbers of animals, many of which are now so rare as to be unknown to many and objects of curiosity to all.

Hays devoted several paragraphs to the plight of the buffalo, ending with a

typical indictment of the white man's extravagant hunting practices:

> ...It would seem that the bison once roamed over the entire country, now known as the United States, and extending as far north as the sixtieth parallel in British America. They are not found now east of the Missouri river, nor south of Colorado; at the rate at which they have been driven back and destroyed, it is probable that they are soon to be known only in history....It is a low estimate to place the number of bison destroyed by man each year at not less than half a million.[49]

This concern over the destruction of the buffalo reiterates a theme which has recurred throughout this study: the conflict between civilization and the wilderness. Exuberance over the opportunities afforded by the West. was countered by the fear that those resources and opportunities would quickly be spent.[50] The example of the buffalo demonstrated clearly that the white man's civilization could not coexist with unspoiled nature; and the realization of this fact sounded a dissonant note in the chorus voicing its belief in America's constant and inevitable progress.

Almost every image of the buffalo dating from the second half of the nineteenth century touches on the theme of extinction in some way. In Albert Bierstadt's paintings of the late 1860s the reference to the demise of the species is so subtle as to be easily overlooked, while the dominant theme appears to be the harmony of the natural world. In his two versions of *The Buffalo Trail* (one located in the Boston Museum of Fine Arts; the other, subtitled *The Impending Storm,* in the Corcoran Gallery in Washington, D.C.), a herd of buffalo makes its way in single file from background towards the foreground, moving undisturbed through wooded landscapes. These two images of buffalo migrations are related to Hays's paintings and may have been inspired by them; but Bierstadt's treatment is significantly different. His paintings are primarily landscapes which dominate the animals, rather than images of immense herds which dominate the landscape. The settings are not the spacious prairielands depicted by Hays, but the far fringes of the prairies bordering on the Rocky Mountains—the western-most range of the plains buffalo. Thus Bierstadt's paintings depict migrating herds arriving at the uttermost limit of their gradual retreat. The storm that gathers in the background of the painting in Washington may be a further allusion to the impending tragedy facing these animals.

Among Carl Wimar's several paintings of the buffalo are two related compositions of 1859, presenting similar subjects in vastly different contexts: *Buffalo Crossing the Platte* (St. Louis Art Museum) and *Buffalo Crossing the Yellowstone* (St. Louis, Washington University Art Gallery). The setting of the former is a tranquil evening scene, whose effects

were described by a reviewer in the St. Louis *Republican* of October 1871 as follows:

> This picture has Wimar's suggestive color effects but we regard it as one of his best pictures, viewed at a proper distance however, there is harmony in its dusk tints and a charm of the wilderness about it that causes the eye to willingly revert to its contemplation.[51]

By contrast, the second painting provides a dramatic scene in which a herd of buffalo flee before the eerie glow of a distant prairie fire. In the midst of the swarms of buffalo swimming the river and scrambling up the chalky cliffs of the shore, a single buffalo bull turns to face the fire in the distance. Raised slightly above the rest of the herd and silhouetted against the glow of the river illuminated with reflected light, he gazes towards the burning horizon like some tragic hero confronting the end of the world.

George Catlin's painting of *Buffalo Herds Crossing the Upper Missouri* (Washington, D.C., National Collection of Fine Arts) provides a precedent for Wimar's theme, but not for Wimar's dramatic—one could say apocalyptic—treatment. Compare Wimar's setting, with the distant fire casting an impressive and mysterious glow over the animals swimming in the river, to St. John's description of the final days of the world as found in *Revelations:*

> The first angel sounded, and there followed hail and fire mingled with blood, and they were cast upon the earth. . . . And the second angel sounded, and as it were a great mountain burning with fire was cast into the sea: and the third part of the sea became blood; and the third part of the creatures which were in the sea, and had life, died. . . . (Ch. 8, vv. 7-9)

The apocalyptic overtones of Wimar's painting were intentional, and they refer to the impending extinction of the species. Wimar alluded to the issue in several paintings which postdate the composition in question. One of the panels for the St. Louis Courthouse, it will be remembered, included a buffalo herd retreating before the westward push of the American empire (see above p. 82); and in one of his images of the buffalo hunt of 1861, he hinted at the demise of both Indian and buffalo in the motif of a buffalo skull and bones in the foreground.[52] In the present example the prairie fire is more than a terrifying natural phenomenon: it symbolizes an irresistible force threatening the buffalo species and pushing it into a final and tragic retreat.[53]

Few nineteenth century sports could match the excitement and thrill of hunting buffalo on horseback. The nearest equivalent was tracking big game in Africa or India; and even some sporting Britons preferred the lure of the American West to that of the Dark Continent or the Far East. During the

days of the abundance of buffalo on the American prairies, wealthy and ti-
tled visitors from Great Britain and Russia participated in organized expedi-
tions into buffalo territory. Sir William Drummond Stewart, whom we have
encountered before in this study as the patron of Alfred Jacob Miller, made
several generously outfitted trips onto the prairies to hunt buffalo during
the 1830s and '40s. Sir George Gore stirred considerable controversy with
his excursion of 1855, during which he and his retinue slaughtered over 2000
buffalo. In 1872 a hunt was organized for the young Russian Grand Duke
Alexis, who was accompanied on this well-publicized adventure by such
noted western personalities as Buffalo Bill Cody and Lieutenant Colonel
George Custer.[54] Americans, too, were eager to experience the thrill of the
buffalo hunt; and among those who ventured onto the prairies were literary
men who joined expeditions to the West for the adventure and who later
capitalized on the experience by writing travel narratives. Washington Irv-
ing's jaunt onto the prairies was the prototype for such adventures, and his
account of the trip published in 1835 did much to popularize the idea.
William Kendall joined the Texan Santa Fe Expedition "to visit regions in-
habited only by the roaming Indian, to find new subjects upon which to
write, as well as to participate in the wild excitement of buffalo-
hunting...."[55]

Images of *white men* hunting buffalo were intended to convey some
idea of the thrills of the hunt and the exhilaration of life in the West.
However, in the late decades of the nineteenth century—following the
massive destruction of buffalo that took place in the early 1870s—these im-
ages became biting indictments of this wholesale slaughter. Images of the
Indian buffalo hunt were more numerous, and generally can be classified
with other depictions of Indian life as records of Indian customs and man-
ners, although embellished with an overlay of romantic adventure. But
many of these images carried deeper implications, alluding to the tragic fate
of the Indian made inevitable by the advancement of white civilization.

Typical of the romantic images of the buffalo hunt are those of Alfred
Jacob Miller. Like Delacroix's paintings of lion hunts, which they resemble
in composition, Miller's paintings of buffalo hunts pit human skill against
animal passion. Miller is less successful than Delacroix in conveying the in-
tensity and passion of the struggle, perhaps because his technique (which
adheres closely to academic standards) lacks the freshness and spontaneity
of Delacroix's handling of paint. *The Surround* (Omaha, Neb., Joslyn Art
Museum) is Miller's most interesting and original treatment of the theme.
It is a large panoramic composition depicting a particular Indian
technique of hunting the buffalo.[56] In a surround, mounted hunters encom-
pass a herd and run it in circles until one or two animals can be weaned
away and killed. In Miller's painting, Sir William Drummond Stewart and

other members of his party join the Indians in the chase. The composition is two-tiered: in the upper section circle the herd and its pursuers, while in a broad pit in the foreground a group of Indians tighten in on a bull singled out for the kill. Within the panoramic prairie setting of the upper portion the mass of hunters and buffalo racing at full speed in a circle acts as a centerfuge drawing in from the periphery all stray hunters, horses, and buffalo.[57] The stampeding herd draws everything towards it, just as the excitement of the chase commands for the moment all attention.

Miller's depiction corresponds to narratives of the buffalo chase which describe the intensifying excitement of the pursuit. In Chapter 19 of his *Tour on the Prairies,* for example, Washington Irving described the heightening of anticipations of his party as it neared buffalo country:

> This morning the camp was in a bustle at an early hour; the expectation of falling in with buffalo in the course of the day roused everyone's spirit....
> ...In the course of the morning we were overtaken by the lieutenant and seventeen men, who had remained behind, and who came laden with the spoils of buffaloes; having killed three on the preceding day....
> The excitement of our hunters, both young and old, now rose almost to fever-height, scarce any of them having ever encountered any of this far-famed game of the prairies. Accordingly, when in the course of the day the cry of buffalo! buffalo! rose from one part of the line, the whole troop were thrown in agitation.[58]

Miller himself, in describing one of his watercolors entitled *Wounded Buffalo* (Walters Collection, No. 56), commented: "In the middle the hunters are chasing the retreating band, it is impossible to resist the excitement, and all go in pell-mell."

It was this irresistible thrill offered by life on the frontier that had appealed so strongly to Miller's patron, Sir William Drummond Stewart, and to the artist himself. It also appealed to Americans on the eastern seaboard who had never seen the hunt but who were fascinated by the tales of its adventure: hence the popularity of Miller's (and others') paintings. In his treatment of the theme, Miller presented the hunt as the romantic essence of the frontier as he had seen it in the 1830s.

At about the time that the image of the buffalo hunt on horseback became popular in American art—that is, during the 1830s[59]—there developed an association between the buffalo and the native American which recognized that the fates of the Indian and the buffalo were intertwined and somewhat analogous: both were disappearing from the east, "removed" or driven west by American settlers moving into the Mississippi Valley.

George Catlin was among the first to publicize the fate of the Indian— and of the buffalo—in his account of his trip up the Missouri River in 1832. The very purpose of Catlin's trip was to produce "a literal and graphic

delineation of the living manner, customs, and character of an interesting race of people, who are rapidly passing away from the face of the earth...,'' and throughout his narrative, Catlin repeatedly lamented the tragic fate of both buffalo and Indian:

> It is a melancholy contemplation for one who has travelled as I have, through these realms, and seen this noble animal [i.e., the buffalo] in all its pride and glory, to contemplate it so rapidly wasting from the world, drawing the irresistible conclusion too, which one must do, that its species is soon to be extinguished, and with it the peace and happiness (if not the actual existence) of the tribes of Indians who are joint tenants with them, in the occupancy of these vast and idle plains.[60]

In the 1840s similar comparisons between the fates of the Indian and the buffalo appeared frequently in popular and widely read western travel narratives. Writing in 1845, John C. Fremont devoted several paragraphs to the problem of the disappearance of the buffalo in the far West: "Like the Indians themselves, [the buffalo] have been a characteristic of the great West; and...like them, they are visibly diminishing...."[61] George Frederick Ruxton suggested that even the Indians were aware of their fate and of the similarity of their future to that of the buffalo:

> Reckless...of the future, in order to prepare robes for the traders, and procure the pernicious fire-water, [the Indians] wantonly slaughter vast numbers of buffalo cows every year..., and thus add to the evils in store for them. When questioned on this subject, and such want of foresight being pointed out to them they answer, that however quickly the buffalo disappears, the Red man "goes under" in greater proportion; and that the Great Spirit has ordained that both shall be "rubbed out" from the face of nature at one and the same time—"that arrows and bullets are not more fatal to the buffalo than the small-pox and fire-water to them, and that before many winters' snows have disappeared, the buffalo and the Red man will only be remembered by their bones, which will strew the plains.[62]

As Ruxton's description suggests, the image of buffalo skulls and bones whitening under the relentless sun of a vast prairie landscape was a fitting *memento mori*. We have seen how Hays used the motif in *Herd on the Move* to refer to the future extinction of the bison; in other examples, it has broader implications, referring to the fate of the Indian as well. Alfred Jacob Miller's watercolor, *Group of a Mountaineer and Kansas Indian* (fig. 40), presents an Indian, his son, and a fur trapper seated around a large buffalo skull. The Indian, talking animatedly to the mountaineer, points toward the prairie expanses in the background. Miller explained the scene in his commentary, in words that sound very much like Ruxton's:

> The Kansas Indians live pretty much now on the recollections of the past:—the future for them is entirely hopeless....

In the sketch a Kansas Indian is recounting to a Trapper the remembrances of his youth, when the Buffalo in countless herds traversed the prairie, and wild horses in large bands were captured and converted to their use. All these have disappeared, and the only momentoes now left are the skulls of Buffalo lying about the prairie and bleaching in the sun.

...In a few, very few years, they will be swept from the face of the earth, and the places that now know them shall behold them no more—forever.[63]

In his commentary to another watercolor, *Sioux Indian at a Grave,* Miller suggests that the Indians themselves appropriated the buffalo skull as a symbol of death:

One of the strongest objections the Indians have made (in their removal to their homes in the Far West) has been that of leaving the graves of their relatives and friends....The modes of burial are various....The ordinary burial is a mound with a Buffalo skull (fit emblem of mortality) placed upon it.[64]

The consciousness that time was running out for both Indian and buffalo added a certain aura of fatalism to images of the Indian buffalo hunt, especially when the motif of skull and bones appeared somewhere in the scene. Rena Coen has discussed the use of this and related motifs in Carl Wimar's two buffalo hunts of 1860 and 1861, and in Albert Bierstadt's two versions of *The Last of the Buffalo* of 1888.[65] We need only mention its appearance in James Walker's *Buffalo Hunt* of 1878 and Louis Maurer's *Great Royal Buffalo Hunt* of 1894, to point out the currency of the motif in the nineteenth century.

Ever since its creation in 1888, Bierstadt's *Last of the Buffalo* (Washington, D.C., Corcoran Gallery of Art; fig. 41), has been one of the most widely known images of the Indian buffalo hunt in American art. Carefully constructed for the maximum dramatic effect, it is more than just a depiction of the excitement of the hunt; it is a metaphor of the passing away of the American frontier. Thus it is an appropriate image with which to conclude this study.

The setting of the painting is a broad and deep prairie landscape which stretches to meet the hazy forms of mountains rising in the distant background.[66] The drama of the hunt is enacted in the foreground, where, near the center of the composition, a buffalo bull attacks a mounted Indian on his rearing horse. As the bull charges, the Indian raises his feathered lance to thrust into its hump. In spite of their adversary roles, the Indian and buffalo form a compact visual unit, expressive of their close relationship. Because the Indian was dependent on the buffalo for sustenance, his fate was inextricably linked to the fate of the buffalo. Thus the last of the buffalo meant also the decline and extinction of the native American.

This relationship is reiterated elsewhere in the foreground. Among the

forms of dying buffalo there lies the partially concealed body of an Indian hunter who has himself fallen in the chase. The predator has become a victim, sharing the fate of the wounded buffalo that surround him.

Next to the body of the fallen hunter lies the form of a buffalo calf; significantly, it is an albino—an animal sacred to the Plains Indians. Albino buffalo were scarce and usually kept toward the center of the herd, where they were protected from the attacks of hunters. To kill or capture an albino was therefore a rare and momentous event, considered by the Indians to be a sign of special favor from the Great Spirit. Such occasions were celebrated by an elaborate ceremony, during which the hunter who had killed the albino symbolically purged and humbled himself and experienced a renewal of life.[67] In 1882 anthropologist Alice Fletcher described such a ceremony, which she had been permitted to witness. She quoted the Indians' explanation of the ritual in part as follows:

> The old die, the new are born, and the race lives on forever. The white buffalo is the chief of the herd, and from the buffalo comes our animal food and this gives life and strength....[68]

In the context of Bierstadt's painting, the death of an albino calf—representing the future generations of buffalo and the source of life and strength for the Indians—when coupled with the death of an Indian warrior signifies not the renewal of life, but rather extinction. In death as in life, the Indian and the buffalo were indissolubly linked; and the image of the Indian warrior lying near the dying buffalo poignantly foretells the doom of both.

In a newspaper article of 1889, Bierstadt was quoted as stating that his purpose in painting *The Last of the Buffalo* was "to show the buffalo in all his aspects and depict the cruel slaughter of a noble animal now almost extinct."[69] Given the close association between Indian and buffalo which we have just demonstrated, it is unlikely that the "cruel slaughter" to which Bierstadt referred was meant to be understood as the Indian buffalo hunt. It is more likely that Bierstadt had in mind the massive slaughters of buffalo which took place in 1872-74, when white hunters—motivated purely by hope of commercial gain—killed the animals indiscriminately, stripping the bodies of their valuable hides and leaving the carcasses to rot in the prairie sun. Thus, Bierstadt perceived the melancholy fate of buffalo and Indian to be the result of the white man's encroachment on the western frontier.

A very subtle visual clue reinforces this interpretation. In the left foreground there lie scattered in the prairie grasses the skulls and bones of buffalo long since hunted and killed. They are, of course, the pervasive western symbols of death and extinction which we have identified in

numerous other images; but running through the same section, imprinted in the prairie soil, is the mark of a wheel rut, a sign of the white man's presence in the West. Coupled with the bleached animal bones, it is also a symbol of the white man's intrusion on, perhaps even of his violation of, the western environment.

Because the Indian and the buffalo symbolized for many Americans the essence of the West, their extinction also implied the end of the frontier. More than any other image of the West from the later decades of the nineteenth century, Bierstadt's painting epitomizes the passing of the frontier and its unfortunate consequences. The events and conditions to which the image refers—the slaughter of the buffalo and the deteriorating status of the Indians—were not the reasons for the end of the frontier, but rather its symptoms. The West as a wilderness, uninhabited except for wild animals, savages, and semicivilized hunters and trappers, and the West as a land of romance and adventure had given way to the West of the cattleman and the prairie farmer. The organization of the Kansas and Nebraska territories in 1854 had been a sign of the times, for it signalled the relentless push of white settlers into the land that, less than twenty-five years earlier, had been considered virtually uninhabitable and therefore fit only for Indians. As the population of the United States oozed into these lands, it pushed the frontier of settlement westward towards the Pacific Coast until the findings of the Census of 1890 revealed that this frontier no longer existed. Bierstadt's painting anticipated the announcement of this fact by a few years, and it summarized what Americans had for over forty years observed and lamented. The fears of those Americans who valued America's western wilderness, its inhabitants, and its wildlife—the fears of those romantics who viewed every step of the white man into a virgin environment as a step closer to the end of its unspoiled state—had proved to be all too true.

Conclusion

Ever since 1893, when Frederick Jackson Turner published his landmark essay, "The Significance of the Frontier in American History," the West and westward expansion have been a focus of attention and the cause of much controversy among scholars of American history. Although Turner's fundamental premise that "the existence of an area of free land, its continuous recession, and the advance of American settlement westward, explain American development," was hotly disputed in the 1930s and '40s, Americans of the nineteenth century would have found his idea perfectly congenial. We find intimations of the idea as early as 1819 in Congressional debates over the Seminole War:

> ...The Western frontier is that portion of the world where civilization is making the most rapid and extensive conquest of the wilderness, carrying in its train the Christian religion and all the social virtues. It is the point where the race is most progressive....
> *(Annals of Congress,* 15th Cong., 2d Sess., Col. 838.)

And Stephen Douglas, speaking in Congress in 1850, anticipated Turner's thesis by forty-three years:

> ...There is a power in this nation greater than either the North or the South—a growing, increasing, swelling power that will be able to speak the law to this nation, and to execute the law as spoken. That power is the country known as the great West—the Valley of the Mississippi...There sir, is the hope of this nation—the resting-place of the power that is not only to control, but to save, the Union....
> *(Congressional Globe,* 31st Cong., 1st Sess., Appen., p. 365.)

This study has proceeded from the assumption that westward expansion was indeed a phenomenon of central importance to the nineteenth century, and that the issues raised by expansion were of fundamental concern to American thinking. The symbols, motifs, and themes appropriated by American artists to portray the West, when carefully studied, reveal the deeper implications of these concerns. Throughout the four preceding essays, certain themes have recurred which identified four major issues: the

conflict between civilization and wilderness, the relationship between the white man and the Indian, the American sense of national mission, and the nature of American progress. It has been the aim of this study to examine these issues in relation to the visual arts and to study the particular ways in which these issues were expressed.

In many ways the overriding problem raised by westward expansion was the conflict between civilization and the wilderness. While Americans valued the wilderness for its pristine condition, the grandeur of its scenery, and its supposed beneficial effects on the individual, they were also proud of the achievements of their advancing civilization. However, the presence of civilization necessarily precluded the survival of the wilderness. Thus Americans had a dualistic attitude towards the latter, regarding it as something to be preserved , on one hand, and as an environment to be subdued and conquered, on the other. This dualism is reflected in the varying representations of Daniel Boone—as a child of nature and forest philosopher, and as an agent of civilization and leader of settlement. It is also evident in the divergent interpretations of the fur trapper as a romantic hero enjoying the freedom of the West, or as a national hero overcoming the threats of the wilderness and leading the way West for pioneers and settlers.

The conflict of values between civilization and the wilderness operated on two levels—as a personal dilemma and as a national concern. The individual who contemplated living in the wilderness faced a choice between solitude and society. The popular story of Daniel Boone moving from Kentucky to Missouri in order to escape encroaching settlements illustrates the romantic ideal in which the choice is made for nature and solitude. This choice was perfectly acceptable in the first decades of the nineteenth century, for it was believed that the individual morally benefitted from contact with the wilderness. Thomas Cole's painting of Daniel Boone epitomizes this ideal, depicting Boone as a kind of wilderness saint receiving enlightenment from his intimate communion with nature. As more and more Americans made the choice to move west into the wilderness, however, Americans became aware of the moral and physical dangers involved in such an enterprise. The environment could be inhospitable; and its native inhabitants, when hostile, could pose a danger to the very lives of the pioneers. These conditions threatened to strip the veneer of civilization from frontier settlements, causing men to revert to barbarity. In the visual arts the physical threat was depicted in representations of Indians, who personified the wilderness, attacking the pioneers, who represented white civilization. The frequency and character of these representations, which sometimes allude to biblical imagery (as in Bingham's *Captured by Indians*) suggest that Americans were aware of the moral issues involved; and that

perhaps they felt a need to depict the values of civilization in direct conflict with those of the wilderness, as if to assure themselves that society would not acquiesce to savagery.

The threat of the wilderness did not stop the advance of settlement. As in a military campaign, each step that civilization took westward meant a corresponding retreat for the wilderness. Many observers pointed to the corruption of the Indian and the dwindling numbers of western wildlife—particularly buffalo—as evidence of the destruction of the wilderness. The frequent images of buffalo hunts, depicting dying or wounded animals along with buffalo skulls and bones—western *mementi mori*—expressed the melancholy awareness that the frontier and the wilderness were passing away in the face of the expanding population of the West.

The relationship of the white man to the Indian was one of the questions subsumed in the broader issue of the conflict between civilization and the wilderness. Although this author has purposefully avoided dealing directly with the imagery of the Indian, which has already been discussed by Ellwood Parry and others, it was necessary at various points in the present study to touch upon the issue of Indian-White relations as it pertained to each of the four themes considered. It is clear that Americans were also of two minds regarding the Indian. As mentioned previously, the Native American could be viewed as a threat to civilization. As such he was to be opposed, outwitted, or subdued by the heroic actions of western heroes. But as a noble savage and the uncorrupted child of nature, the Indian was the object of much concern and sympathy. Those who wished to save the Indians from extinction and to integrate them peacefully with American civilization saw the fur trappers and traders who lived in the wilderness as agents of a much hoped-for reconciliation of the races. The symbol of this dream was the interracial marriage, which actually occurred on a small scale on the frontier, but was unfortunately impracticable as a national policy. The dream succeeded only in the visual arts—most notably in Alfred Jacob Miller's *Trapper's Bride,* or in George Caleb Bingham's *French Trapper and his Half-Breed Son.* These images demonstrate that the ideal of harmonious race relations existed in spite of prevailing attitudes and official governmental policies which sought to remove the Indian entirely out of the range of advancing American civilization.

Central to the understanding of the westward movement in American history, and particularly of the era of Manifest Destiny, is a discussion of the American concept of national mission. Living in a relatively new world, in an environment almost totally different from that of Europe, and under a novel form of government empowered by the common man, Americans

believed themselves to be a unique people—indeed, a "chosen people" destined to fulfill history and prophecy. If it was possible to perfect human society—and the nineteenth century was predisposed to believe that it was—then surely the United States was to be the nation in which that perfection, the earthly millennium, was to be realized. Moreover, America would not selfishly accomplish this task of perfecting its society for itself only, but would do so to provide an example for the whole world.

Such a rationale underlay arguments in favor of expansionism in the 1840s. America would be better able to fulfill its purpose, it was said, if it expanded and allowed its population to spread its virtues and the blessings of its society to the utmost limits of the continent. American pioneers were, not surprisingly, pictured as the agent of this messianic mission in representations which alluded appropriately to scriptural prophecies. Thus Daniel Boone and other pioneers became modern-day Josephs leading their families into new lands, as in Bingham's painting of the *Emigration of Boone into Kentucky*, or in William Jewett's *The Promised Land.* The West was depicted as a new Eden, a garden of abundance in which all material wants would be supplied, and where moral and civic virtues were to be perfected. The millennium, in other words, was to be inaugurated in the West.

In the nineteenth century westward expansion was explained and justified not only in terms of a national mission—a concept essentially religious in origin—but also in terms of the secular theory of progress. According to this theory, the history of civilization was believed to show evidence of continual development and improvement; and the center of civilization was thought actually to be moving westward. From its origins in Mesopotamia, it had moved to Egypt, then to Greece, Rome, Europe, England,and finally across the Atlantic Ocean to America. Americans, interpreting this theory in light of their own national experience, saw the torch of civilization continuing to advance westward across their continent. Taking Bishop Berkeley's words—"Westward the course of empire takes its way"—as a motto, they equated progress with geographic expansion. Not surprisingly, in the late 1860s and '70s there appeared several images in which the progress of American civilization was visualized as technological improvements moving west. Frances Palmer's lithograph *Across the Continent* of 1869 and John Gast's painting *Westward Ho!* of 1872 are the classic examples of this notion.

The concepts of progress and national mission, the recognition that the wilderness is not an inexhaustible resource, and the concern over past and present treatment of the native American are issues which seem as important to American society today as they were to Americans of the nineteenth

century. Perhaps they can be considered indigenous to the American experience. This study has shown that these concerns can be found underlying images of the American west and westward expansion. Thus, however much nineteenth century American art relied on European precedents and examples for style and the use of motifs, its fundamental American character is undeniable.

Fig. 1. *Boone in a Fur Collar*
 Engraving by James P. Longacre after painting by Chester
 Harding (1820)
 From *National Portrait Gallery of Distinguished
 Americans,* 1835

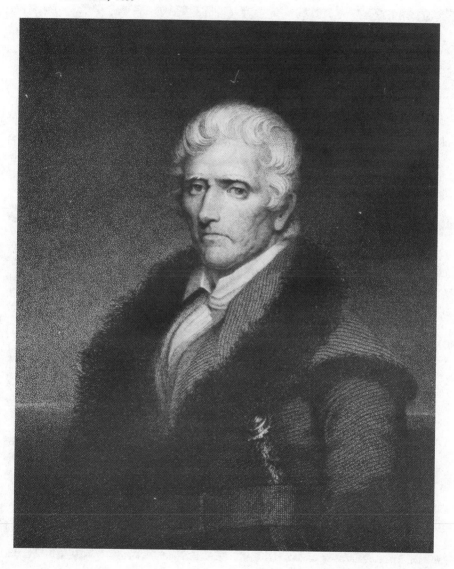

Fig. 2. *Thomas Jefferson,* by Rembrandt Peale, 1805
 Oil
 Courtesy The New York Historical Society

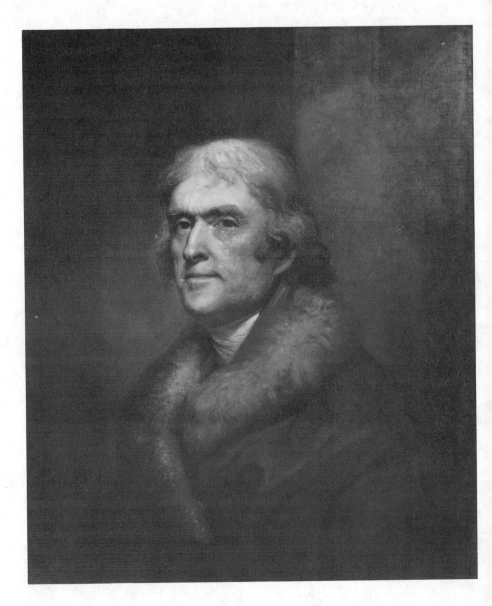

Fig. 3. *Col. Daniel Boone,* 1820
Engraving by James O. Lewis after design by Chester
Harding
Courtesy The Missouri Historical Society, St. Louis

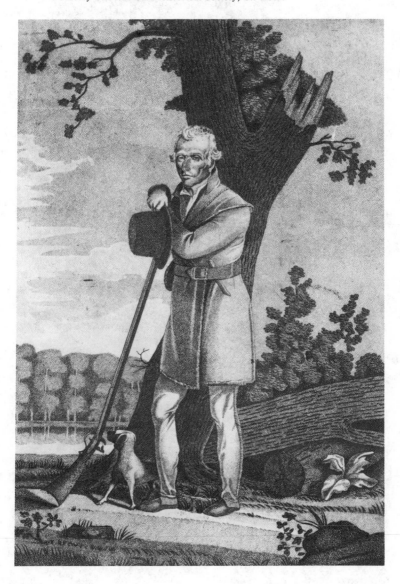

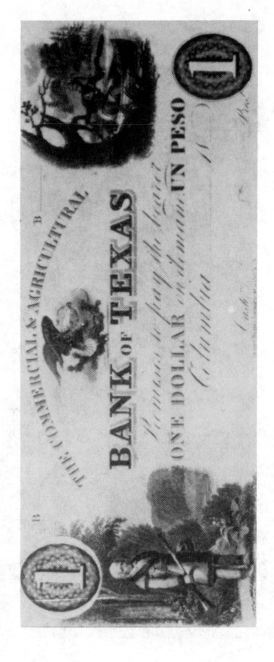

Fig. 4. Texas bank note, ca. 1838
Engraved by Draper, Tappan, Longacre & Co. after a
design by James P. Longacre

Fig. 5. *Daniel Boone,* 1861
Engraving after a painting by Alonzo Chappell
From *National Portrait Gallery of Eminent Americans,*
1861

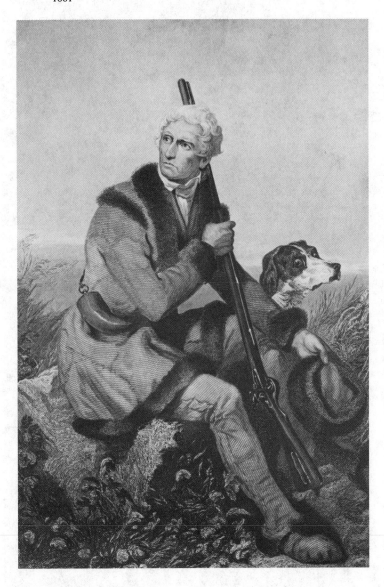

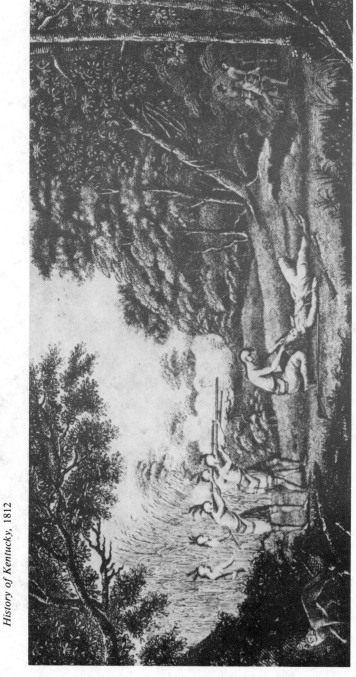

Fig. 6. *An Attack of the Indians Upon Dan'l and Squire Boone
and John Stewart*
Engraved frontispiece from Humphrey Marshall's
History of Kentucky, 1812

Fig. 7. *Daniel Boone Seated Outside His Cabin*, Thomas Cole, 1826
Oil
Amherst College, Mead Gallery of Art, Amherst, Mass.

Fig. 8. *St. Jerome in Penitence,* Albrecht Durer
Engraving
Courtesy Museum of Fine Arts, Boston. Katherine E.
Bullard Fund.

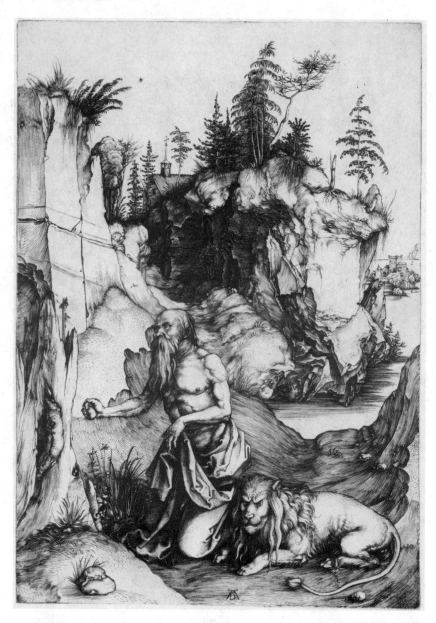

Fig. 9. Engraved frontispiece from Joseph Story's *The Power of Solitude,* 1804

Fig. 10. *Conflict Between Daniel Boone and the Indians,* Enrico
Causici, 1826-27
Marble relief
United States Capitol Building, Washington, D.C.

Fig. 11. *The Murder of Jane McCrea,* John Vanderlyn, 1804
Oil
Courtesy Wadsworth Atheneum, Hartford, Conn.

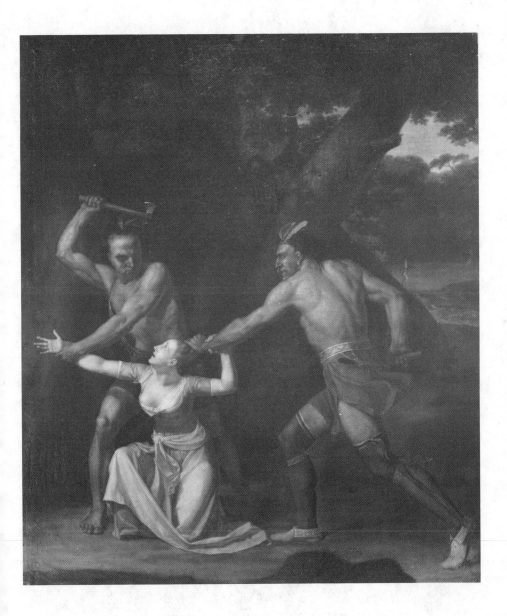

Fig. 12. Frontispiece to George C. Hill's *Daniel Boone, the Pioneer of Kentucky,* 1859

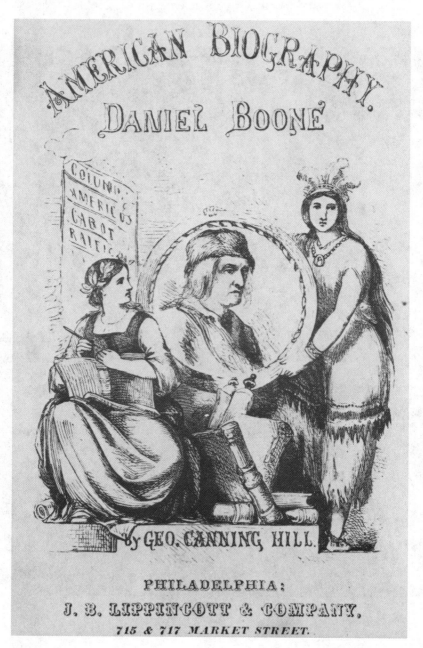

Fig. 13. *The Emigration of Daniel Boone into Kentucky,* George
Caleb Bingham, 1851
Oil
Washington University Gallery of Art, St. Louis

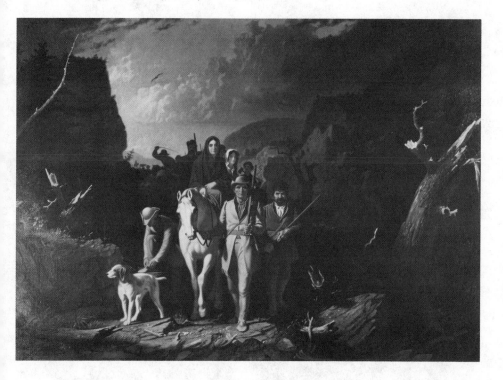

Fig. 14. *Trappers Starting for the Beaver Hunt,* Alfred Jacob
Miller, 1857-60
Watercolor
Walters Art Gallery, Baltimore, Md.

Fig. 15. *Trappers,* Alfred Jacob Miller, 1857-60
Watercolor
Walters Art Gallery, Baltimore, Md.

Fig. 16. *The Lost Greenhorn,* Alfred Jacob Miller, 1857-60
 Watercolor
 Walters Art Gallery, Baltimore, Md.

Fig. 17. *The Trapper's Bride,* Alfred Jacob Miller
Joslyn Art Museum, Omaha

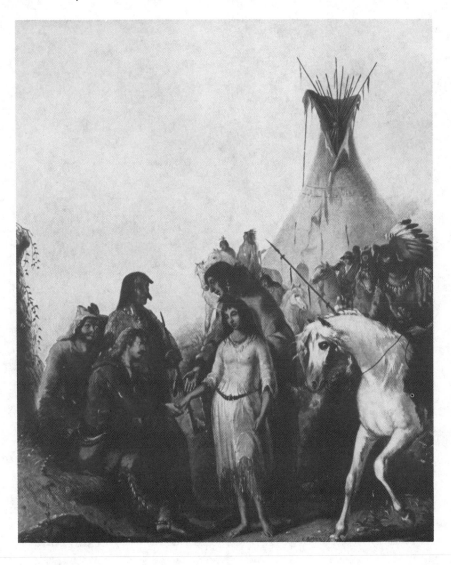

Fig. 18. *French Trader and His Half-Breed Son (Fur Traders Descending the Missouri),* George Caleb Bingham, 1845
Oil
The Metropolitan Museum of Art, New York. Morris K. Jesup Fund.

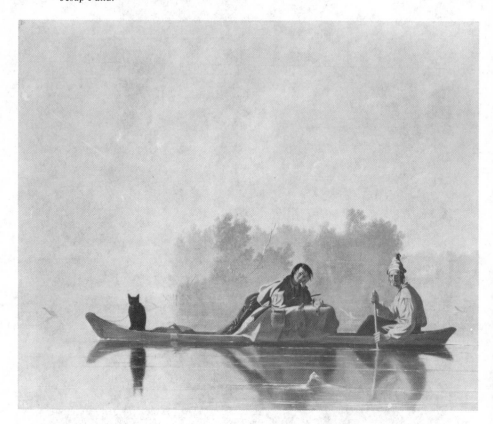

Fig. 19. *Long Jakes,* 1846
 Engraving by W.G. Jackman after painting by Charles
 Deas (1844)

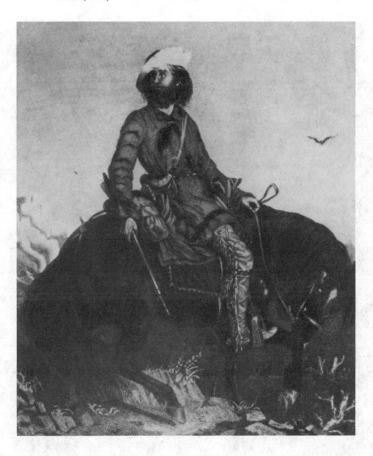

Fig. 20. *The Death Struggle,* Charles Deas, 1844
Oil
Courtesy The Shelburne Museum, Shelburne, Vt.

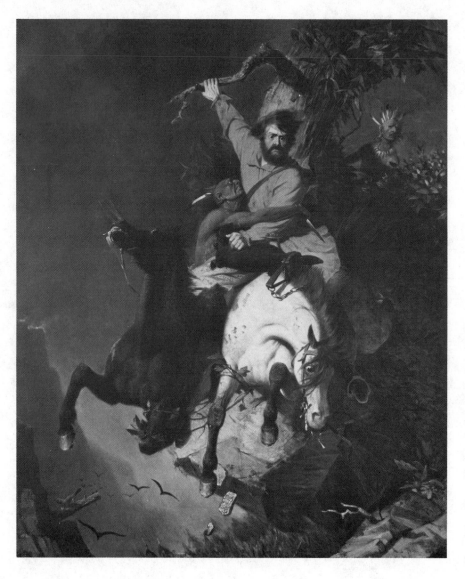

Fig. 21. *Crockett's Wonderful Leap and Miraculous Escape from the Indians*
Wood engraving from Crockett's Almanac, 1844
Courtesy The Metropolitan Museum of Art, New York

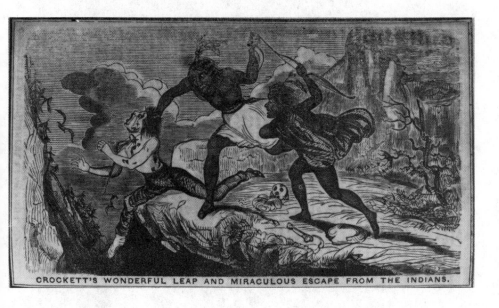

CROCKETT'S WONDERFUL LEAP AND MIRACULOUS ESCAPE FROM THE INDIANS.

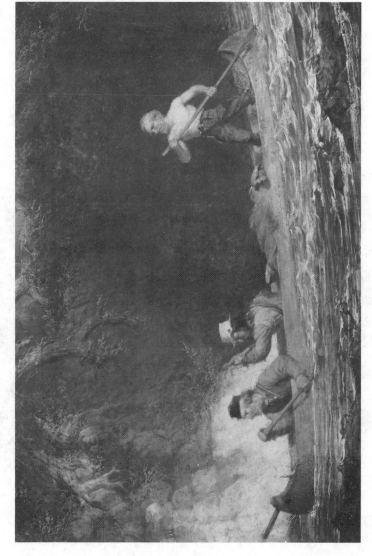

Fig. 22. *The Voyageurs*, Charles Deas, 1846
Oil
Courtesy Museum of Fine Arts, Boston. M. and M.
Karolik Collection

Fig. 23. *The Trapper's Last Shot*
Lithograph after a painting by William Ranney (1850)
Courtesy The Missouri Historical Society, St. Louis

Fig. 24. *Trappers*, William Ranney, 1851
Oil
Joslyn Art Museum, Omaha

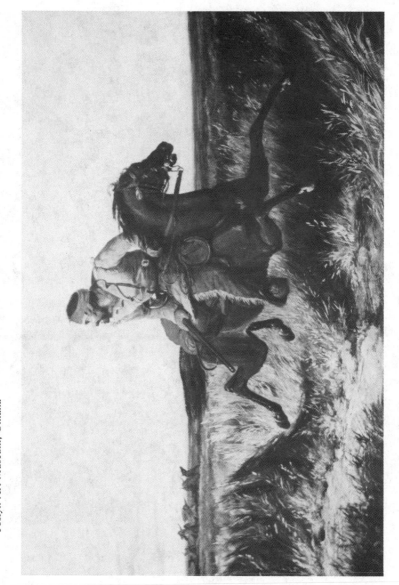

Fig. 25. *Prairie Hunter/"One Rubbed Out,"* Arthur F. Tait, 1852
Oil
Joslyn Art Museum, Omaha

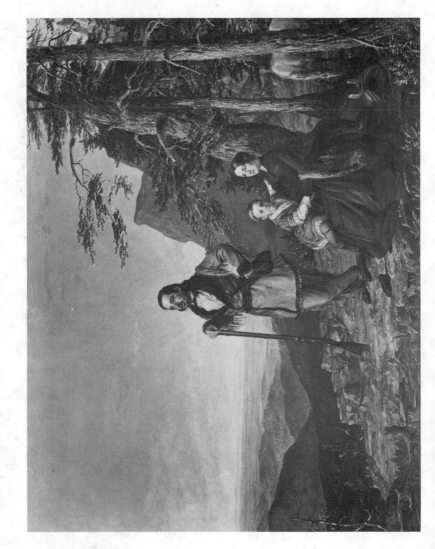

Fig. 26. *The Promised Land,* William S. Jewett, 1850
Oil
Terra Museum of American Art, Evanston, Ill.

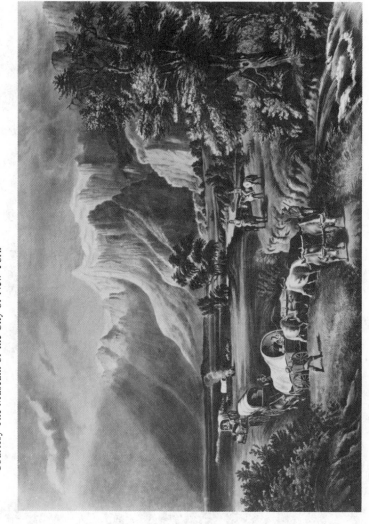

Fig. 27. *The Rocky Mountains: Emigrants Crossing the Plains,*
Currier and Ives, 1866
Lithograph designed by Frances Palmer
Courtesy The Museum of the City of New York

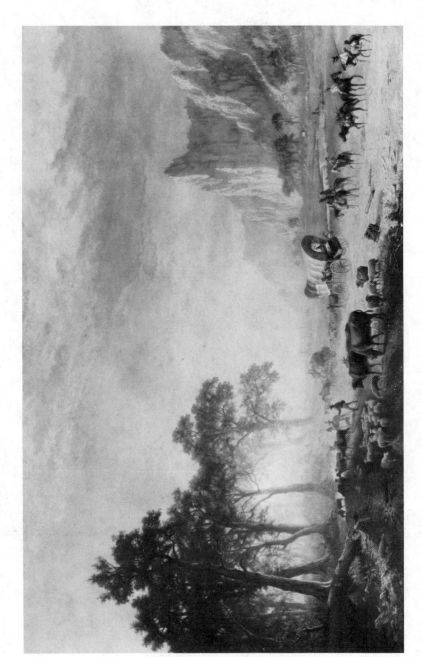

Fig. 28. *The Oregon Trail*, Albert Bierstadt, ca. 1859
Oil
The Butler Institute of American Art, Youngstown, Ohio

Fig. 29. *The Rescue,* Horatio Greenough, 1837-50
Marble
United States Capitol Building, Washington, D.C.

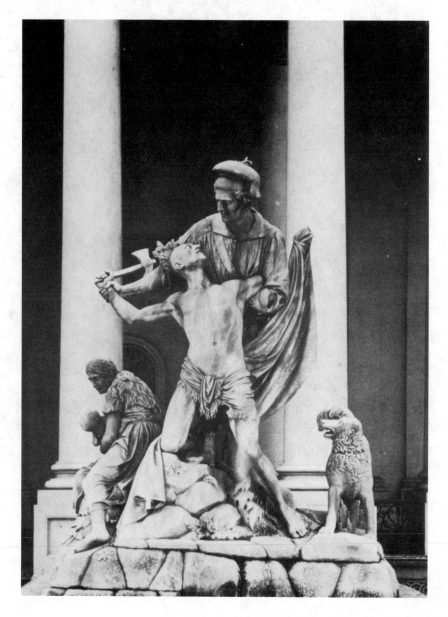

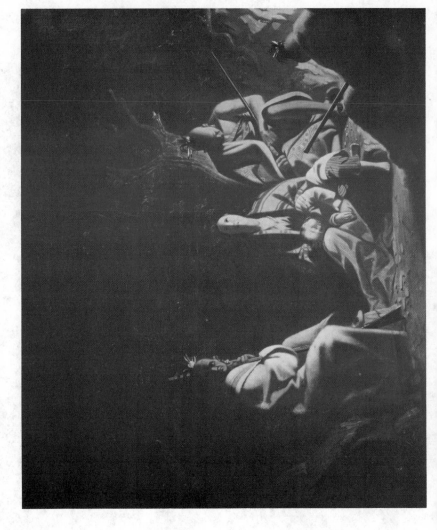

Fig. 30. *Captured by Indians*, George Caleb Bingham, 1848
Oil
St. Louis Art Museum. Bequest of Arthur C. Hoskins

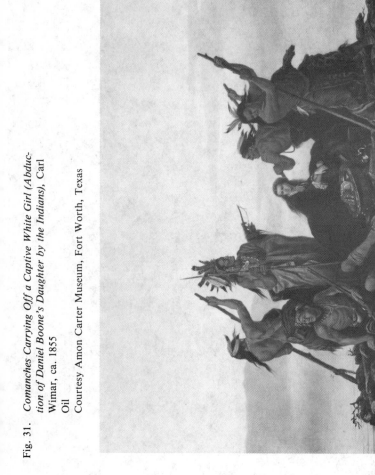

Fig. 31. *Comanches Carrying Off a Captive White Girl (Abduction of Daniel Boone's Daughter by the Indians)*, Carl Wimar, ca. 1855
Oil
Courtesy Amon Carter Museum, Fort Worth, Texas

Fig. 32. *The Pioneer's Home: On the Western Frontier*, Currier
and Ives, 1867
Lithograph designed by Frances Palmer
Courtesy The Museum of the City of New York

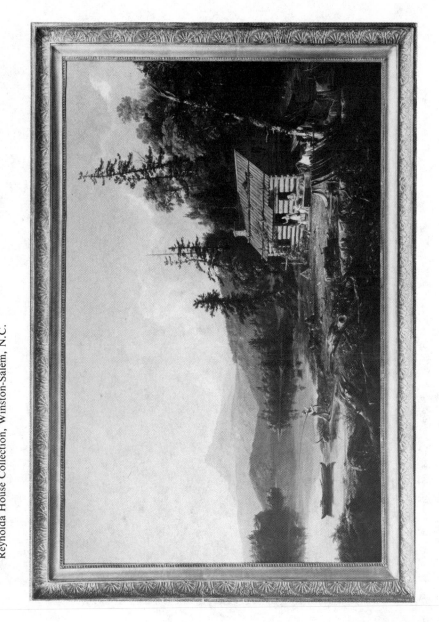

Fig. 33. *Home in the Woods*, Thomas Cole, 1846
Oil
Reynolda House Collection, Winston-Salem, N.C.

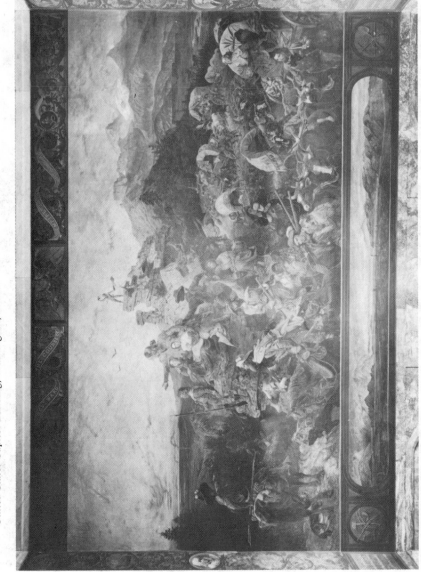

Fig. 34. *Westward the Course of Empire Takes Its Way,* Emanuel
Leutze, 1862
Mural
United States Capitol Building, Washington, D.C.

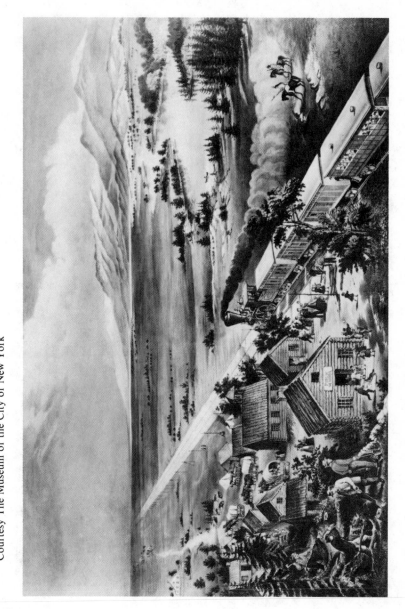

Fig. 35. *Across the Continent: Westward the Course of Empire Takes Its Way*, Currier and Ives, 1868
Lithograph designed by Frances Palmer
Courtesy The Museum of the City of New York

Fig. 36. *On the Road*, Thomas Otter, 1860
Oil
Nelson Gallery-Atkins Museum, Kansas City, Missouri.
Nelson Fund.

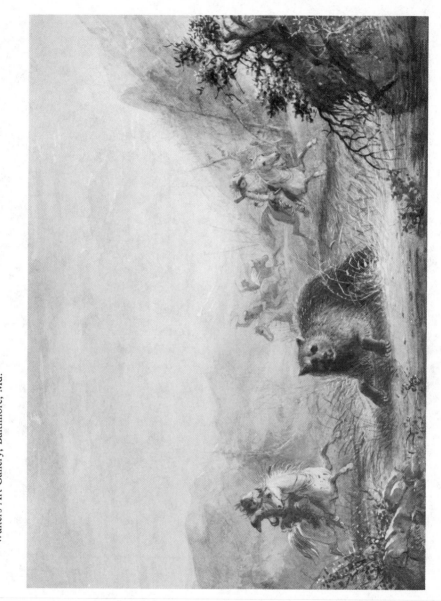

Fig. 37. *Hunting the Bear*, Alfred Jacob Miller, 1857-60
Watercolor
Walters Art Gallery, Baltimore, Md.

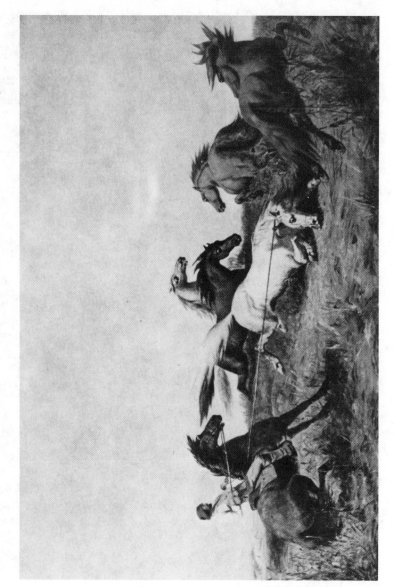

Fig. 38. *Hunting Wild Horses*, William Ranney, 1846
Oil
Joslyn Art Museum, Omaha

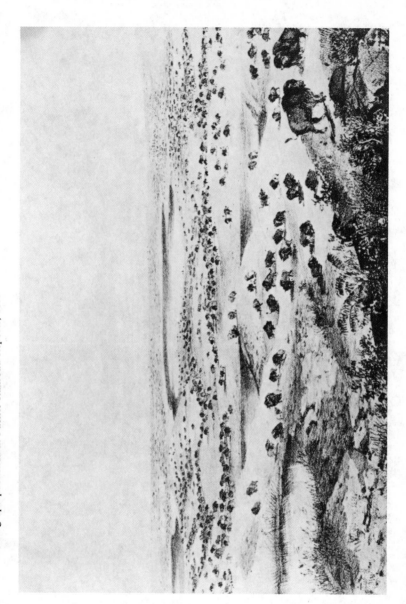

Fig. 39. *Herd of Bison Near Lake Jessie*, John Mix Stanley
Lithograph published in Pacific Railroad Reports, 1855

Fig. 40. *Group of a Mountaineer and Kansas Indian,* Alfred
 Jacob Miller, 1857-60
 Watercolor
 Walters Art Gallery, Baltimore, Md.

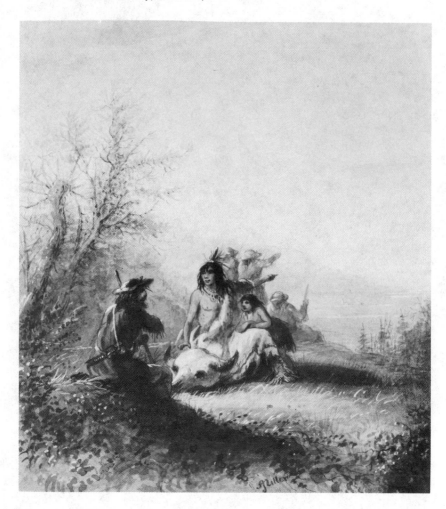

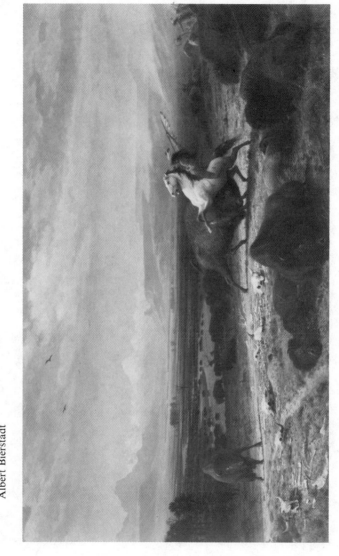

Fig. 41. *Last of the Buffalo*, Albert Bierstadt, 1888
Oil
Corcoran Gallery of Art, Washington, D.C. Gift of Mrs.
Albert Bierstadt

Notes

Chapter 1

1. Clarence Alvord ("The Daniel Boone Myth," *Journal of the Illinois State Historical Society,* 19 [1926], 18) points out, for example, that "during the hundred years preceding Boone's famous exploration in 1769, the land called Kentucky had been visited by many hundreds of white men, explorers, hunters, speculators, geographers, soldiers, and was consequently extremely well-known." Alvord also explains that Boone was not solely responsible for settling the region, but that he was merely the "employee of a land jobber and the companion of the innumerable surveyors and other agents of speculators who swarmed over Kentucky" (p. 28).

 Simon Kenton and James Harrod did receive special attention in early accounts of Kentucky history, such as that of Humphrey Marshall (see above, p. 9), but they have never had the imaginative appeal as subjects of literature and the visual arts that Boone has enjoyed.

2. For a thorough discussion of the origin and development of the Boone myth, see Richard Slotkin, *Regeneration Through Violence: The Mythology of the American Frontier, 1600-1860* (Middletown, Conn.: Wesleyan University Press, 1974), especially Chapters 9 and 10. Compare Henry Nash Smith's succinct overview of Daniel Boone's role in the American imagination, in *Virgin Land: The American West as Symbol and Myth* (1950; rpt. Cambridge Mass.: Harvard University Press, 1970), Chapter 5.

3. The original edition was published in Wilmington, Delaware by James Adams. It is available in a facsimile edition, edited by Willard Rouse Jillson, *Filson's Kentucke: A Reproduction of the Original Wilmington Edition of 1784* (Louisville, Ky.: John P. Morton & Co., 1929).

4 . The Boone narrative appeared separately in editions published in Norwich (1786) and Hartford (1794). The French and German editions of Filson's entire book (including the history of Kentucky as well as the Boone narrative) were published in Paris (1785) and Leipzig (1790), respectively. See the bibliography in Slotkin, *Regeneration Through Violence*, pp. 601-2, for the various eighteenth and nineteenth century editions. In addition, Marshall W. Fishwick mentions an edition of Filson's work published in Philadelphia in 1787 ("Daniel Boone and the Pattern of the Western Hero," *Filson Club History Quarterly*, 17 [1953], 125).

5. Slotkin, *Regeneration Through Violence*, pp. 314-20; Fishwick, "Daniel Boone and the Pattern of the Western Hero," p. 125.

6. Jillson, ed., *Filson's Kentucke,* pp. 53-54.

7. Roderick Nash and Leo Marx have each written a thorough study of American attitudes towards nature. Nash, in his *Wilderness and the American Mind,* rev. ed. (New Haven, Conn.: Yale University Press, 1973), Chapter 4, discusses American attitudes towards the wilderness as revealed in the novels of James Fenimore Cooper and the paintings and statements of Thomas Cole and others. He points out some of the evidence for their ambivalent feelings. Leo Marx, in *The Machine in the Garden: Technology and the Pastoral Ideal in America* (New York: Oxford University Press, 1967), approaches the American concept of the relation of the wilderness and civilization from the other side—that is, by examining Americans' attitudes towards technology; and again he finds a lack of consensus and conflicting feelings within single individuals.

8. Jillson, ed., *Filson's Kentucke,* p. 49.

9. For a discussion of Byron's description of Boone in relation to a painting by Thomas Cole, see above, p. 10. Some time in the decade of the 1830s, an American poet, William Ross Wallace, wrote a poem entitled "Daniel Boone," which seems to draw its inspiration from Byron. See William J. Coggeshall, *The Poets and Poetry of the West* (Columbus, Oh.: Follett, Foster & Co., 1860), pp. 228-29.

10. Apparently a French artist, Jean Francois de Vallee, painted a watercolor portrait of Boone in 1816. See *American Art: From the Limners to the Eight,* Exhibition catalogue (Huntington, W. Va.: Huntington Galleries, 1976), Cat. No. 9, p. 16. The watercolor, which is signed and dated, belongs to a private collector. It was probably not widely known during the nineteenth century and therefore had little, if any, influence on subsequent Boone imagery.

11. *A Sketch of Chester Harding, Artist, Drawn by His Own hand,* ed. Margaret E. White (1929; rpt. New York: DeCapo Press, 1970), pp. 26-27. This book is based on Harding's *My Egotistography,* first published in 1866.

12. Most of the information concerning the known extant portraits of Daniel Boone has been gathered by Roy T. King and published in his article, "Portraits of Daniel Boone," *Missouri Historical Review* 33 (1938-39), 171-83. According to the data presented therein, no portrait predates 1820, although in the cases of the portraits by John James Audubon and Thomas Sully, definitive dates have not been determined. King did not know of the portrait by Vallee, which, if it is indeed a likeness of Boone, would in fact be the earliest portrait of the pioneer.

13. An exception might be John James Audubon's portrait of Boone, which was probably done from the artist's memory of his meeting with the pioneer (Ibid., p. 177).

14. See, for example, the portraits discussed by Charles Coleman Sellers in his book, *Benjamin Franklin in Portraiture* (New Haven, Conn.: Yale University Press, 1962), including a pastel portrait by Jean Baptiste Greuze (1777), an oil portrait by Joseph Duplessis (1778), and various engraved portraits based on the latter.

15. The Jefferson portrait by Peale was never engraved, but was on public display in the Peale Museum until 1854. See *Catalogue of American Portraits in The New York Historical Society* (New Haven, Conn.: Yale University Press, 1974), I, Cat. No. 1052, p. 401. Harding tells us in his autobiography that sometime before his meeting with Boone he had made a trip to Philadelphia to study art (*A Sketch of Chester Harding,* p. 24). He undoubtedly visited the Peale Museum at that time and could have seen the Jefferson portrait.

16. Mariana Jenkins, *The State Portrait, Its Origins and Evolution,* Monographs on Archaeology and Fine Arts sponsored by the Archaeological Institute of America and The

College Art Association of America, (New York: College Art Association in conjunction
with the *Art Bulletin,* 1947), p. 41.

17. Sellers, *Benjamin Franklin in Portraiture,* pp. 70-71, 132.

18. See, for example, the portraits of Boone at the beginning of articles on the pioneer by
Charles B. Seymour in his *Self-Made Men* (New York: 1858), and by A. D. Jones in
American Portrait Gallery (New York: 1869), the rather crude portrait frontispiece of the
1856 edition of Timothy Flint's biography of Boone, *The First White Man of the West,
or the Life and Exploits of Col. Dan'l Boone, the First Settler of Kentucky* (Cincinnati:
Applegate & Co.); or Y.W. Berry's portrait, engraved and reproduced in the Cincinnati
Western Magazine, I (1833), facing p. 95. These portraits follow a common pattern of
depicting Boone hatless, facing left, dressed in a fur trimmed jacket, with a white shirt,
and more or less resembling the facial features of Harding's portrait.

19. Boone died on September 26, 1820. Notices announcing the intended publication of a
full-length portrait engraving of Boone appeared in issues of the *Missouri Republican* in
October, 1820, and in the September 30 and October 14, 1820 issues of the St. Louis *En-
quirer.* It is not known whether the original design by Harding was a painting or a draw-
ing. The advertisements of the intended publication of the portrait stated that the print
was to be taken "from a characteristic and correct painting" (King, "Portraits of Daniel
Boone," p. 173). There is a full-length portrait of Boone attributed to Harding in the
Louisville Free Public Library. Although it is in very poor condition it is clearly not the
model for the engraving, as it depicts Boone seated.

20. The tradition can be traced back through the seventeenth century hunting portraits by
Velasquez and van Dyke, to English precedents of the sixteenth century. See the discus-
sion of van Dyke's *Charles I at the Hunt* by Julius Held, "Le Roi a la Chasse," *Art
Bulletin,* 40 (1958), 139-49. Before the eighteenth century, the hunting portrait remained
almost exclusively the prerogative of royalty or the aristocracy. In England in the
eighteenth century, however, wealthy gentlemen began to have themselves painted
out-of-doors and in hunting costume. In the hands of an artist like Thomas
Gainsborough these portraits achieved a refreshing informality, which Harding's portrait
resembles in spirit.

21. Larry Koller, *The Fireside Book of Guns* (New York: Simon Schuster, 1959), p. 39.
At the time of Harding's portrait, the weapon was known simply as "the long rifle."
The name Kentucky rifle did not become current until later in the nineteenth century,
and probably refers to its association with the Kentucky frontiersmen who used it,
rather than to its place of origin. Most of the rifles that fit into the category of the long
rifles were manufactured in Pennsylvania or in other areas outside the Kentucky ter-
ritory.

22. See Charles D. Lowery, "The Great Migration to the Mississippi Territory, 1798-1819,"
Journal of Mississippi History, 30 (1968), 173-92.

23. John William Ward discusses this legend and its significance in Chapter 2 of his book,
Andrew Jackson: Symbol for an Age (1962; rpt. Oxford; Oxford University Press,
1973). He points out the fictionalized elements of the story of the Battle of New Orleans
and sets them against the facts as we can best determine them. Ward's thesis is that the
legend about the Kentucky hunters arose in response to a prevailing attitude towards
nature, and "a persistent tendency in American thought to account for the development
of the United States by appeals to nature and the frontier" (p. 29). For an extensive

study of the Kentucky backwoodsman and his significance to nineteenth century American thought, see Arthur K. Moore, *The Frontier Mind* (1957; rpt. New York: McGraw -Hill, 1963).

24. Ward, *Andrew Jackson,* pp. 13-14. See also B. A. Botkin, ed., *A Treasury of American Folklore* (1944; rpt. New York: Crown Publishers, 1955), pp. 9-12.

25. The original design by Longacre is a sepia drawing, now in the New York Historical Society (see *Catalogue of American Portraits*, I, Cat. No. 204, p. 87). Given the fact that Longacre had engraved Harding's *Boone in a Fur Collar*, it is possible that the engraver also had access to Harding's original full-length portrait, creating from it his own variation.

26. The firm which published the Texas banknote—Draper, Tappan and Longacre—was established in 1838. However, King cites an 1837 series of Missouri State Bonds which bear the same image ("Portraits of Daniel Boone," p. 181).

27. An inscription states that the painting from which the engraving was made was owned by J. K. Paulding, but this original has not been located. An undated watercolor copy of the design (taken either from the original painting or from the engraving) was made by a Miss Chesney. The engraver Redfield exhibited the print at the National Academy of Design in New York in 1836.

28. Jillson, ed., *Filson's Kentucke*, p. 55.

29. Humphrey Marshall had commented that "accustomed to being much alone, (Boone) acquired the habit of contemplation and self-possession." (History of Kentucky, p. 35.) Timothy Flint described Boone as "essentially a poet" who "loved nature...with the intensest admiration. He never wearied of admiring the charming natural landscapes spread before him..."(*Biographical Memoir of Daniel Boone, the First Settler of Kentucky* Cincinnati, 1845, pp. 64-65.)

30. King, "Portraits of Daniel Boone," pp. 172-73. Apparently Harding's portrait was allowed to deteriorate until the artist managed to salvage it in 1861, at which time he had to have extensive repairs and repainting done by one of his assistants.

31. The engraving after Chappell's design is accompanied by the legend, "From the original painting by Chappell in the possession of the publishers," but this original has not been located.

32. In the portrait, Audubon appears to be in his late 50s. He was born in 1785.

33. Another example of the motif occurs in a photograph of the German artist and naturalist Balduin Mollhausen, who posed "in frontier costume"—i.e. buckskins—with rifle seated on a rock in front of a painted landscape backdrop. Mollhausen served as naturalist and topographer on a U. S. Government expedition to the West in 1853. It seems likely that he consciously wished to imitate Audubon in this photographic portrait. The photo is reproduced in Preston A. Barba, *Balduin Mollhausen, The German Cooper* (University of Pennsylvania, 1914; *Americana Germanica*, Vol. 17). Robert Taft discusses Mollhausen in *Artists and Illustrators of the Old West, 1850-1900* (New York: Charles Scribner's Sons, 1953), Chapter 2.

34. C. W. Webber, *The Hunter-Naturalist: The Romance of Sporting* (Philadelphia: Grambo & Co., 1852), p. 4.

35. Ibid., p. 161.

36. For a full discussion of the history of the white man's attitudes towards the Indian, see Roy Harvey Pearce, *Savagism and Civilization: A Study of the Indian and the American Mind,* rev. ed. (Baltimore, Md.: The Johns Hopkins Press, 1965). Slotkin *(Regeneration Through Violence,* Chapters 1-5) also discusses the Puritan experience in the wilderness and with the Indian, and traces the evolution of their thinking as revealed in sermons, captivity narratives, and accounts of Indian wars. See also Ellwood Parry, *the Image of the Indian and the Black Man in American Art, 1590-1900* (New York: George Braziller, 1974), Chapter 2, for a discussion of colonial attitudes as reflected in visual images of the late seventeenth and eighteenth centuries.

37. Slotkin, *Regeneration Through Violence,* Chapters 2-5. Pearce discusses the evolution of the captivity narrative in his article "The Significance of the Captivity Narrative," *American Literature,* 19 (1947-48), 1-20. His approach, however, is to examine the narratives chiefly as a literary form.

38. Samuel Y. Edgerton, Jr., in his article, "The Murder of Jane McCrea: The Tragedy of an American *Tableau d'Histoire,"* Art Bulletin, 47 (1965), 481-92, discusses the origin of the theme, its popularity and significance in American literature, and its various representations in nineteenth century American art, particularly Vanderlyn's version. See also Parry's discussion of the theme and its relation to political cartoons of the War of 1812, and to an incident from Cooper's Leatherstocking Tales *(The Image of the Indian and the Black Man,* pp. 58-63).

39. See the examples cited by Edgerton ("The Murder of Jane McCrea," *passim).* Of the illustrations of the Jane McCrea theme, only the engraving published in Joel Barlow's *Columbiad* (1807) predates the example from Marshall's book. Other illustrations of Indian attacks, however, appeared before 1812, one very interesting example being an illustration from P. Gass's *Journal of the Voyages and Travels of Capt. Lewis and Capt. Clarke* (1810), depicting Clark shooting at Indians. The general format, and even the style of this illustration is reminiscent of the frontispiece in Marshall's *History.*

40. The idea of depicting contemporary history was in itself a fairly novel development of the late eighteenth century, as Edgar Wind has shown in his classic study, "The Revolution of History Painting," *Journal of the Warburg and Courtauld Institutes,* 2 (1938-39), 116-27. Benjamin West was the first to paint a contemporary event using contemporary costumes in his renowned *Death of General Wolfe;* but his influence made a greater impact in Europe than in America. Even his ambitious American student, John Trumbull, who undertook to paint the great events of the American Revolution, achieved only moderate success, and the project took him years to complete. Lloyd Goodrich, in summarizing American history painting, concluded that after West and his school there was virtually no school of American history painting, and that "more than the painters, it was the illustrators and printmakers who were the visual recorders of American history" ("The Painting of American History: 1775-1900," *American Quarterly,* 3 (1951), 286 ff.).

41. The painting is listed in one of Cole's notebooks (now belonging to the Detroit Institute of Arts) under the date of 1826 as "Col. Boon sitting at the door of his cabin—Gentleman from Hartford $75." It was exhibited at the Boston Atheneum in 1827 as "Col. D. Boone—the first settler in Kentucky." It is now known as *Daniel Boone and His Cabin at Great Osage Lake.*

42. See Cole's list of possible subjects in his sketchbook in the New York State Library at Albany, published by William Merritt in *Studies on Thomas Cole, An American Roman-*

ticist, Baltimore Museum of Art Annual II (Baltimore, Md.: Baltimore Museum of Art, 1967), pp. 82ff. Cole kept the list from 1827 until his death in 1848. It includes the following entries: "Byron's Darkness—volcano light" and "A scene from Byron's Manfred." The latter was painted in 1833. For a fuller discussion of the relation of Byron's poetry to Cole's painting, and particularly to his *Course of Empire* series, see Alan P. Wallach, "Cole, Byron and *The Course of Empire,*" *Art Bulletin,* 50 (1968), 375-79.

43. Susan Kuretsky, "Rembrandt's Tree Stump: An Iconographic Attribute of St. Jerome," *Art Bulletin,* 56 (1974), 571-80.

44. Quote in Louis Legrand Noble, *The Life and Works of Thomas Cole,* ed. Elliot S. Vessell (Cambridge, Mass.: The Belknap Press of Harvard University Press, 1964), p. 41. Noble's biography of Cole was first published in New York in 1853.

45. Irma B. Jaffe, *John Trumbull, Patriot-Artist of the American Revolution* (Boston: New York Graphic Society, 1975), p. 324. The full inscription reads: "Painted on a Kit Kat Cloth/London 1784 May--/ 'And look thro' Nature, up to Nature's God.'/ April 19th 1782/ J.T." It will be remembered that Trumbull was one of Cole's early mentors after the young artist had moved to New York in 1825. It is therefore not unreasonable to postulate that Cole had actually seen Trumbull's painting or the drawing, and had possibly discussed its meaning with the artist.

46. Listed as No. 3 on Cole's list of subjects *(Studies on Thomas Cole,* p. 84). At about the same time Cole proposed painting the subjects of the "Children of Israel in the Wilderness," and "Hagar in the Wilderness."

47. Charles H. Brown, *William Cullen Bryant* (New York: Charles Scribner's Sons, 1971), pp. 136-37. For a full discussion of the close ties that developed between artists and writers in New York during the nineteenth century, see James T. Callow, *Kindred Spirits: Knickerbocker Writers and American Artists, 1807-1855* (Chapel Hill, N.C.: University of North Carolina Press, 1967).

48. *Poems of William Cullen Bryant* (London: Oxford University Press, 1914), pp. 67-68.

49. Joseph Story, *The Power of Solitude: A Poem in Two Parts,* new and improved ed. (Salem, Mass.: Bernard B. Macanulty, 1804), pp. 55-56.

50. There is a preparatory drawing for Cole's painting depicting an Indian seated on a rock in a pose identical to that of Boone in the finished painting. In the left corner is a study for the head of Boone, who wears an expression of intense concentration. An inscription on the sheet reads, "For the picture of Col. Boon Sitting at the Door of His Cabin." Appropriating the pose and costume of the seated Indian for his figure of Boone, Cole made one significant change in the position of the head: the profile view of the Indian becomes a frontal view of Boone in the painting. Furthermore, Cole softened the rather fierce expression of the first drawing of Boone's head, creating the less focussed stare of one whose thoughts are inwardly directed. The drawing is discussed by Charles H. Morgan and Margaret C. Toole, "Notes on the Early Hudson River School," *Art in America,* 39 (1951), 167-68; and by Ellwood C. Parry, III, "Thomas Cole and the Problem of Figure Painting," *American Art Journal,* 4 (1972), 73.

Parker Lesley, in his article "Thomas Cole and the Romantic Sensibility," *Art Quarterly,* 5 (1942), p. 206, believes that the figure of Boone in the painting was "certainly adopted from a life model in the National Academy of Design"; but life-drawing classes at the Academy did not begin until the winter of 1826-27, presumably after Cole had completed his painting. Parry (pp. 73-74) suggests that for the drawing Cole may have used a model he hired in New York.

The pose of the Indian in the drawing and of Boone in the painting was a common one, and was adopted to many uses. We have already seen it in portraits of "hunter-naturalists" (see above, p. 8).

51. The relief was executed in 1826–27. See *Compilation of Works of Art and Other Objects in the United States Capitol* (88th Congress, 2d Session, House Document No. 362; Washington, D.C.: United States Printing Office, 1965), p. 290.

52. For a brief account of the history of the commission, see Glenn Brown, *History of the United States Capitol* (1900; rpt. 2 vols. in 1, New York: DaCapo Press, 1970), p. 75.

53. The subjects, artists, dates, and locations of the four panels are as follows:
 William Penn's Treaty with the Indians by Nicholas Gevelot, 1826–27; North door.
 Conflict of Daniel Boone and the Indians, by Enrico Causici, 1826-27; South Door.
 The Landing of the Pilgims, by Enrico Causici, 1825; East door.
 The Preservation of Captain John Smith by Pocahontas, by Antonio Capellano, ca. 1825; West door.

54. Albert K. Weinberg, *Manifest Destiny: A Study of Nationalist Expansionism in American History* (1935; rpt. Chicago: Quadrangle Books, 1963), p. 72. Pearce *Savagism and Civilization,* pp. 59–60) points out that Americans rationalized removal by various arguments, chiefly contending that contact with white civilization tended to lower the standards of Indians, and thus it was to their benefit to be removed beyond the influence of the white man. Nonetheless, the basic assumption was that if the Indian could not be "civilized" (i.e., conformed to the white man's way of life), he had no right to the land that belonged inevitably to advancing civilization.

55. *Register of Debates in Congress,* 18th Cong., 2d Sess, 1825, I, 639–40. The Removal Bill was passed in 1830. For a discussion of the Indian Removal policy, see Pearce, *Savagism and Civilization,* Chapter 2; Weinberg, *Manifest Destiny,* passim; and Arthur Alphonse Ekirch, Jr., *The Idea of Progress in America, 1818-1860* (New York: Peter Smith, 1951), pp. 44ff.

56. The most thorough modern study of westward expansion is Ray Allen Billington's *Westward Expansion: A History of the American Frontier,* 3rd ed. (New York: Macmillan, 1967). See his comprehensive bibliographical essay for further references and for specialized studies of individual topics in expansionism.

57. The classic study of Manifest Destiny is Albert Weinberg's, cited above, n. 54. Compare Frederick Merk's *Manifest Destiny and Mission in American History: A Reinterpretation* (New York: Vintage Books, 1966).

58. John M. Peck, *Life of Daniel Boone,* in Jared Sparks, ed., *The Library of American Biography* (Boston: Charles C. Little and James Brown, 1847), 2nd ser., Vol. 13, pp. 24–25. Cecil B. Hartley as early as 1859 suggested the connection between the painting and Peck's description. (See Hartley's *Life and Times of Colonel Daniel Boone,* p. 47.)

59. For details on Ranney's life, plus a catalogue of his known paintings, see Francis Grubar, *William Ranney, Painter of the Early West* (Washington, D.C.: Corcoran Gallery of Art, 1962).

60. The subject is listed as No. 118 on Cole's list of subjects *(Studies on Thomas Cole,* p. 99). No. 109 on the list—"Cross in the wilderness"—was executed in 1845, and presumably his idea for the Boone subject dates from after that date.

61. Henry T. Tuckerman, "Over the Mountains, or The Western Pioneer," *The Home Book of the Picturesque* (New York: G.P. Putnam, 1852), p. 117.

62. George Canning Hill, *Daniel Boone, the Pioneer of Kentucky* (Philadelpha, 1865), title page.

63. The use of the Indian as a personification of the American continent developed in European imagery of the sixteenth and seventeenth centuries. See Hugh Honour, *The New Golden Land: European Images of America from the Discoveries to the Present Time* (New York: Pantheon Books, 1975), Chapter 4. Ellwood Parry, however, points out that use of an Indian princess as a personification of America became less frequent after the Revolutionary War *(The Image of the Indian and the Black Man in American Art,* p. 68).

64. Ranney depicted this incident from Washington's life in a drawing owned by one of the artist's descendents (Mr. Claude J. Ranney of Malvern, Pennsylvania). A finished painting, *Washington and Gist Crossing the Allegheny River* (Pittsburgh, Mellon Collection) does not highlight the rescue. See Grubar, *William Ranney,* Cat. Nos. 134 and 81.

65. Timothy Flint, *Biographical Memoir of Daniel Boone,* pp. 62–63. There were several editions of Flint's biography, the original being published in 1833. This early edition is accessible today in an edition edited by James K. Folsom (New Haven, Conn.: College and University Press, 1967).

66. Quoted in Grubar, *William Ranney,* Cat. No. 66, p. 41, from the New York *Herald,* May 23, 1853.

67. Grubar, *William Ranney,* Cat. No. 71, p. 42. The painting of 1853 depicts an older trapper leading his horse through the snow. Since Squire Boone's journey took place in the summer, it is not likely that Ranney intended this painting to illustrate that incident from Boone's career. For a brief discussion of the 1853 painting in relation to trapper imagery, see above, p. 50.

68. W. H. Bogart, *Daniel Boone and the Hunters of Kentucky* (Auburn and Buffalo: Miller, Orton & Mulligan, 1854), p. 69.

69. Maurice E. Bloch, *George Caleb Bingham* (Berkeley: University of California Press, 1967), Vol. I. *The Evolution of An Artist,* pp. 120 ff; Vol. II, *A Catalogue Raisonné,* Cat. No. 219, p. 84.

70. When Bingham mentioned working on the painting in a letter to James Rollins, dated New York, March 30, 1851, he was evidently fully conscious that his choice of subject differed from Ranney's. Bingham wrote: "You wish to know what I am doing. I am now painting the *Emigration of Boone* and his family to Kentucky....The subject is a popular one in the West, and one which has never yet been painted." ("Letters of George Caleb Bingham to James S. Rollins," ed. C. B. Rollins, in *Missouri Historical Review,* 32 [1937–38], 21.)

71. Bloch, *George Caleb Bingham,* I, 16, n. 10.

72. Bingham to Rollins, September 23, 1844. Quoted in "Letters of George Caleb Bingham to James S. Rollins," pp. 13–14.

73. The *Missouri Statesman* of May 23, 1851, reviewing Bingham's painting, states that it is based on Humphrey Marshall's account in his *History of Kentucky* (Bloch, *George Caleb Bingham,* I, 126, n. 164); but Bingham could have read any one of a number of other accounts (such as those by Flint, Peck, or John McClung), all of which were similar to

Marshall's narrative and to each other. Peck's biography, published in 1847, would have been one of the more recent sources, and also a popular one readily available, which Bingham might have consulted. Describing the first attempt at emigration, Peck wrote: "At Powell's Valley, through which their route lay, they (Boone and his family) were joined by five families and forty men, all well armed. This accession of strength gave them courage, and the party advanced full of hope and confident of success.... The party had passed Wallen's Ridge, and was approaching the Cumberland Gap. Several young men, who had charge of the cattle, had fallen into the rear some five or six miles from the main body, when, unexpectedly, they were attacked by a party of Indians." (Peck, *The Life of Daniel Boone,* pp. 38–39.)

74. Bloch *(George Caleb Bingham,* I, 126–27) has pointed out a difference in backgrounds between the painting and a lithograph of the composition done in 1852 (see above, p. 22). In the lithograph, the setting is less menacing; and Bloch suggests that Bingham repainted the background after the lithograph had been made in order that his painting correspond more closely with the description of the Cumberland Valley given by Filson: "The aspect of these cliffs is so wild and horrid, that it is impossible to behold them without terror. The spectator is apt to imagine that nature had formerly suffered some violent convulsion; and that these are the dismembered remains of the dreadful shock...."

75. "Letters of George Caleb Bingham to James S. Rollins," p. 16.

76. Quoted in John Francis McDermott, "George Caleb Bingham and the American Art-Union," *New York Historical Society Quarterly,* 42 (1958), 66.

77. John Demos in his article "George Caleb Bingham: The Artist as Social Historian," *American Quarterly,* 17 (1965), 218–28, first pointed out Bingham's distaste for the squatter class. He compares this attitude, as revealed in Bingham's *Squatters,* with the artist's approach to the other classes of a nascent urban society, who are depicted favorably as a stable and settled citizenry. See also Robert F. Westervelt, "The Whig Painter of Missouri," *American Art Journal,* Vol. II, no. 1 (Spring 1970), pp. 46–53, for a discussion of a similar skepticism on Bingham's part as revealed in his Election paintings.

78. A similar interpretation of this figure has also been suggested by Slotkin, *Regeneration Through Violence,* p. 469.

79. Slotkin, *Regeneration Through Violence,* p. 469, points out this resemblance; and recently John G. Cawelti, in his essay, "The Frontier and the Native American" in the exhibition catalogue, *America As Art* (Washington, D.C.: Smithsonian Institution Press, 1976), p. 144, states of the central figures: "Their composition evokes the traditional artistic symbolism of the Holy Family on the Flight into Egypt." Further to the use of Holy Family imagery in American paintings of pioneers, see Chapter 3, pp. 61–63.

80. Peck's biography of Boone contains the following tribute to pioneer wives, included in his account of Boone's 1773 attempt at emigration: "...The wives of our western pioneers are as courageous, and as ready to enter on the line of march to plant the germ of a new settlement, as their husbands." (Peck, *The Life of Daniel Boone,* pp. 37–38.)

81. Religious imagery was common in the rhetoric of Manifest Destiny. See Weinberg, *Manifest Destiny,* and Merk, *Manifest Destiny and Mission, passim.* See also below, Chapter 3.

82. The full text of the dedication is given in a letter from Mrs. Hattie Cannon of July 15, 1932 to the Filson Club, Louisville, Kentucky. (See Filson Club files, s.v. "Boone, Daniel —Portraits, Relics, etc.")

83. The choice of viewpoint is often a significant factor in the interpretation of Bingham's paintings. See Chapter 2, p. 42, for a discussion of Bingham's *Fur Traders Descending the Missouri* and the significance of the viewpoint.

84. Bloch, *George Caleb Bingham,* I, 126. Bingham's painting was the first American work for which Goupil purchased the reproduction rights, a fact which gives some indication of its status.

85. Letter from Bingham to Rollins, June 3, 1857, quoted in "Letters from George Caleb Bingham to James S. Rollins," p. 353.

86. Ibid., p. 365.

87. Quoted in Justin G. Turner, "Emanuel Leutze's Mural *Westward the Course of Empire Takes Its Way,*" *Manuscripts,* Vol. 18, no. 2 (Spring 1966), p. 15.

88. There are two oil studies for the mural: one in the National Collection of Fine Arts in Washington, D.C., and one in the Gilcrease Institute in Tulsa. In the former, the portraits appear to either side of the lower panel, and the names of Boone and Clark are inscribed above them. In the latter study, the portraits are also included, but they are not labelled.

Chapter 2

1. Literature on the fur trade written in this century is plentiful, and only a few titles can be mentioned here. Hiram Chittenden's *American Fur Trade of the Far West,* 2 vols. (1902; rpt. Stanford, Ca.: Academic Reprints, 1954) remains one of the most complete histories of the fur trade to date. Other important studies include Robert Class Cleland, *This Reckless Breed of Men: The Trappers and Fur Traders of the Southwest* (New York: Alfred A. Knopf, 1950); Bernard DeVoto's popular and very readable account in *Across the Wide Missouri,* Sentry ed. (Boston: Houghton Mifflin Co., 1947); Le Roy Hafen's many book-length studies of trappers, explorations, and western travels; and John E. Sunder, *The Fur Trade on the Upper Missouri* (Norman, Ok.: University of Oklahoma Press, 1965).

2. Washington Irving, *The Adventures of Captain Bonneville,* forward by Alfred Powers (Portland, Ore.: Benfords and Mort, n.d.), p. 144. The original edition was published in 1837.

3. As Henry Nash Smith has pointed out in his study, *Virgin Land: The American West as Symbol and Myth* (1950; rpt. Cambridge, Mass.: Harvard University Press, 1970), the dream of discovering a northwest "passage to India" (i.e. the rich markets of the Orient) had been one of the forces motivating western exploration on the American continent from the time of the Spanish explorers in the sixteenth century. It may have been one of the factors in Thomas Jefferson's mind when he negotiated the Louisiana Purchase. During the era of fur trade explorations—the 1820s and '30s—the aim of various expeditions to the Far West was to search for routes across the Rocky Mountains to the Pacific coast,

a land of abundance considered a desirable goal in itself. For a thorough discussion of the role of the fur trade in western exploration, see William H. Goetzmann, *Exploration and Empire: The Explorer and the Scientist in the Winning of the American West* (New York: Alfred A. Knopf, 1971), Chapters 4 and 5.

4. Astor established a colony on the Pacific Coast specifically for the purpose of trading furs in the Pacific Northwest. In writing his history of the enterprise, Irving had access to Astor's private papers, and so his book remains even today an authoritative, if biased, account. Chittenden's account of the Astorian venture is perhaps more objective, but it still relies heavily on Irving's work for its basic facts. Edgeley Todd's introduction to the 1964 edition of *Astoria* (Norman, Ok.: University of Oklahoma Press) contains much helpful information.

5. The literature is so vast that a full bibliography cannot be included here. See Henry R. Wagner, *The Plains and the Rockies: A Bibliography of Original Narratives of Travel and Adventure, 1800-1865,* 3rd ed., rev. Charles L. Camp (Columbus, Oh.: Long's College Book Company, 1953).

6. Washington Irving, *Astoria,* pp. 3, 32.

7. George Frederick Ruxton, *Adventures in Mexico and the Rocky Mountains,* new ed. (London: John Murray, 1861), p. 111. The first edition was published in 1847.

8. Ruxton, *Life in the Far West,* ed. LeRoy Hafen (Norman, Ok.: University of Oklahoma Press, 1951), p. 51. Ruxton's book was first published serially in *Blackwoods Edinburgh Magazine* in 1848. It appeared in book form in England and in America first in 1849, and went through several editions in both countries. It was obviously a highly popular and successful work. Ruxton, however, was not an American, but a Scot.

9. David H. Coyner, *The Lost Trappers,* ed. David J. Weber (Albuquerque, N.M.: University of New Mexico Press, 1970), pp. 153, 82. The book was first published in 1847.

10. W. A. Ferris, *Life in the Rocky Mountains,* ed. Paul C. Phillips (Denver: Old West Publishing Co., 1940), p. 41. Ferris' account was originally published serially in the *Western Literary Messenger* from January 1843 through May 1844.

11. Ruxton, *Adventures in Mexico and the Rocky Mountains,* pp. 241-42.

12. Goetzmann, in *Exploration and Empire,* pp. 106-9, identifies two stereotypes that evolved to describe the mountain man: the exotic Byronic image, and the pathetic image of the fur trapper as a symbol of the disappearing wilderness. Both of these images essentially fit into the category of romantic hero. Goetzmann proposes that the mountain man was actually a Jacksonian entrepreneur (an "expectant capitalist"), and as such was closely identified with the national destiny. However, Harvey L. Carter and Marcia C. Spencer argue against this latter identification of the trapper as a Jacksonian capitalist in their article, "Stereotypes of the Mountain Man," *Western Historical Quarterly,* Vol. 6, no. 1 (Jan. 1975), pp. 17-32.

13. Chittenden, *The American Fur Trade,* I, 379-80, Sunder, *The Fur Trade on the Upper Missouri,* pp. 23-24.

14. Catlin made his trip in the summer of 1832; Bodmer in 1833; Miller in 1837; and Audubon in 1843.

15. Miller, like Catlin and Bodmer, also studied and sketched the Indians he met during his trip. His Indian sketches and paintings were as popular among eastern patrons as his

trapper themes. See the "Account of Indian Pictures" (the notations from Miller's account book from 1846 to 1874), appended to *The West of Alfred Jacob Miller,* rev. and enlg., ed. Marvin C. Ross (Norman Ok.: University of Oklahoma Press, 1968), pp. lv–lix, which lists various sets of "Indian scenes" and "Indian sketches."

16. John C. Ewers gives a thorough account of the trips of Catlin and Bodmer (as well as that of Miller) in his *Artists of the Old West,* enl. ed. (Garden City, N.Y.: Doubleday and Co., 1973), Chapters 6, 7, and 8. Catlin's famous Indian Gallery of paintings resulted from his trip; the products of Bodmer's excursion with Prince Maximilian were his illustrations for Maximilian's *Travels in North America.*

17. For an account of Stewart's life and career, see Odessa Davenport and Mae Reed Porter, *Scotsman in Buckskin: Sir William Drummond Stewart and the Rocky Mountain Fur Trade* (New York: Hastings House, 1963).

18. The best account of Miller's trip is the one by Ewers in *Artists of the Old West,* pp. 98–117. See also the introduction by Marvin Ross in *The West of Alfred Jacob Miller.*

19. Miller completed several oil paintings in New Orleans immediately following his return from the west. These paintings were exhibited in Baltimore in 1838. It is not known how many of them were done for Stewart; but in the following year in New York Miller exhibited 18 paintings which were reported to be "the property of Sir Wm. D. Stewart." In 1840 Miller went to Scotland to visit Stewart at Murthly, Stewart's castle, and to complete more paintings, among them a version of *The Trapper's Bride,* which was discussed in detail above, pp. 39–41.

20. See the "Account of Indian Pictures," in *The West of Alfred Jacob Miller,* pp. lv–lix.

21. Walters's personal collection of art forms the core of the Walters Art Gallery in Baltimore, Md., where the watercolors done by Miller are now located. The entire set of two hundred watercolors has been reproduced in *The West of Alfred Jacob Miller,* along with the commentaries by Miller to each one. Miller painted other sets of watercolors—for Stewart, and for an Alexander Brown of Liverpool. The latter set is now in the Public Achives of Canada in Ottawa, and is reproduced in *Braves and Buffalo: Plains Indian Life in 1837,* intro. Michael Bell, The Public Archives of Canada Series, No. 3 (Toronto: University of Toronto Press, 1973).

22. DeVoto, in *Across the Wide Missouri,* p. 309, points out similarities between Miller's commentaries and Ruxton's work. Comparisons can also be made with Irving's *Adventures of Captain Bonneville.* For example, Miller refers to the rendezvous as a "saturnalia" in his commentary to Watercolor No. 110 of the Walters Collection; and Irving had used this same term to describe these festivities (p. 144).

23. See the introduction by Ross in *The West of Alfred Jacob Miller,* pp. xiv–xv.

24. Irving, *Adventures of Captain Bonneville,* p. 9.

25. *The West of Alfred Jacob Miller,* No. 1.

26. The notion that decay and corruption accompanied civilization was, of course, one of the fundamental assumptions of primitivism in the eighteenth century. See Roy Harvey Pearce's discussion in *Savagism and Civilization: A Study of the Indian and the American Mind* (Baltimore, Md.: The John Hopkins Press, 1967), pp. 136ff; also Lois Whitney, *Primitivism and the Idea of Progress in English Popular Literature of the Eighteenth Century* (New York: Octagon Books, Inc., 1965), especially Chapter 2.

27. *The West of Alfred Jacob Miller,* No. 29.

28. Ibid., No. 157.

29. The sepia drawing, along with other sketches done by Miller on his 1837 trip, are part of the Northern Natural Gas Collection in the Joslyn Museum, Omaha, Nebraska.

30. *The West of Alfred Jacob Miller,* No. 27.

31. In his commentary (Ibid., No. 67) Miller identifies one of the trappers as Black Harris, a notorious mountaineer whom Miller had personally met during his trip west in 1837.

32. The artist's account book lists the subject four times between 1846 and 1870, in addition to the watercolor included in the Walters set (Ibid., pp. lv–lix).

33. Roger B. Stein, *Seascape and the American Imagination* (New York: Clarkson N. Potter, Inc., in association with the Whitney Museum of American Art, 1975), p. 40.

34. George Wilkins Kendall, *Narrative of the Texan Santa Fe Expedition* (1844; rpt. Chicago: The Lakeside Press, 1929), pp. 204–5.

35. The "Account of Indian Pictures" lists two "Indian Brides" in 1836, which may or may not be the same subject as "The Trapper's Bride." The latter title is listed twice, in 1850 and 1856. Adding the version done for Stewart and Walters, we arrive at a total of at least four, and possibly six, paintings of the theme. See *The West of Alfred Jacob Miller,* pp. lv–lvi.

36. Ibid., No. 22.

37. The classic study of white attitudes towards the American Indian in the eighteenth and nineteenth centuries is Pearce's *Savagism and Civilization.* Bernard W. Sheehan's *Seeds of Extinction: Jeffersonian Philanthropy and the American Indian* (Chapel Hill, N.C.: University of North Carolina Press, 1973) is a very fine study of American thinking and policy with regard to the Indian during the same period, focussing particularly on the thought of Jefferson and his followers. Sheehan examines the idea of racial intermarriage and its role in Jefferson's proposed policies in Chapter 4, pp. 162ff. and 174ff. Richard Slotkin, in *Regeneration Through Violence: The Mythology of the American Frontier, 1600–1860* (Middletown, Conn.: Wesleyan University Press, 1974) examines the methaphorical and mythical implications of the theme, particularly as they were manifested in Puritan communities.

38. In his letter to Sir Thomas Dale, written in 1614, Rolfe said: "Let therefore this my well advised protestation, which here I make betweene God and my own conscience, be a sufficient witness, at the dreadfull day of judgement... to condemne me herein, if my chiefest intent and purpose be not, to strive with all my power of body and mind, in the undertaking of so mightie a matter, no way led... with the unbridled desire of carnall affection: but for the good of this plantation, for the honour of our countrie, for the glory of God, for my owne salvation, and for the converting of the true knowledge of God and Jesus Christ, an unbeleeving creature, namely Pokahuntas." (Quoted in Malcomb E. Washburn, ed., *The Indian and the White Man,* Documents in American Civilization Series [Garden City, N.Y.: Doubleday & Company, Inc., 1964], p. 22.)

39. For a brief historical review of miscegenation laws, see the dissenting opinion of Justice Shenk in the landmark California case of *"Perez v. Lippold," Pacific Reporter,* 2nd series, Vol. 198 (1949), pp. 38-39.

40. Sheehan, *Seeds of Extinction,* pp. 176–77. Sheehan points out also that in 1784 Patrick Henry introduced legislation in the Virginia House of Delegates that would have given free education, tax benefits, and bounties for children to anyone who would marry an Indian. See also Slotkin's discussion of William Byrd's advocacy of racial intermarriage in *Regeneration Through Violence,* pp. 215–17.

41. The most recent and thorough discussion of this debate is Antonello Gerbi's *The Dispute of the New World: The History of a Polemic, 1750-1900,* rev. and enlg., trans. Jeremy Moyle (Pittsburgh: University of Pittsburgh Press, 1973). Sheehan *(Seeds of Extinction,* Chapter 3) deals with the Jefferson-Buffon controversy as it specifically pertained to the issue of Indian-White relations; and William Peden, in his introduction and notes to Thomas Jefferson's *Notes on the State of Virginia* (New York: W. W. Norton & Company, Inc., 1972) discusses Jefferson's responses to the debate.

42 See Sheehan, *Seeds of Extinction,* pp. 68–69.

43. The definitive edition available today is the one edited by William Peden, mentioned in n. 4. above. Jefferson's answer to Query VI ("Productions Mineral, Vegetable and Animal") constitutes his major refutation of Buffon's theory of degeneracy. Jefferson devotes several paragraphs to an examination of the native American.

44. Sheehan, *Seeds of Extinction,* p. 174. Sheehan quotes a letter from Jefferson to Creek Indian agent Benjamin Hawkins: "The ultimate point of rest and happiness for [the Indians] is to let our settlements and theirs meet and blend together, to intermix, and become one people. Incorporating themselves with us as citizens of the United States, this is what the natural process of things will of course, bring on, and it will be better to promote than retard it."

45. Timothy Flint, *Recollections of the Last Ten Years, Passed in Occasional Residences and Journeyings in the Valley of the Mississippi* (1826; rpt. with introduction by James D. Norris, New York: DaCapo Press, 1968), p. 147.

46. For a discussion of the Removal policy and its effects, see James C. Malin, "Indian Policy and Westward Expansion," *Bulletin of the University of Kansas Humanistic Studies,* Vol. 2, no. 3 (Nov. 1921), entire issue.

47. Coyner, *The Lost Trappers.* p. 82.

48. Quoted in Malin, "Indian Policy and Westward Expansion," p. 88.

49. Edgeley W. Todd first pointed out the relationship between Whitman's description and Miller's painting, in his article, "Indian Pictures and Two Whitman Poems," *The Huntington Library Quarterly,* Vol. 19, no. 1 (Nov. 1955), pp. 1-11. As Todd demonstrates, there can be no question that Whitman had seen a version of the *Trapper's Bride.* In the original version of "Song of Myself" (published in 1855), the description of the trapper reads: "One hand rested on his rifle...the other hand held firmly the wrist of the red girl." Whitman changed the line in the fourth edition of Leaves of Grass to read, in part "He held his bride by the hand." This change must have been prompted by Whitman's reexamination of the painting, and by the poet's desire to describe more precisely the details of the scene as the artist had depicted it.

50. For the dating of these commissions, see the introduction by Ross in *The West of Alfred Jacob Miller,* pp. xxv, xxvii.

51. Miller studied and copied many of Raphael's paintings when he visited Italy during his European trip of 1833-34. This author has not been able to determine definitely whether

he made a copy of *The Marriage of the Virgin.* It is possible that he knew of the composition through reproductions.

52. In white society marriage implied domestication; and it might therefore be argued that the image of the trapper marrying the Indian signifies the taming of the wilderness. In Miller's depiction, however, the fact that the trapper is marrying according to Indian custom, in an Indian ceremony, suggests his assimilation with the ways of the wilderness rather than the imposition of white society on nature.

53. It should also be pointed out that from colonial times the Indian had traditionally been regarded by the white man as lacking sexual inhibitions. (See Sheehan, *Seeds of Extinction,* pp. 80-82, Slotkin, *Regeneration Through Violence,* passim.) Although marriage would signify, to a certain degree, sexual restraint as opposed to promiscuity, marriage to an Indian may have been perceived by whites (including Miller's patrons) as fundamentally a less inhibited relationship than marriage to a white woman within the customs of white society. It is true that Miller's image is a controlled and orderly composition, which would imply restraint; but it is also true that Whitman remarked on the Indian girl's "voluptuous limbs," thus giving some evidence that a contemporary observer could have seen elements within the composition that were tantalizingly suggestive.

54. The definitive work on Bingham is Maurice Bloch's two-volume work, *George Caleb Bingham;* Vol. I: *The Evolution of an Artist;* Vol. II: *A Catalogue Raisonné* (Berkeley, Ca.: University of California Press, 1967). For his discussion of the painting described here, see Vol. I. pp. 79-83, and the catalogue entry in Vol. II, pp. 52-53, No. 136.

55. There is some question as to the identity of the animal in the canoe. Bloch identifies it as a fox, as do most art historians; but John Demos, in his article, "George Caleb Bingham; The Artist as Social Historian." *American Quarterly,* 17 (1965), p. 228, suggests that the artist may have intended its identity to remain ambiguous, "so as to dramatize the feelings of wonder, of puzzlement, of both envy and suspicion with which Missouri town folk would regard these fur-traders."

56. Sunder, *The Fur Trade on the Upper Missouri,* pp. 17ff.

57. Bloch, *George Caleb Bingham,* II, Cat. No. 136, pp. 52-53. Bloch notes that the painting was called "French Trader and Half-breed Son" when it was submitted to the American Art Union in 1845.

58. Irving, *Adventures of Captain Bonneville,* pp. 13, 8.

59. Charles Lanman, *A Summer in the Wilderness* (New York: D. Appleton & Co., 1847), p. 75.

60. Flint, *Recollections of the Last Ten Years,* pp. 163-64.

61. It should be remembered, however, that with some Americans half breeds had a rather unsavory reputation as a lazy, degenerate, and generally distasteful class of men.

62. To date the best available study of Deas and his work is an article by John Francis McDermott, "Charles Deas: Painter of the Frontier." *Art Quarterly,* 13 (1950), 293-311.

63. Lanman, *A Summer in the Wilderness,* pp. 15-16.

64. Journal of Lieutenant J. Henry Carleton, quoted in McDermott, "Charles Deas," p. 302.

65. The painting, now lost, was exhibited at the American Art Union in that year (1844),

and was awarded to G. F. Everson of New York. See Mary Bartlett Cowdrey, *American Academy of Fine Arts and American Art Union, Exhibition Record* (New York: New York Historical Society, 1953), p. 103. A copy of the work (possibly done from Jackman's engraving) is located in the Yale University Art Gallery.

66. The exhibition records of the Pennsylvania Academy of Fine Arts list David's *Napoleon Crossing the Alps* each year between 1822 and 1829. In 1831, a copy by Charles B. Laurence was exhibited. See Anna Wells Rutledge. *Cumulative Record of Exhibition Catalogues of the Pennsylvania Academy of Fine Arts. 1807-1870* (Philadelphia: American Philosophical Society, 1955), p. 58. Deas may also have known the composition through reproductions. Another equestrian portrait by David—that of Count Potocki (1781)—is even closer to Deas's painting, especially in the pose of the horse; but there is not evidence to suggest that Deas could have know of this latter composition.

67. For a discussion of the state portrait, including the equestrian tradition, see Mariana Jenkins, *The State Portrait, Its Origin and Evolution.* Monographs on Archaeology and Fine Arts, sponsored by the Archaeological Institute of America and the College Art Association, III (New York: The College Art Association, in conjunction with the *Art Bulletin,* 1947).

68. In Reuben G. Thwaites, ed., *Early Western Travels,* 1748-1846 (Cleveland: Arthur H. Clark, Co., 1906), Vol. 27, pp. 239-40.

69. Ruxton, *Adventures in Mexico and the Rocky Mountains,* p. 244.

70. *The Broadway Journal,* January 4, 1845; quoted in McDermott, "Charles Deas," p. 302. To gauge the success with which Deas assimilated the equestrian tradition to his own purposes, we need only compare his Long Jakes to two other images of western characters which use a similar format, but which create a decidedly less majestic impression. The trapper of an anonymous print in the collection of the Huntington Library—a print possibly inspired by Deas's painting—appears as a dissolute antihero; while in Charles Nahl's *Lone Miner,* a lithograph of 1852, a look of greed and suspicion replaces the alertness of Deas's *Long Jakes.*

71. *The Reveille,* February 8, 1847; quoted in McDermott, "Charles Deas," p. 308.

72. According to McDermott (Ibid., p. 302-3), this painting was exhibited at the American Art Union in the winter of 1844-45.

73. There are numerous engravings of the theme from the sixteenth century, by Altdorfer, Cranach, Georg Pencz, Hans Brosamer, Heinrich Aldegrever, Hendrick Goltzius, and Jan Collaert. For these and other examples, see A. Pigler, *Barockthemen,* 2nd ed., enlg. (Budapest: Akademiai Kiado, 1974), II, 384-85.

74. See the edition by Edward A Maser, *Baroque and Rococo Pictorial Imagery: The 1758-60 Hertel Edition of Ripa's 'Iconologia'* (New York: Dover Publications, Inc., 1971), No. 35.

75. The incident was chosen as one of six episodes commemorating *Heroic Deeds of Former Times,* and published as a set of six prints designed by G. W. Fasel in 1851. See *Old Print Shop Portfolio,* Vol. 6, no. 9 (May 1947), pp. 210-11ff.

76. On the Almanacs, see *The Crockett Almanacks, Nashville Series, 1835-1838,* ed. with intro. Franklin J. Meine (Chicago: The Caxton Club. 1955).

77. Lanman, *A Summer in the Wilderness, p. 141.*

78. Irving, *Adventures of Captain Bonneville,* p. 7.

79. The painting was exhibited at the National Academy of Design in 1847. See *National Academy of Design Exhibition Record, 1826–1860* (New York: New York Historical Society, 1943), I, 116.

80. Quoted in McDermott, "Charles Deas," p. 308.

81. From the *Broadway Journal,* April 19, 1845; quoted in McDermott, "Charles Deas," p. 302.

82. The chief study of Ranney to date is Francis Grubar's catalogue, *William Ranney: Painter of the Early West* (Washington, D.C.: Corcoran Gallery of Art, 1962).

83. *The Literary World,* 2 (1847), 303.

84. Another source for the compositional format of Ranney's painting, in which horse and rider are viewed from behind and placed at an angle oblique to the picture plane, might have been Theodore Gericault's *Officer of the Imperial Guard Charging,* which would have been available to Ranney through reproductions. Ranney's composition, however, is decidedly less baroque than Gericault's.

85. The original title of the American Art Union painting was *The Last Bullet,* while the title of the painting exhibited at the Western Art Union was *The Trapper's Last Shot.* The title of the former was changed to *The Last Shot* late in 1850, and finally to *The Trapper's Last Shot.* See Francis Grubar, "Ranney's *The Trapper's Last Shot,*" *American Art Journal,* Vol. 2, no. 1 (Spring 1970), p. 95.

86. See Grubar, *William Ranney,* Nos. 188–92.

87. On the Great Plains environment, see Walter Prescott Webb, *The Great Plains* (New York: Grosset & Dunlap, 1957); also G. Malcolm Lewis, "The Great Plains Region and Its Image of Flatness," *Journal of the West,* 6 (1967), 11–26.

88. This composition was at one time identified as *Squire Boone Crossing the Mountains,* a subject discussed above (p. 18); but, as mentioned earlier, the wintry landscape precludes identification with the Boone theme.

89. This is the date given by Grubar, *William Ranney,* No. 61, p. 40, based on what is visible of the date painted on the canvas.

90. See the paintings of voyageurs by Deas, for example.

91. On Tait, see the biographical sketch by Warder H. Cadbury in the exhibition catalogue, *A. F. Tait: Artist in the Adirondacks* (Blue Mountain Lake, N.Y.: The Adirondack Museum, 1974),pp. 9–12.

92. For a complete listing of Currier and Ives prints after Tait's paintings, see Frederic A. Conningham, *Currier and Ives Prints: An Illustrated Check List* (New York: Crown Publishers, 1949).

93. For a study of the importance and evolution of plains weapons, see Webb, *The Great Plains,* pp. 167–79.

94. John C. Ewers, "The White Man's Stongest Medicine," *Bulletin of the Missouri Historical Society,* October 1967, unpaginated reprint.

95. The best account of the latter years of the fur trade is Sunder, *The Fur Trade on the Upper Missouri.* On the status of Indian-White relations during this period (1850–1870), see Malin, "Indian Policy and Westward Expansion."

96. A study for the painting belongs to the Gilcrease Institute in Tulsa, Oklahoma. See Grubar, *William Ranney,* No. 69, p. 41.

97. Ruxton, *Adventures in Mexico and the Rocky Mountains,* p. 281.

98. For Miller's campfire scenes, see watercolors Nos. 4, 36, 52, 161, 161, 162, 177, and 197 in the Walters Collection. Palmer designed two such scenes in 1866, both lithographed by Currier and Ives (see Conningham, *Currier and Ives Prints,* Nos. 6123-4). Bierstadt's paintings which include campfire scenes are *The Trapper's Camp,* 1861 (New Haven, Conn., Yale University Art Gallery) and *Camping in the Yosemite,* 1864 (San Diego, Ca., Timken Art Gallery).

99. Ray Allen Billington, *The Far Western Frontier, 1830-1860* (New York: Harper and Brothers, 1956), p. 96; Frederic E. Voelker, "The French Mountain Men of the Early Far West," in John Francis McDermott, ed., *The French in the Mississippi Valley* (Urbana, Ill.: University of Illinois Press, 1965), p. 96.

Chapter 3

1. *Niles National Register,* 57 (Nov. 30, 1839), 224.

2. Ibid., 64 (July 1, 1843), 275.

3. Charles D. Lowery, "The Great Migration to the Mississippi Territory, 1798-1819," *Journal of Mississippi History,* 30 (1968), 179-83.

4. The most comprehensive treatment of westward migration in the United States is Ray Allen Billington's *Westward Expansion: A History of the American Frontier,* which has gone through several editions. Much of the factual material in the following discussion of emigration comes from Billington's study, specifically the third edition (New York: Macmillan, 1967).

5. See various reports in *Niles National Register,* 1843-1844. Billington, in another book-length study, *The Far Western Frontier, 1830-1860* (New York: Harper & Brothers, 1956), states that caravans in 1843-44 averaged twenty to thirty wagons, but that later groups divided into parties of eight or ten wagons (p. 107).

6. Albert K. Weinberg, *Manifest Destiny: A Study of Nationalist Expansion in American History* (1935; rpt. Chicago: Quadrangle Books, 1963), p. 116. Weinberg's work remains the classic study of the era in United States history, but for a more recent study, with a somewhat modified view, see Frederick Merk, *Manifest Destiny and Mission in American History: A Reinterpretation* (1963; rpt. New York: Vintage Books, 1966).

7. Weinberg, *Manifest Destiny,* p. 89. See also the speech by Representative Lewis C. Levin in the House on 9 January 1846: "There is one ground of title which no power on earth can controvert or take away from us. It is that memorial of the people of Oregon asking for the extension of our laws and constitution over that country...American-born citizens have made a permanent settlement in that wild country. Not mere companies of trappers, with their military forts and garrisons, who only cultivate sufficient land for their present necessities, but the settlement of families who build and plant, and there abide forever to transmit the soil to their children." *(Congressional Globe,* 29th cong., 1st Sess., 1846, Appendix, pp. 95-96; quoted in Norman A. Graebner, ed., *Manifest Destiny* [New York: Bobbs-Merrill Co., 1968] pp. 100-101.)

8. *Congressional Globe,* 28th Cong., 1st Sess., 1844, p. 637.

9. Ibid., 28th Cong., 2nd Sess., 1845, Appendix, p. 139; also quoted in Graebner, ed., *Manifest Destiny,* p. 73.

10. For this very abbreviated synopsis of the issue, this author has relied on the study by Richard Slotkin, *Regeneration Through Violence: The Mythology of the American Frontier, 1600-1860* (Middletown, Conn.: Wesleyan University Press, 1974), especially pp. 37ff.

11. Further to the idea of mission, see above p. 62 and n. 27, below.

12. For a thorough study of this topic, see Arthur A. Ekirch, Jr., *The Idea of Progress in America, 1815-1860,* Studies in History, Economics, and Public Law edited by the Faculty of Political Science of Columbia University, No. 511 (New York: Peter Smith, 1951).

13. Howard Mumford Jones has shown how the cyclical theory remained current in the first part of the nineteenth century appearing in various manifestations in the writings of Cooper and in the paintings of Thomas Cole, especially his *Course of Empire* series ("Prose and Pictures: James Fenimore Cooper." *Tulane Studies in English,* 3 [1952], 133-54).

14. *United States Magazine and Democratic Review,* 24 (Jan.-June 1849), 43. The poem, authored by one Eugene Lies, is essentially a derivative of Bishop George Berkeley's "Verses on America," written more than a century earlier, but still popular in America in the nineteenth century as a prophecy of the nation's destiny. We shall refer again to Berkeley's poem as it relates to the imagery of westward expansion (see above, p. 77).

15. Henry Nash Smith, *Virgin Land: The American West as Symbol and Myth* (1950; rpt. Cambridge, Mass.: Harvard University Press, 1970) discusses this issue in depth, especially in Book III: "The Garden of the World."

16. The origin of the image of the plains as the "Great American Desert" has generally been attributed to the reports of the exploring expedition headed by Major Stephen Long in 1820; but William Goetzmann has shown that Zebulon Pike actually was the first to characterize the southwest region as a desert *(Exploration and Empire: The Explorer and the Scientist in the Winning of the American West* [New York: Alfred A. Knopf, 1971], pp. 51ff.).

17. Billington, *The Far Western Frontier,* pp. 86-87. For a discussion of the imaginative metamorphosis of the Plains region from desert to Garden, see Smith, *Virgin Land,* Chapter 16; also David M. Emmons, "The Influence of Ideology on Changing Environmental Images: The Case of Six Gazetteers," in Brian W. Blouet and Merlin P. Lawson, eds., *Images of the Plains: The Role of Human Nature in Settlement* (Lincoln, Neb.: University of Nebraska Press, 1975), pp. 125-36; and Christopher J. Schnell, "William Gilpin and the Destruction of the Desert Myth," *Colorado Magazine,* 46 (1969), 131-44.

18. *Congressional Globe,* 31st Cong., 1st Sess., 1850, Appendix, p. 77. The real reason for opposition to California's admission as a state, which came chiefly from Southern Congressmen, was the fact that its entrance into the Union as a free state would upset the balance of power between slaveholding and free states in the Senate. See Billington, *Westward Expansion,* pp. 592-93.

19. *Congressional Globe,* 31st Cong., 1st Sess., 1850, Appendix, p. 248.

20. Although Reinhart reportedly made trips to the midwest, his depiction of pioneer emigrants contains at least one glaring inaccuracy: his covered wagons are the large and

sloping-sided Conestoga wagons, which were not used on the Oregon Trail because of their cumbersome and unwieldy size. The smaller Murphy wagons or prairie schooners were used instead. On Reinhart, see the Corcoran Gallery of Art's *Catalogue of the Collection of American Paintings* (Washington, D.C.: Corcoran Gallery of Art, 1966), I, 124. On the types of wagons used in the great overland migrations, see George R. Stewart, "The Prairie Schooner Got Them There," *American Heritage,* Vol. 13, no. 2 (February 1962), pp. 4–17ff.

21. The sun may also signify the westward course of empire, as implied in Bishop Berkeley's poem and in its derivatives, such as the one quoted in the text above, p. 58.

22. *Congressional Globe,* 29th Cong., 1st Sess., 1846, p. 130.

23. The family has been identified by Stewart ("The Prairie Schooner Got Them There," p. 16) as Captain Andrew Jackson Grayson, his wife, and son. Stewart, however, does not cite his reasons or sources for this identification.

24. For the few published facts about Jewett's life, see Helen C. Nelson, "The Jewetts: William and William S.," *International Studio,* 83 (Jan.–April 1926), 39–43; Elliot Evans, ed., "Some Letters of William S. Jewett, California Artist," *California Historical Society Quarterly,* 23 (1944), 149–77, and 227–46; idem., "William S. and William D. Jewett," ibid., 33 (1954), 309–20.

25. On Claude's composition, see Marcel Rothlisberger, *Claude Lorrain: The Paintings* (New Haven: Yale University Press, 1961), I, No. 232; II, fig. 96.

26. See above p. 73, for a discussion of the motif of the spies carrying the grapes of Eschol and its adaptation to the imagery of homesteading in the American west. Significantly, Americans chose an animal—the slain stag—rather than fruit to symbolize the richness of the land in its pristine state, the implication being that it would take the enterprise of the American pioneer farmer to turn this land into an abundant garden.

27. On the development of this American sense of mission, and its implications, see Ernest Lee Tuveson, *Redeemer Nation: the Idea of America's Millennial Role* (Chicago: University of Chicago Press, 1968). Weinberg, *Manifest Destiny,* Chapter IV, and Merk *Manifest Destiny and Mission* also discuss the issue and its application to American expansionism.

28. Quoted in Tuveson, *Redeemer Nation,* p. 31.

29. Ezra Stiles, "The United States Elevated to Glory and Honor. Sermon preached...May 8, 1783," in John W. Thornton, ed., *The Pulpit of the American Revolution: Political Sermons of the Period of 1776* (1860; rpt. New York: Da Capo Press, 1970), p. 403.

30. *Congressional Globe,* 29th Cong., 1st Sess., 1846, Appendix, p. 175.

31. Ibid., pp. 150, 277.

32. There are actually two versions of this composition. Gordon Hendricks, *Albert Bierstadt: Painter of the American West* [New York: Harry N. Abrams, Inc., in association with the Amon Carter Museum of Western Art, 1974] dates the earlier version, known as *Emigrants Crossing the Plains,* to 1867. It is located in Oklahoma City, in the Collection of the National Cowboy Hall of Fame and Western Heritage Center. The second version, discussed and illustrated here, is dated by Hendricks to 1869.

33. Quoted in Graebner, ed., *Manifest Destiny,* p. 7; originally published in *The Dial* for April, 1844.

34.　On Colman, see Wayne Craven, "Samuel Colman (1832–1920): Rediscovered Painter of Far-Away Places," *American Art Journal,* Vol. 8, no. 1 (May 1976), pp. 16–37. Colman's western paintings resulted from a trip to the Far West he made around 1870.

35.　Milton Cronin, in his article, "Currier and Ives: A Content Analysis," *American Quarterly,* 4 (1952), 317–30, comes to a similar conclusion. Of the Currier and Ives railroad prints, he states (p. 324): "It is apparent that trains alone... were considered, if not exactly things of beauty, at least objects commanding interest... It is also evident that the public of Currier and Ives did not find it difficult to reconcile this symbol of industrialism with nature. Not only is it frequently surrounded by an abundance of scenery, but apparently no incongruity was felt when it was thrown in as an incidental part of a landscape picture."

36.　John C. Ewers, "Fact and Fiction in the Documentary Art of the American West," in John Francis McDermott, ed., *The Frontier Reexamined* (Chicago: University of Illinois Press, 1967), p. 86.

37.　See Slotkin, *Regeneration Through Violence,* especially pp. 39–40ff., for a discussion of Puritans' anxieties about their relationship to their wilderness environment, and how these anxieties were manifested in Puritan literature.

38.　For a history of the work, see Sylvia E. Crane, *White Silence: Greenough, Powers and Crawford, American Sculptors in Nineteenth Century Italy* (Coral Gables, Fla.: University of Miami Press, 1972).

39.　Letter of November 15, 1837; quoted in *Letters of Horatio Greenough, American Sculptor,* ed. Nathalia Wright (Madison: University of Wisconsin Press, 1972), p. 221.

40.　*Literary World,* 3 (1848), 832.

41.　Letter to Senator James Pearce, March 14, 1859; quoted in Crane, *White Silence,* p. 136.

42.　Henry Tuckerman, *A Memorial of Horatio Greenough* (1853; rpt. New York: Benjamin Blom, 1968), p. 56.

43.　That Greenough felt in competition with the earlier work done in the Capitol Rotunda, is indicated by a letter of July 1, 1837 to John Forsyth concerning the commission, in which Greenough stated: "I propose to make a group. which shall commemorate the dangers and difficulty of peopling our continent, and which shall also serve as a memorial of the Indian race, and an embodying of the Indian character; a matter of great interest to no distant posterity—a subject which with due respect, has not been exhausted by the gentlemen whose bas reliefs adorn the Rotunda..." (Quoted in *Letters of Horatio Greenough,* p. 214.)

44.　On the concept of the backwoods hunter as a demi-savage, see Slotkin, *Regeneration Through Violence, passim,* and Arthur K. Moore, *The Frontier Mind* (New York: McGraw-Hill Book Company, Inc., 1963), Chapters 5, 6, and 9, *passim.*

45.　See Maurice Bloch, *George Caleb Bingham,* Vol. II: *A Catalogue Raisonné* (Berkeley: University of California Press, 1967) Cat. No. 154, p. 61. The painting is also known as *The Captive.*

46.　Compare the Indians, carefully arranged in profile and frontal views, to the sleeping guards of Piero della Francesca's fresco of *The Resurrection of Christ* in Borgo San Sepolcro. Michelangelo's *Pieta* in St. Peter's is the closest precedent for the group of the pioneer mother and her child; but it is not necessary to determine specific models for Bingham's figures. It was enough if his composition evoked the idea of a religious theme.

47. William Romain Hodges, in his study, *Carl Wimar: A Biography* (Galveston, Texas: Charles Reymershoffer, 1908), p. 16, states that Wimar "is said to have painted" four versions of the Abduction of Boone's Daughter, all of which were supposedly done while Wimar was in Dusseldorf between 1852 and 1856. The two versions today in public collections (the "canoe picture" in the Washington University Gallery, St. Louis, and the "raft picture" in the Amon Carter Museum, Fort Worth) are dated 1853 and 1855, respectively. Dr. Lincoln B. Spiess of Washington University, who has done extensive research on Wimar, informed this author in an interview in November, 1975 that in Wimar's letters the artist referred to his painting only as "an abduction," without reference to the Boone subject. Apparently, however, the identification with the Boone narrative was made even in Wimar's lifetime and was accepted by him. The *Daily Missouri Republican* of March 22, 1868, for example, reviews the exhibition of the painting entitled "The Capture of Daniel Boone's Daughter," which clearly refers to the "canoe picture." (See clipping in the artist's files of the Missouri Historical Society, St. Louis, *s.v.* Carl Wimar.)

48. According to most nineteenth century biographies of Boone that include an account of the abduction, Boone's daughter was kidnapped while she and her friends were canoeing on a river near Fort Boonesborough. As soon as the girls were missed, father Daniel organized a rescue party which eventually succeeded in saving the girls from their captors.

49. *Ballou's Pictorial Drawing Room Companion,* Vol. 14, no. 25 (June 19, 1858), p. 392; illustrated by an engraving on p. 393.

50. The setting itself, reminiscent of a Louisiana bayou, must be a fabrication, based probably on Wimar's preconceptions about what the western wilderness should look like. The author is grateful to Dr. Spiess for pointing out the changes that Wimar's landscapes undergo once the artist had actually travelled on the frontier in 1858 and 1859.

51. Lorenz Eitner, "The Open Window and the Storm-tossed Boat: An Essay in the Iconography of Romanticism," *Art Bulletin,* 37 (1955), 287–90.

52. See Barbara Groseclose, *Emanual Leutze, 1816–1868: Freedom is the Only King* (Washington, D.C.: Smithsonian Institution Press, 1975; published for the National Collection of Fine Arts), Cat. No. 102, p. 97.

53. Hodges, *Carl Wimar,* lists two versions of the subject, one dated 1854 (p. 35). Traditionally the second version has been dated 1856. Some confusion arises in Perry Rathbone's catalogue essay in *Charles Wimar, 1826–1862: Painter of the Indian Frontier* (St. Louis: City Art Museum, 1946), in which he quotes a letter by Wimar in which the artist refers to the painting (pp. 15–16): "I have outlined it after a description by Gabriel Ferry. It represents a caravan of gold-diggers encamped on the prairie, who are defending themselves in the camp against an attack by an Indian band." Rathbone dates the letter 1856, but the description clearly refers to the version of the painting dated 1854. The confusion apparently arose from Rathbone's use of translations of Wimar's letters in the possession of the St. Louis City Art Museum, in which the dates are faultily transcribed. Dr. Lincoln Spiess, who has transcribed and translated the original manuscripts himself, pointed out the discrepancy to this author.

54. The title of the lithograph, published by J. E. Tilton & Co., of Boston, is *On the Prairie.* See Harry T. Peters, *America on Stone* (New York: Doubleday, Doran & Co., Inc., 1931), Pl. 24.

55. For a discussion of the race question on the frontier during the nineteenth century, see

Eugene H. Berwanger, *The Frontier Against Slavery: Western Anti-Negro Prejudice and the Slavery Extension Controversy* (Chicago: University of Illinois Press, 1967). Much of the information included in the following discussion is derived from this study.

56. On Leutze's political and ideological orientation, see Groceclose, *Emanuel Leutze.*

57. William Tod Helmuth, *Arts in St. Louis* (St. Louis: 1864), p. 40.

58. Reka Neilson, "Charles F. Wimar and Middle Western Painting of the Early Nineteenth Century," Unpub. Master's Thesis Washington University 1943, pp. 38-9.

59. David D. March, *The History of Missouri* (New York: Lewis Historical Publishing Company, Inc., 1967), II, 853.

60. Cronin ("Currier and Ives," pp. 321-22) concludes from his analysis of Currier and Ives prints that the view of western farm life depicted therein is idealized and pleasant, with western farms characterized by happy families, abundance, and spectacular scenery. He says, "What evidence we have, therefore, suggests that Currier and Ives added their voice to that chorus which sang the praises of the West as a veritable garden...."

61. Poussin's painting was reproduced as an engraving by Jean Pesne, and also as an illustration in the *Protestant Bible* published in London in 1789 (as after Salvatore Rosa). See Anthony Blunt, *The Paintings of Nicolas Poussin: A Critical Catalogue* (London: Phaidon Press, 1966), Cat. No. 5, p. 10.

62. The image of the American West as a garden was actually much older than the concept of the "Great American Desert," having originated in the eighteenth century, and developed by such commentators as Benjamin Franklin, St. John de Crevecoeur, and Thomas Jefferson. See Smith, *Virgin Land,* Chapter XI, *passim.*

63. Howard S. Merrit, *Thomas Cole,* Exhibition Catalogue (Rochester, N.Y.: University of Rochester Art Gallery, 1969) Cat. Nos. 52, p. 39, and 55, p. 40. No. 52 is actually the oil sketch for *The Hunter's Return.*

64. Henry T. Tuckerman, *Book of the Artists: American Artist Life* (New York: G. P. Putnam & Son, 1867), p. 231.

65. According to Merritt *(Thomas Cole,* No. 52, p. 39), the dimensions of *The Hunter's Return* were reported as 40 x 60 in.; those of *Home in the Woods* are 44 x 66 in. The paintings were not, however, commissioned as a pair, nor even for the same patron; therefore, it cannot be said that Cole thought of them as pendants. On the other hand, Louis Legrand Noble, in his 1853 biography of Cole, described the two paintings together as if they were a pair, describing them as "both large landscapes, and full of the rarest excellencies of the pencil." *(The Life and Works of Thomas Cole,* ed. Elliot S. Vesell [Cambridge, Mass.: The Belknap Press of Harvard University Press, 1964], p. 271.)

66. In describing his plan for *The Hunter's Return,* Cole used the term "my wild scene." The entire description follows: "A log hut in the forest—several figures. Two men carrying a deer on a pole—a child running to meet them and a woman standing in the door of the cabin with a child in her arms—a dog—*my wild scene.* [Italics added.] (See "Thomas Cole's List, 'Subjects for Pictures,'" in *Studies on Thomas Cole, An American Romanticist,* The Baltimore Museum of Art Annual II [Baltimore, Md.: Baltimore Museum of Art, 1967], p. 90.)

67. Significantly, one of Cole's earliest ideas for his pair of paintings, *The Past* and *The Present* was "American scenery—a scene in its primeval wildness—with Indians—the same under the hand of civilization." (Ibid., p. 92.) While it is true that Cole identified the

Indian with the wild state (rather than the white hunter), in the context of the progress of the white man's civilization the hunter would represent the wild state, while the farmer/fisherman would naturally signifiy the next, or pastoral, stage.

68. Barbara Novak, "The Double-edged Axe," *Art in America,* Vol. 64, no. 1 (Jan.–Feb. 1976), pp. 44–50. See also Kenneth J. LaBudde, "The Rural Earth: Sylvan Bliss," *American Quarterly,* 10 (1958), 144. LaBudde also suggests that the presence of a mother and child in one of Cole's landscapes was a symbol of the "tamed wilderness" (p. 152).

69. *Literary World,* 2 (1847), 277.

70. Grubar, *William Ranney,* Cat. No. 30, p. 30. There is also an oil sketch, presumably a study for the finished painting (Ibid., Cat. No. 31, pp. 30–31).

71. The first version of the poem was actually written early in 1726, and was included in a letter of February 1726 from Berkeley to Lord Percival. The verses were first published, in somewhat revised form, in 1752. *(The Works of George Berkeley, Bishop of Cloyne,* ed. A. A. Luce and T. E. Jessop [London: Thomas Nelson and Sons, Ltd., 1955], VII, 369–73.) The verse quoted in the text here is from the 1752 version.

72. As early as 1854 Leutze was approached with the possibility of a commission to paint a mural for the Capitol, and at that time the artist suggested the topic of *Emigration to the West,* along with several other subjects. The commission was not actually awarded until 1861, by which time Leutze had definitely decided upon the emigration theme. The history of the project has been discussed by Raymond L. Stehle, "Westward Ho!": The History of Leutze's Fresco in the Capitol." in F. C. Rosenberger, ed., *Records of the Columbia Historical Society of Washington, D.C., 1960–1962* (Washington, D.C.: Columbia Historical Society, 1963), pp. 306–22; also by Justin G. Turner, "Emanuel Leutze's Mural *Westward the Course of Empire Takes Its Way." Manuscripts,* Vol. 18, no. 2 (Spring 1966), pp. 4–16. Barbara Groseclose *(Emanual Leutze,* pp. 60–62, and Cat. No. 101, pp. 96–97) has summarized the history, adding some additional information not included in the previous articles.

73. Leutze did not enumerate the other three "great causes" in his notes, which are transcribed in full in Turner, "Emanuel Leutze's Mural," pp. 14–16. Unless otherwise specified, all identifications of figures and sections of the mural, as well as quoted descriptions, are derived from these notes.

74. The subjects of the other paintings were to be "the earlier history of Western Emigration, in illustrations from Boone's adventures, the discovery of the valleys of the Ohio, Mississippi—."

75. One feature which appears in the oil study for the mural, now in the National Collection of Fine Arts in Washington, D.C., is a group of pioneers burying one of their companions who has died. Leutze left this episode out of the final composition, perhaps because he wanted his mural to sound a more positive note during the days of Civil War.

76. Tuveson, *Redeemer Nation,* p. 34.

77. Tuveson discusses the apocalyptic view of the Civil War in Chapter 7 (Ibid., pp. 187–209). He points to the Battle Hymn of the Republic, with its millennialist diction, as a particularly striking manifestation of this attitude.

78. "Emmanual [sic] Leutze, the Artist," *Lippincott's Magazine,* 2 (July–Dec. 1868), 536.

79. Nathaniel Hawthorne "Chiefly About War-Matters," *Atlantic Monthly,* 10 (July–Dec. 1862), 46.

80. Much of the factual information given in the following discussion is pieced together from the three studies on Wimar previously cited: Hodges, *Carl Wimar, a Biography;* Rathbone, *Charles Wimar;* and Neilson, "Charles F. Wimar." Additional information was gleaned from material in the Missouri Historical Society, St. Louis.

81. The subjects of the panels were: DeSoto discovering the Mississippi; Laclede landing at the site of St. Louis; an Indian attack on St. Louis; and "Westward the Star of Empire takes its course." (Hodges, *Carl Wimar, A Biography,* p. 25.)

82. From a typewritten article, "Mural Paintings in the Courthouse by Wimar," in the Wimar Papers of the Missouri Historical Society, St. Louis. The article reproduces a translation of the letter from Tausig to a Mr. Pretorius, published in German in the *Westliche Post,* September 19, 1886.

83. An account by Charles Ketchum, published in the St. Louis Post-Dispatch in 1922, claims that Wimar's murals had to be restored as early as 1865, and that at the time two of the originals, including *Westward the Star...*, were painted out entirely and replaced with new designs. According to Ketchum, the west panel had originally depicted a herd of buffalo. This story, however, was refuted by one of the men who restored the paintings in 1905. At least one other restoration was undertaken, in 1888, by Wimar's step-brother, who may have helped with the original painting, and who claimed that the originals were still there in 1888. (Neilson, "Charles F. Wimar," pp. 70–71, and n. 20.) The history is unfortunately almost hopelessly confused.

84. For a fuller discussion of Wimar's buffalo imagery, see above, p. 106, and n. 64.

85. *Yesterday and Today: A History of the Chicago and Western Railway System,* 3rd ed., rev. and elg. (Chicago: 1910), p. 70.

86. On the ideological significance of the transcontinental railroad, see Smith, *Virgin Land,* Chapter 2, *passim.*

87. Patricia Hills, in her essay in the exhibition catalogue, *The American Frontier: Images and Myths* (New York: Whitney Museum of American Art, 1973), p. 10, cites Otter's painting as an example of an image which specifically depicts the advantages of the railroad over the covered wagon. The implication in Palmer's lithograph might be that the train will soon overtake and pass the wagon train disappearing over the horizon.

88. As early as 1833 it was argued that education was vital to the West and therefore deserved public support. The opinion was best expressed in a speech by Edward Everett, in which he appealed to Bostonian businessmen to donate funds to a newly founded college in Ohio. Everett stressed the importance of the West to the rest of the nation: "The balance of the country's fortunes is in the west. There lie...the influences which will most power-fully affect our national weal and woe." Summarizing his plea, he stated: "In the west is a vast and growing population, possessing a great and increasing influence in the political system of which we are members. It is for our interest, strongly, vitally for our interest, that this population should be intelligent and well educated...." ("Education in the Western States," quoted in Douglas T. Miller, ed., *The Nature of Jacksonian America,* Problems in American History Series [New York: John Wiley and Sons, Inc., 1972], pp. 133–39.)

89. However, as Leo Marx has shown in his study, *The Machine in the Garden: Technology and the Pastoral Ideal in America* (New York: Oxford University Press, 1967), the intru-sion of technology into the American landscape was also the cause for much anxiety, as well as for optimism, about America's future.

90. Quoted in Wilcombe E. Washburn, ed., *The Indian and the White Man,* Documents in American Civilization Series (Garden City, N.Y.: Doubleday and Company, Inc., 1964), p. 128. The lithograph was published by George A. Crofutt.

Chapter 4

1. A. C. Crombie, *Augustine to Galileo: The History of Science A.D. 400-1650* (London: Falcon Press, 1952), Chapter 6; A. R. Hall, *The Scientific Revolution, 1500-1800; The Formation of the Modern Scientific Attitude* (Boston: Beacon Press, 1956), p. xii.

2. Such studies were known as Natural Theology. David M. Knight, in *Natural Science Books in English, 1600-1900* (New York: Praeger Publishers, 1972) discusses the waning of Natural Theology in the nineteenth century, but points out that "perhaps the majority of scientific books written in English between 1650 and 1850 contain references to the Creator, and praise for His capacities as a Designer. . . ." (p. 47). See also William Martin Smallwood, *Natural History and the American Mind* (New York: Columbia University Press, 1941), pp. 216, 234.

3. Quoted in Henry Savage, Jr., *Lost Heritage* (New York: William Morrow and Company, Inc., 1970), p. 88.

4. Further to the Jefferson-Buffon controversy, see above, Chapter 2, p. 37 and n. 37. In addition to the references cited there, see also Gilbert Chinard, "Eighteenth Centry Theories on America as a Human Habitat," *Proceedings of the American Philosophical Society,* 91 (1947), 27-57; and Edwin T. Martin, *Thomas Jefferson: Scientist* (New York: Henry Schuman, 1952), Chapter 7.

5. Chinard, "Eighteenth Century Theories," pp. 35-36. See also Dwight Boehm and Edward Schwartz, "Jefferson and the Theory of Degeneracy," *American Quarterly,* 9 (1957), 453, for evidence of the persistence of the degeneracy theory as late as 1837.

6. John James Audubon, *Delineations of American Scenery and Character* (New York: G.A. Baker & Co., 1926), p. 4. Originally Audubon's commentaries had been interspersed with his illustrations in his monumental *Birds of America.*

7. For some indication of this variety, see the illustrations in the section devoted to birds and animals of the Louisiana Territory in the exhibition catalogue, *Westward the Way,* ed. Perry T. Rathbone (St. Louis: City Art Museum, 1954), pp. 127ff. The motif of the slain stag in landscapes of the American West as a symbol of abundance was discussed in the previous chapter. See above, pp. 83-84, and n. 26.

8. The American bison is not a buffalo, though it early acquired this appellative, which has persisted to the present day and is accepted in common usage by all but the most ardent purists. Because this discussion is not an essay on zoology, and because presumably strict accuracy of terminology is not therefore essential, the terms *bison* and *buffalo* shall be used interchangeably for the sake of variety.

9. W. A. Ferris, *Life in the Rocky Mountains,* ed. Paul C. Phillips (Denver, Colo.: Old West Publishing Company, 1940), p. 36.

10. Bodmer's sketches include drawings of the wildlife of the Missouri River area, as well as of its geologic formations and native inhabitants. Many of the sketches found their way into finished illustrations accompanying Maximilian's *Travels in the Interior of North America.* They are today most readily available in black and white reproductions in Vol. 25 of *Early Western Travels, 1748-1846,* ed. Reuben Gold Thwaites (Cleveland: Authur H. Clark, Co., 1906).

11. *The West of Alfred Jacob Miller,* ed. Marvin C. Ross, rev. and enl. edition (Norman, Okla.: University of Oklahoma Press, 1968), No. 32.

12. Walters Collection, No. 107.

13. *The West of Alfred Jacob Miller,* No. 135. The hero of Miller's story was a trapper named Markhead.

14. Walker, born in England in 1819, grew up in New York City. He travelled widely in the Southwest and Far West, and his depictions of the Spanish-American ranches in California are based on his first hand experiences and observations.

15. Smallwood, *Natural History and the American Mind,* p. 240; Knight, *Natural Science Books in English,* pp. 55–56.

16. William Smellie, *The Philosophy of Natural History,* ed. John Ware, 4th ed. (Boston: Hilliard, Gray, Little, and Wilkins, 1832), pp. 307, 310–11. For a modern discussion of the concept of the chain of being, see Arthur O. Lovejoy, *The Great Chain of Being; A Study of the History of an Idea* (Cambridge, Mass.: Harvard U. Press, 1936).

17. The publication in 1859 of Charles Darwin's *Origin of the Species* marked the dramatic climax, rather than the beginning, of such changes. Evolutionary ideas had been in the air throughout the first half of the century.

18. Agassiz was the most vociferous critic and opponent in America of Darwin's theories. For a brief discussion of Agassiz in relation to Darwin, see Paul F. Boller, Jr., *American Thought in Transition: The Impact of Evolutionary Naturalism, 1865-1900,* The Rand McNally Series on the History of American Thought and Culture, ed. David D. van-Tassel (Chicago: Rand McNally & Company, 1969), p. 13.

19. Gordon Hendricks, *Albert Bierstadt: Painter of the American West* (New York: Harry N. Abrams, Inc., 1974), p. 116.

20. References to Pegasus or to Hippocrene as sources of creative inspiration appear in the seventeenth century in Milton's *Paradise Lost* and in the nineteenth century in Keats' *Ode to a Nightingale.* (See Philip Mayerson, *Classical Mythology in Literature, Art, and Music.* [Waltham, Mass.: Xerox College Publishing, 1971], p. 297.) Anita C. Costello, in an unpublished Masters' Thesis entitled "Picasso's *Boy Leading a Horse* and Related Works," (Bryn Mawr, 1974; pp. 30ff.) discusses the use of Pegasus as a symbol for creativity in the late nineteenth and early twentieth centuries in the visual arts as well as in literature. Although this author has been unable to locate a visual image from the first half of the nineteenth century in which the association of the horse with creativity is indisputably made, it seems likely that such a notion did exist in some form prior to its appearance in the work of the French artist Odilon Redon in the 1880s.

21. Washington Irving, *A Tour on the Prairies,* pref. James P. Wood (New York: Pantheon Books, 1967), pp. 116, 126.

22. Robert M. Denhardt, *The Horse of the Americas* (Norman, Ok.: University of Oklahoma Press, 1948), p. 112. See also *The Oxford Companion to American Literature,* ed. James D. Hart, 4th ed. (New York: Oxford University Press, 1965), s.v. *Pacing Mustang,* p. 629.

23. George Wilkins Kendall, *Narrative of the Texan Santa Fe Expedition* (1844; rpt. Chicago: Lakeside Press, 1929), pp. 108–10.

24. "The White Steed of the Prairie," in *United States Magazine and Democratic Review,* 12 (April 1843), 367. An explanatory note preceding the poem quotes Kendall's description of the legend as it had appeared in the *Picayune.*

25. Herman Melville, *Moby Dick; or, the Whale,* ed. with introduction by Harold Beaver (New York: Penquin Books, 1972), pp. 290–91.

26. *The West of Alfred Jacob Miller,* No. 176.

27. Ibid., No. 92.

28. Francis S. Grubar, *William Ranney: Painter of the Early West* (Washington, D.C.: Corcoran Gallery of Art, 1962), Cat. Nos. 20 and 21, pp. 27–28.

29. These are reproduced in Hendricks, *Albert Bierstadt,* CL-100 and CL-101.

30. See, for example, *Thunderstorm in the Rocky Mountains,* 1859 (Boston Museum of Fine Arts), which actually depicts the approach of a storm; *Storm in the Rocky Mountains* (now lost, but known through a lithograph and a copy by W. C. Sharon in the De Young Museum in San Francisco); *Storm in the Mountains,* undated (Boston Museum of Fine Arts); and *Sierra Nevada Morning,* 1870 (Tulsa, Ok., Gilcrease Institute).

31. See, for example, the various images of the Apotheosis of Hercules listed in A. Pigler, *Barockthemen,* 2nd ed., enl., 3 vols. (Budapest: Akademiai Kiado, 1974), II, 131–33. These include paintings and frescoes by Lodovico Carracci, Pietro da Cortona, Andrea Pozzo, the Tiepolos, Peter Paul Rubens, et al.

32. Hendricks, *Albert Bierstadt,* pp. 116ff.

33. Fitz Hugh Ludlow, *The Heart of the Continent: A Record of Travel Across the Plains and in Oregon* (1870; rpt. New York: A.M.S. Press, 1970), pp. 130–31, 158.

34. The painting is undated, but Hendricks dates it tentatively to 1859–60, or shortly after Bierstadt's return from his first trip West *(Albert Bierstadt,* fig. 54, p. 75). If Hendricks is correct, the painting precedes the trip with Ludlow by three years; but this does not mean that its interpretation cannot be enhanced by reference to Ludlow's descriptions, which in many respects typify the reactions of nineteenth century travellers on the American frontier. Ludlow may even have been predisposed to such reactions from his contact with Bierstadt, who had undoubtedly shared with his friend his impressions of earlier trips west.

35. George D. Brewerton, "In the Buffalo Country," *Harper's New Monthly Magazine,* 25 (September, 1862), 460. Brewerton, it will be remembered, was a painter whose prairiescapes convey the vastness and aridness of the Great Plains and Southwestern regions. The buffalo, however, does not figure significantly in his work.

36. Horace Greeley, *An Overland Journey from New York to San Francisco in the Summer of 1859* (1860; rpt. Ann Arbor, Mich.: University Microfilms, Inc., 1966), p. 86.

37. See the examples in the exhibition catalogue, *The Bison in Art: A Graphic Chronicle of the American Bison,* essay by Larry Barsness (Flagstaff, Ari.: Northland Press, in conjunction with the Amon Carter Museum of Western Art, Fort Worth, Tx., 1977), pp. 40–47.

38. Cy Martin, *The Saga of the Buffalo* (New York: Hart Publishing Company, Inc., 1973), p. 15.

39. John C. Fremont, *Narratives of Exploration and Adventure,* ed. Allan Nevins (New York: Longmans, Green & Co., 1956), p. 102.

40. Greeley, *An Overland Journey,* pp. 87–88.

41. Quoted in Robert Taft, *Artists and Illustrators of the Old West, 1850–1900* (New York: Charles Scribner's Sons, 1953), p. 16.

42. Ibid., p. 36.

43. Ibid., p. 47. The description is taken from an exhibition catalogue of the early 1860s. It was reused by Henry Tuckerman in *Book of the Artists: American Artist Life* (New York: G. P. Putnam & Son, 1867), pp. 495–96.

44. Likewise from the exhibition catalogue mentioned above, n. 43, and quoted in Taft, *Artists and Illustrators,* p. 48.

45. The tragic story of the near demise of the buffalo is told in Martin, *The Saga of the Buffalo,* pp. 10ff.; in Tom McHugh, *the Time of the Buffalo* (New York: Alfred A. Knopf, 1972), pp. 249ff., 273ff; and in a vivid pictorial record in *The Bison in Art,* pp. 110–27. McHugh (p. 275) estimates that over four million buffalo were slaughtered between 1872 and 1874. However, Barsness argues that the hide hunters of the 1870s were not solely responsible for the near-extermination of the buffalo, but that the decline of the species had begun as early as 1830, at the rate of about one million per year, at the hands of both white hunters and Indians *(The Bison in Art,* p. 13).

46. There are many passages in Catlin's book which mention the theme. Typical of his gloomy, yet accurate predictions, is the following: "It is truly a melancholy contemplation for the traveller in this country, to anticipate the period which is not far distant, when the last of these noble animals [i.e., the buffalo], at the hands of white and red men, will fall victims to their cruel and improvident rapacity...." *The Manners, Customs, and Conditions of the North American Indians,* I, 256.)

47. Josiah Gregg, *Commerce of the Prairies* (1844; rpt. Chicago: The Lakeside Press, 1926), p. 318; George Frederick Ruxton, *Adventures in Mexico and the Rocky Mountains,* new ed. (London: John Murray, 1861), p. 269; Greeley, *An Overland Journey,* p. 129.

48. Kendall, *Narrative of the Texan Santa Fe Expedition,* pp. 93–94.

49. William Jacob Hays, "Notes on the Range of Some of the Animals in America at the Time of the Arrival of the White Men," *The American Naturalist,* 5 (1871), 387, 390.

50. Hans Huth, in his study, *Nature and the American: Three Centuries of Changing Attitudes* (Berkeley; University of California Press, 1957), has discussed at length this very interesting issue of American's consciousness of nature. Another study of particular interest to this discussion because of its presentation of visual material, is the exhibition catalogue, *National Parks and the American Landscape,* essay by William H. Truettner and Robin Bolton-Smith (Washington, D.C.: The Smithsonian Institution Press for the National Collection of Fine Arts, 1972). The essay considers in particular the conservation movement and the efforts to preserve America's wilderness in national parks. With regard to the latter subject, it is worth pointing out that George Catlin was among the first Americans in the nineteenth century to propose the establishment of a national park, specifically in order to maintain the buffalo and the Indian in their native habitats. In *Manners, Customs, and Conditions of the North American Indian* (I, 262) he wrote: "And what a splendid contemplation, too, when one (who has travelled these realms, and can duly appreciate them) imagines them as they *might* in future be seen, (by

some great protecting policy of government) preserved in their pristine beauty and-
wildness, in a *magnificent park,* where the world could see for ages to come, the native
Indian in his classic attire, galloping his wild horse, with sinewy bow, and shield and
lance, amid the fleeting herds of elks and buffaloes. What a beautiful and thrilling
specimen for America to preserve and hold up to the view of her refined citizens and the
world, in future ages! A *nation's park,* containing man and beast, in all the wild and
freshness of their nature's beauty!''

51. Quoted in Hodges, *Carl Wimar, A Biography,* p. 26.

52. Rena N. Coen, in her article, "The Last of the Buffalo," *American Art Journal,* 5
 (1973), 83–94, discusses the use of this motif in Wimar's painting as a *memento mori,* and
 points out that in an earlier version of the theme, done in 1860, a rock formation in the
 foreground resembles tombstones, likewise an allusion to death. Further to the imagery
 of the buffalo hunt, see above, pp. 105ff., and n. 65, below.

53. The English artist, John Martin, treated the theme of St. John's apocalyptic vision in a
 composition entitled *The Opening of the Seventh Seal,* published as a wood engraving in
 1836. (See Christoper Johnstone, *John Martin* [New York: St. Martin's Press, 1974], p.
 84.) Interestingly, this composition depicts a single figure on a rocky promontory facing a
 turbulent sea and a stormy sky illuminated by lightning—a scene very similar to Wimar's
 Buffaloes Crossing the Yellowstone.

54. McHugh, *The Time of the Buffalo,* pp. 247–50. As the result of complaints voiced about
 Sir George Gore's trip, Congress passed a bill in 1855, which, had it been observed,
 would have afforded some protection to the buffalo (Barsness, *The Bison in Art,* p. 11).

55. Kendall, *Narrative of the Texan Santa Fe Expedition,* p. 3.

56. The original version of *The Surround,* now in the collection of the Joslyn Museum in
 Omaha, Nebraska, was painted for Sir William Drummond Stewart. Miller painted at
 least two other oil versions of the theme in 1848 and 1858, respectively, a fact which gives
 some indication of its success and popularity. (See "Account of Indian Pictures," in
 Ross, ed, *The West of Alfred Jacob Miller,* pp. lv–lix.)

57. Marvin Ross points out that the original sketch for the subject bears the notations "More
 distance" and "Dust," directives which indicate that Miller's intent was indeed to con-
 vey the sense of speed and frenzied action within a spacious setting (Ibid., p. xxi).

58. Irving, *A Tour on the Prairies,* pp. 113, 115.

59. One of the earliest versions of the theme on the Indian hunting the buffalo is a lithograph
 of 1832, based on a sketch made by Titian Ramsey Peale on his trip west in 1819–20 with
 the Long expedition. (See *The Bison in Art,* p. 52.)

60. Catlin, *Manners, Customs, and Condition of the North American Indian,* I, 3, 261.

61. Fremont, *Narratives of Exploration and Adventure,* pp. 232–33.

62. George F. Ruxton, *Life in the Far West,* ed. LeRoy Hafen (Norman, Ok.: University of
 Oklahoma Press, 1951), p. 106.

63. *The West of Alfred Jacob Miller,* No. 42.

64. Ibid., No. 191.

65. Coen, "The Last of the Buffalo," p. 88. Coen's thesis is that the image of the Indian
 buffalo hunt was "an allegory of the West—a veiled allusion to the disappearance not
 only of the buffalo, but of his savage hunter as well" (p. 83). This author is in full agree-
 ment with this interpretation.

66. Coen (Ibid., p. 84) describes the setting, with its skulls and bones, its distant mists, deep empty space, and peculiar light effects, as evoking a memory of Golgotha and thus alluding to martyrdom.

67. McHugh, *The Time of the Buffalo,* p. 128–29.

68. Alice C. Fletcher, "The White Buffalo Festival of the Uncpapas," in *Reports of the Peabody Museum of American Archaeology and Ethnology* (Cambridge, Mass.: 1887), III, 271–72.

69. Quoted in Hendricks *Albert Bierstadt,* p. 291. Tradition has it that Bierstadt's painting aroused such concern over the fate of the buffalo that it prompted the first official census of the species. The findings of that census revealed that only 551 buffalo remained in the United States.

Bibliography

Alvord, Clarence W. . "The Daniel Boone Myth." *Journal of the Illinois State Historical Society* 19, no. 1–2 (April –July, 1926): 16–30.

American Bank Note Company. *Bank Note Vignettes.* 11 vols. New York: New York Public Library, Prints Division.

"American Works of Painting and Sculpture." *United States Magazine and Democratic Review* 20 (1847):56–66.

Amon Carter Museum of Western Art. *Catalogue of the Collection, 1972.* Fort Worth, Tx.: Amon Carter Museum of Western Art. 1973.

Apollo Association. *Transactions.* 1839–1843.

Audubon, John James. *Delineations of American Scenery and Character.* Introduction by Frances Hobart Herrick. New York: G. A. Baker & Co., 1926.

Baltimore Museum of Art. *Studies on Thomas Cole, An American Romanticist.* Annual II. Baltimore, Md.: Baltimore Museum of Art, 1967.

Barba, Preston Albert. *Baldwin Mollhausen, The German Cooper.* Phila., Pa.: University of Pennsylvania, 1914.

Barsness, Larry. *The Bison in Art: A Graphic Chronicle of the American Bison.* Flagstaff, Ar.: The Northland Press, in conjunction with the Amon Carter Museum of Western Art, 1977.

Berkhofer, Robert F., Jr. *Salvation and the Savage: An Analysis of Protestant Missions and American Indian Response, 1787–1862.* Lexington, Ky.: University of Kentucky Press, 1965.

Berwanger, Eugene H. *The Frontier Against Slavery: Western Anti-Negro Prejudice and the Slavery Extension Controversy.* Urbana, Ill.: University of Illinois Press, 1967.

Billington, Ray Allen. *The Far Western Frontier, 1830–1860.* New York: Harper and Brothers, 1956.

_____.*Westward Expansion: A History of the American Frontier.* 3rd ed. New York; MacMillan, 1967.

Bingham, George Caleb. "Letters of George Caleb Bingham to James S. Rollins." Edited by C.B. Rollins. In *Missouri Historical Review* 32 (1937–38), 3–34, 164–202, 340–77, 484–522.

Bloch, E. Maurice. *George Caleb Bingham. Vol I: The Evolution of an Artist.* Vol. II: *A Catalogue Raisonne.* Berkeley: University of California Press, 1967.

Blouet, Brian W. and Merlin P. Lawson, eds. *Images of the Plains: The Role of Human Nature in Settlement.* Lincoln, Neb.: University of Nebraska Press, 1975.

Boehm, Dwight, and Schwartz, Edward. "Jefferson and the Theory of Degeneracy." *American Quarterly* 9 (1957): 448-53.

Bogart, W. H. *Daniel Boone and the Hunters of Kentucky.* Buffalo, N.Y.: Miller, Orton & Mulligan, 1854.

"Boone, Daniel—Portraits, Relics, etc." File in Filson Club Library, Louisville, Ky.

Boston Museum of Fine Arts. *M. and M. Karolik Collection of American Paintings, 1815 to 1865*. Cambridge, Mass.: Harvard University Press, 1949.

Bowron, Bernard, Marx, Leo, and Rose, Arnold. "Literature and Covert Culture," *American Quarterly* 9 (1957): 377–86.

Brewerton, George D. "In the Buffalo Country." *Harper's New Monthly Magazine* 25 (Sept. 1862): 447–86.

Brewster, Anne. "Emmanuel [sic] Leutze, The Artist." *Lippincott's Magazine* 2 (1868): 533–38.

Brown, Glenn. *History of the United States Capitol*. 1900: Reprint (2 vols. in 1). New York: DaCapo Press, 1970.

Bryan, Daniel. *The Mountain Muse: Comprising the Adventures of Daniel Boone, and the Power of Virtuous and Refined Beauty*. Harrisonburg Va.: Davidson & Bourne, 1813.

Bryant, Keith L. "George Caleb Bingham: The Artist as a Whig Politician." *Missouri Historical Review* 59 (July 1965): 448–63.

Cadbury, Warder H. *A. F. Tait: Artist in the Adirondacks*. Blue Mountain Lake, N.Y.: Adirondack Museum, 1974.

_____. "Arthur F. Tait." *American Art Review* 1, no. 5 (July–Oct. 1974): 61–68.

Callow, James T. *Kindred Spirits: Knickerbocker Writers and American Artists, 1807–1855*. Chapel Hill, N.C.: University of North Carolina Press, 1967.

Carter, Harvey Lewis, and Spencer, Marcia Carpenter. "Stereotypes of the Mountain Man." *Western Historical Quarterly* 6, no. 1 (Jan. 1975): 17–32.

Catlin, George. *The Manners, Customs, and Condition of the North American Indians*. 2 vols. London: Published by the author, 1841.

Cawelti, John G. "The Frontier and the Native American." In *America as Art* by Joshua C. Taylor. Washington, D.C.: Smithsonian Institution Press, for the National Collection of Fine Arts, 1976.

Chinard, Gilbert. "Eighteenth Century Theories on America as a Human Habitat." *Proceedings of the American Philosophical Society* 91 (1947): 27–57.

Chittenden, Hiram Martin. *The American Fur Trade of the Far West*. 2 vols. 1902. Reprint. Stanford, Ca.: Academic Reprints, 1954.

Cleland, Robert Glass. *This Reckless Breed of Men: The Trappers and Fur Traders of the Southwest*. New York: Alfred A. Knopf, 1950.

Coen, Rena N. "The Last of the Buffalo." *American Art Journal* 5, no. 2 (Nov. 1973): 83–94.

Coggeshall, William T. *The Poets and Poetry of the West*. Columbus, Oh.: Follett, Foster & Co., 1860.

Cole, Thomas. Miscellaneous Papers. New York Public Library, Manuscripts Division.

_____. *Thomas Cole's Poetry*. Edited by Marshall B. Tymn. York, Pa.: Liberty Cap Books, 1972.

Colton, Walter. *Three Years in California*. New York: A. S. Barnes & Co., 1852.

Compilation of Works of Art and Other Objects in the United States Capitol. Prepared by the Architect of the Capitol under the direction of the Joint Committee on the Library. 88th Cong., 2nd Session, House Document No. 362. Washington, D.C.: U.S. Government Printing Office, 1965.

Conningham, Frederic A. *Currier and Ives Prints, An Illustrated Check List*. New York: Crown Publishers, 1949.

Corcoran Gallery of Art. *A Catalogue of the Collection of American Paintings in the Corcoran Gallery of Art*. 2 vols. Washington, D.C.: Corcoran Gallery of Art, 1966.

Costello, Anita B. "Picasso's *Boy Leading a Horse* and Related Works." Unpub. M.A. Thesis, Bryn Mawr, 1974.

Cowdrey, Mary Bartlett. *American Academy of Fine Arts and American Art Union.* 2 vols. New York: New York Historical Society. 1953.

_____. *National Academy of Design Exhibition Record, 1826-1860.* 2 vols. New York: New York Historical Society, 1943.

Coyner, David H. *The Lost Trappers.* Edited by David J. Weber. Albuquerque, N.M.: University of New Mexico Press, 1970.

Crane, Sylvia E. *White Silence: Greenough, Powers, and Crawford, American Sculptors in Nineteenth Century Italy.* Coral Gables, Fla.: University of Miami Press, 1972.

Craven, Wayne. "Samuel Colman (1832-1920): Rediscovered Painter of Far-Away Places." *American Art Journal* 8, no. 1 (May 1976): 16-37.

The Crockett Almanacks, Nashville Series, 1835-1838. Edited by Franklin J. Meine, with a note on their humor by Harry J. Owens. Chicago: The Caxton Club, 1955.

Cronin, Milton. "Currier and Ives: A Content Analysis." *American Quarterly* 4 (1952): 317-30.

Curry, Larry. *The American West: Painters from Catlin to Russell.* New York: Viking Press, Inc., in association with the Los Angeles County Museum of Art, 1972.

Davidson, Marshall B. "Carl Bodmer's Unspoiled West." *American Heritage* 14, no. 3 (April 1963): 43-65.

Davis, Theodore R. "The Buffalo Range." *Harper's New Monthly Magazine* 38 (Jan. 1869): 147-63.

Demos, John. "George Caleb Bingham: The Artist as Social Historian." *American Quarterly* 17 (1965: 218-28.

Devoto, Bernard. *Across the Wide Missouri.* Sentry ed. Boston: Houghton Mifflin Co., 1947.

Durand, Asher B. Asher B. Durand Papers, Correspondence between Thomas Cole and Asher B. Durand for the years 1836-43, 1847. New York Public Library, Manuscripts Division.

Duyckinck, Evert A. *National Portrait Gallery of Eminent Americans.* 2 vols. New York: Johnson, Fry and Co., 1861.

Edgerton, Samuel Y., Jr. "The Murder of Jane McCrea: The Tragedy of an American *Tableau d'Histoire.*" *Art Bulletin* 47 (1965): 481-92.

Ekirch. Arthur Alphonse, Jr. *The Idea of Progress in America, 1815-1860.* Studies in History, Economics, and Public Law edited by the Faculty of Political Science of Columbia, University, No. 511. New York: Peter Smith, 1951.

Emmons, David M. "The Influence of Ideology on Changing Environmental Images: The Case of Six Gazetteers." In *Images of the Plains: The Role of Human Nature in Settlement,* Edited by Brian W. Blouet and Merlin P. Lawson. Lincoln, Neb.: University of Nebraska Press, 1975, pp. 125-36.

Evans, Elliot, "William S. and William D. Jewett." *California Historical Society Quarterly* 33 (1954): 309-20.

Everett, Edward. "Education in the Western States." In *The Nature of Jacksonian America,* Edited by Douglas T. Miller. Problems in American History Series. New York: John Wiley & Sons, Inc., 1972.

Ewers, John C. *Artists of the Old West.* Enl. ed. Garden City, N.Y.: Doubleday & Co., 1973.

_____. "Fact and Fiction in the Documentary Art of the American West." In *The Frontier Re-examined,* edited by John Francis McDermott. Urbana, Ill.: University of Illinois Press, 1967.

_____. "Not Quite Redman: The Plains Indian Illustrations of Felix O. C. Darley." *American Art Journal* 3, no. 2 (Fall 1971): 88-98.

_____. "The White Man's Strongest Medicine." *Bulletin of the Missouri Historical Society* 24 (Oct. 1967): 36-46.

Fairman, Charles E. *Art and Artists of the Capitol of the United States of America.* 69th Cong., 1st Sess. Senate Document No. 95. Washington, D.C.: U.S. Government Printing Office, 1927.

Farnham, Thomas J. *Travels in the Great Western Prairies, the Anahuac and Rocky Mountains, and in the Oregon Territory.* Vols. 28, 29 of *Early Western Travels, 1748-1846.* Edited by Reuben G. Thwaites. Cleveland, Oh.: The Arthur H. Clark Co., 1906.

Ferris, W. A. *Life in the Rocky Mountains.* Edited by Paul C. Phillips. Denver: Old West Publishing Co., 1940

Fishwick, Marshall W. "Daniel Boone and the Pattern of the Western Hero." *Filson Club History Quarterly* 27 (1953): 119-38.

Fletcher, Alice C. "The White Buffalo Festival of the Uncpapas." *Reports of the Peabody Museum of American Archaeology and Ethnology,* III (1880-86) pp. 260-75. Cambridge, Mass., 1887.

Flint, Timothy. *Biographical Memoir of Daniel Boone, the First Settler of Kentucky.* Edited by James K. Folsom. New Haven, Conn.: College & University Press, 1967.

_____. *Recollections of the Last Ten Years, Passed in Occasional Residences and Journeyings in the Valley of the Mississippi.* 1826. Reprinted with intro. by James D. Norris. New York: DaCapo Press, 1968.

Fremont, John Charles. *Narratives of Exploration and Adventure.* Edited by Allan Nevins. New Youk: Longmans, Green & Co., 1956.

Galloway, John D. *The First Transcontinental Railroad: Central Pacific, Union Pacific.* New York: Simmons-Boardman, 1950.

Garrard, Lewis H. *Wah-To-Yah and the Taos Trail.* Edited by Ralph P. Bieber. The Southwest Historical Series, vol. VI. Glendale, Calif.: The Arthur H. Clark Co., 1938.

Gerbi, Antonello. *The Dispute of the New World. The History of a Polemic, 1750-1900.* Rev. and enl. ed. Translated by Jeremy Moyle. Pittsburgh: University of Pittsburgh Press, 1973.

Gerdts, William H. "The Marble Savage." *Art in America* 62, no. 4 (July-Aug. 1974): 64-70.

Goetzmann, William H. *Exploration and Empire: The Explorer and the Scientist in the Winning of the American West.* New York: Alfred A. Knopf, 1971.

_____. "The Mountain Man as Jacksonian Man." *American Quarterly* 15 (1963): 402-15.

_____. "Savage Enough to Prefer the Woods: The Cosmopolite and the West." In *Thomas Jefferson: The Man...His World...His Influence,* edited by Lally Weymouth. New York: G. P. Putnam's Sons, 1975.

Goodrich, Lloyd. "The Painting of American History: 1775-1900." *American Quarterly* 3 (1951): 283-94.

Goosman, Mildred. "Karl Bodmer, Earliest Painter in Montana." *Montana, The Magazine of Western History* 20, no. 3 (July 1970): 36-41.

Graebner, Norman A. *Manifest Destiny.* New York: Bobbs-Merrill Co., 1968.

Greeley, Horace. *An Overland Journey.* 1860. Reprinted in March of America Facsimile Series, No. 92. Ann Arbor, Mich.: University Microfilms, Inc., 1966.

Greenough, Horatio. *Letters of Horatio Greenough, American Sculptor.* Edited by Nathalia Wright. Madison, Wisc.: University of Wisconsin Press, 1972.

Gregg, Josiah. *Commerce of the Prairies.* Edited by Milo Milton Quaife. Chicago: The Lakeside Press, 1926.

Groce, George C., and Wallace, David H. *The New York Historical Society's Dictionary of Artists in America, 1564-1860.* New Haven, Conn.: Yale University Press, 1957.

Groseclose, Barbara S. *Emanuel Leutze, 1816-1868: Freedom Is the Only King.* Washington, D.C.: Smithsonian Institution Press, 1975.

Grubar, Francis S. "Ranney's *The Trapper's Last Shot.*" *American Art Journal* 2, no. 1 (Spring 1970): 92-99.

_____. *William Ranney, Painter of the Early West.* Washington, D.C.: Corcoran Gallery of Art, 1962.

Hale, Edward E. "The Early Art of Thomas Cole." *Art in America* 4 (Dec. 1915): 22–40.

Harding, Chester. *A Sketch of Chester Harding, Artist, Drawn By His Own Hand.* Edited by Margaret E. White. 1929. Reprint. New York: DaCapo Press, 1970.

Harris, Paul S. "Frontiersman Daniel Boone by Chester Harding." *J. B. Speed Art Museum Bulletin* 19, no. 2 (Feb. 1958): n.p.

Hartley, Cecil B. *Life and Times of Colonel Daniel Boone.* Philadelphia: G. G. Evans, 1859.

Hawthorne, Nathaniel. "Chiefly about War-Matters." *Atlantic Monthly* 10 (July–Dec. 1862): 43–61.

Hays, Hoffman Reynolds. *Birds, Beasts, and Men: A Humanist History of Zoology.* New York: G. P. Putnam's Sons, 1972.

Hays, William Jacob. "Notes on the Range of Some of the Animals in America at the Time of the Arrival of the White Man." *The American Naturalist* 5 (1871): 387–92.

Hazard, Lucy Lockwood. *The Frontier in American Literature.* 1927. rpt. New York: Barnes & Noble, Inc., 1941.

Held, Julius S. "'Le Roi a la Chasse.'" *Art Bulletin* 40 (1958): 139–49.

Helmuth, William Tod. *Arts in St. Louis.* St. Louis, 1864.

Hendricks, Gordon. *Albert Bierstadt: Painter of the American West.* New York: Harry N. Abrams, Inc., 1974.

_____. "The First Three Western Journeys of Albert Bierstadt." *Art Bulletin* 46 (1964): 333–65.

Herring, James and Longacre, James B., eds. *The National Portrait Gallery of Distinguished Americans.* 4 vols. Philadelphia: Henry Perkins, 1834–39.

High Museum of Art. *The Dusseldorf Academy and the Americans.* Essays by Wend von Kalnein and Donelson F. Hoopes. Atlanta: High Museum of Art. 1972.

Hills, Patricia. *The American Frontier: Images and Myths.* New York: Whitney Museum of American Art, 1973.

Hodges, William Romaine. *Carl Wimar, A Biography.* Galveston, Tx.: Charles Reymershoffer, 1968.

Honour, Hugh. *The New Golden Land: European Images of America from the Discoveries to the Present Time.* New York: Pantheon Books, 1975.

Huntington, David C. *Art and the Excited Spirit: America in the Romantic Period.* Ann Arbor, Mi.: The University of Michigan Museum of Art, 1972.

Huth, Hans. *Nature and the American: Three Centuries of Changing Attitudes.* Berkeley: University of California Press, 1957.

Irving, Washington. *Adventures of Captain Bonneville.* Forward by Alfred Powers. Portland, Ore.: Benfords and Mort, n.d.

_____. *Astoria, or Anecdotes of an Enterprise Beyond the Rocky Mountains.* Edited by Edgeley W. Todd. Norman Ok.: University Oklahoma Press, 1964.

_____. *A Tour on the Prairies.* Preface by James Playsted Wood. New York: Pantheon Books, 1967.

Jaffe, Irma B. *John Trumbull, Patriot-Artist of the American Revolution.* Boston: New York Graphic Society, 1975.

Jefferson, Thomas. *Notes on the State of Virginia.* Edited with intro. and notes by William Peden. Chapel Hill, N.C.: University of North Carolina Press, for the Institute of Early American History and Culture at Williamsburg, Virginia, 1955.

Jenkins, Mariana. *The State Portrait, Its Origin and Evolution.* Monographs on Archaeology and Fine Arts sponsored by the Archaeological Institute of America and the College Art Association of America, III. New York: College Art Association in conjunction with the *Art Bulletin,* 1947.

Jewett, William S. "Some Letters of William S. Jewett, California Artist." Edited by Elliot Evans. *California Historical Society Quarterly* 23 (1944): 149–77, 227-46.

Jillson, Willard Rouse, *The Boone Narrative,* Louisville, Ky.: Standard Printing Co., 1932.

_____. *Filson's Kentucke: A Facsimile Reproduction of the Original Wilmington Edition of 1784.* Louisville, Ky.: John P. Morton & Co., 1929.

Jones, Howard Mumford. *O Strange New World: American Culture, The Formative Years.* New York: Viking Press, 1967.

_____. "Prose and Pictures: James Fenimore Cooper. " *Tulane Studies in English* 3 (1952): 133–54.

Joslyn Art Museum. *Artist Explorers of the 1830s: George Catlin, Karl Bodmer, Alfred Jacob Miller.* Edited by Mildred Goosman. Rev. ed. Omaha, Neb.: Joslyn Art Museum, 1967.

Kendall, George Wilkins. *Narrative of the Texan Santa Fe Expedition.* Edited by Milo Milton Quaife, Chicago: The Lakeside Press, 1929.

King, Roy, T. "Portraits of Daniel Boone." *Missouri Historical Review* 33 (1938–39): 171–83.

Knight, David M. *Natural Science Books in English, 1600–1900.* New York: Praeger Publishers, 1972.

M. Knoedler & Co. *Washington Irving and His Circle.* New York: M. Knoedler & Co., 1946.

Kuretsky, Susan Donahue. "Rembrandt's Tree Stump: An Iconographic Attribute of St. Jerome." *Art Bulletin* 56 (1974): 571–80.

Kuspit, Donald B. "Nineteenth Century Landscape: Poetry and Property." *Art in America* 64, no. 1 (Jan.–Feb 1976): 64–71.

LaBudde, Kenneth J. "The Rural Earth: Sylvan Bliss," *American Quarterly* 10 (1958): 142–53.

Lanman, Charles. *A Summer in the Wilderness.* New York: D. Appleton & Co., 1847.

Lepley, John G. "The Prince and the Artist on the Upper Missouri," *Montana, The Magazine of Western History* 20, no. 3 (July 1970): 42–54.

Lesley, Everett P., Jr. "Some Clues to Thomas Cole. " *Magazine of Art* 42 1949): 42–48.

Lesley, Parker. "Thomas Cole and the Romantic Sensibility." *Art Quarterly* 5 (1942): 199–220.

"Leutze's New Picture at The Capitol." The New York *Evening Post,* Dec. 17, 1862, p. 1, col. 2.

Lewis, G. Malcolm. "The Great Plains Region and Its Image of Flatness." *Journal of the West* 6 (1967: 11–26.

Lovejoy, David S. "American Painting in Early Nineteenth-Century Gift Books." *American Quarterly* 7 (1955): 345–61.

Lowery, Charles D. "The Great Migration to the Mississippi Territory, 1798-1819." *Journal of Mississippi History* 30 (1968): 173–92.

Ludlow, Fitz Hugh. *The Heart of the Continent: A Record of Travel Across the Plains and in Oregon.* 1870. Reprint. New York: AMS Press, 1970.

McClung, John A. *Sketches of Western Adventure.* 1832. Reprint. Mass Violence in America Series. New York: Arno Press, 1969.

McCracken, Harold. *Portrait of the Old West, with a Biographical Check List of Western Artists.* New York: McGraw-Hill Book Co., Inc., 1952.

McDermott, John Francis. "Charles Deas: Painter of the Frontier." *Art Quarterly* 13 (1950): 293–311.

_____. "George Caleb Bingham and the American Art-Union." *New York Historical Society Quarterly* 42 (1958): 60–69.

_____. *The Lost Panoramas of the Mississippi.* Chicago: University of Chicago Press, 1958.

McHugh, Tom, with the assistance of Victoria Hobson, *The Time of the Buffalo.* New York: Alfred A. Knopf, 1972.

Malin, James C. "Indian Policy and Westward Expansion." *Bulletin of the University of Kansas Humanistic Studies* 2, no. 3 (Nov. 1921).

March, David D. *The History of Missouri.* 4 vols. New York: Lewis Historical Publishing Company, Ind., 1967.

Marshall, Humphrey. *The History of Kentucky, Including an Account of the Discovery, Settlement, Progressive Improvement, Political and Military Events, and Present State of the Country.* 1812. Reprint. Berea, Ky.: Kentucky Reprints, 1971.

Martin, Cy. *The Saga of the Buffalo.* New York: Hart Publishing Company, Inc., 1973.

Marx, Leo. *The Machine in the Garden: Technology and the Pastoral Ideal in America.* New York: Oxford University Press, 1967.

Maximilian Prince of Wied. *Travels in the Interior of North America, 1832-1834.* Vols. 22-25 in *Early Western Travels, 1748-1846,* edited by Reuben Gold Thwaites. Cleveland, Oh.: The A. H. Clark Co., 1906.

Mayor, A. Hyatt. *Popular Prints of the Americas.* New York: Crown Publishers, Inc., 1973.

Merk, Frederick. *Manifest Destiny and Mission in American History: A Reinterpretation.* New York: Vintage Books, 1966.

Merritt, Howard S. *Thomas Cole.* Rochester, N.Y.: Memorial Art Gallery of the University of Rochester, 1969.

Miller, Alfred Jacob. *Braves and Buffalo: Plains Indian Life in 1837.* Intro. by Michael Bell. The Public Archives of Canada Series, No. 3. Toronto: University of Toronto Press, 1973.

_____. *The West of Alfred Jacob Miller.* Edited by Marvin C. Ross. Rev. and enl. ed. Norman, Ok.: University of Oklahoma Press, 1968.

Miller, Lillian B. *Patrons and Patriotism: The Encouragement of the Fine Arts in the United States, 1790-1860.* Chicago: University of Chicago Press, 1966.

Miner, William Harvey. *Daniel Boone: Contribution Toward a Bibliography of Writings Concerning Daniel Boone.* New York: The Dibdin Club, 1901.

Monaghan, Jay. "The Hunter and the Artist." *The American West* 6, no. 6 (Nov. 1969): 4-13.

Moore, Arthur K. *The Frontier Mind.* 1957. Reprint. New York: McGraw-Hill Book Co., Inc.

Morgan, Charles H. and Toole, Margaret C. "Notes on the Early Hudson River School." *Art in America* 39 (Dec. 1951): 161-85.

Moure, Nancy Dustin Wall. "Five Eastern Artists Out West." *American Art Journal* 5, no. 2 (Nov. 1973): 15-31.

Murrell, William. *A History of American Graphic Humor.* 2 vols. New York: Whitney Museum of American Art, 1933.

Nash, Roderick. *Wilderness and the American Mind.* Rev. ed. New Haven, Conn.: Yale University Press, 1973.

National Collection of Fine Arts. *National Parks and the American Landscape.* Essay by William H. Truettner and Robin Bolton-Smith. Washington, D.C.: Smithsonian Institution Press, for the National Collection of Fine Arts, 1972.

Neilson, Reka. "Charles F. Wimar and Middle Western Painting of the Early Nineteenth Century." Unpubl. M.A. Thesis, Washington University, 1943.

Nelson, Helen C. "The Jewetts: William and William S." *International Studio* 83 (Jan. 1926): 39-43.

"The New Picture for the Capitol at Washington," *The New York Evening Post,* Nov. 13, 1861, p. 1, col. 1.

New York Historical Society. *Catalogue of American Portraits in the New York Historical Society.* 2 vols. New Haven: Yale University Press, for The NYHS, 1974.

Noble, Louis Legrand. *The Life and Works of Thomas Cole.* Edited by Elliot S. Vesell. Cambridge, Mass.: The Belknap Press of Harvard University Press, 1964.

Norelli, Martina R. *American Wildlife Painting.* New York: Watson-Guptill, in association with the National Collection of Fine Arts, Smithsonian Institution, 1975.

Novak, Barbara. *American Painting of the Nineteenth Century: Realism, Idealism and the American Experience.* New York: Praeger Publishers, 1969.

———. "The Double-Edged Axe." *Art in America* 64, no. 1 (Jan.-Feb. 1976): 44-50.

Parkman, Francis. *The Oregon Trail.* Edited by E. N. Feltskog. Madison, Wisc.: University of Wisconsin Press, 1969.

Parry, Ellwood C., III. *The Image of the Indian and the Black Man in American Art, 1590-1900.* New York: George Braziller, 1974.

———. "Thomas Cole and the Problem of Figure Painting." *American Art Journal* 4, no. 1 (Spring 1972): 66-86.

Peale Museum. *Alfred Jacob Miller, Artist of Baltimore and the West.* Essay by Wilbur Harvey Hunter, Jr. Baltimore, Md.: The Peale Museum, 1950.

Pearce, Roy Harvey. *Savagism and Civilization: A Study of the Indian and the American Mind.* Rev. ed. Baltimore, Md.: The Johns Hopkins Press, 1967.

———. "The Significance of the Captivity Narrative." *American Literature* 19 (1947-48): 1-20.

Peck, John M. *Life of Daniel Boone.* Vol. 13 of *Library of American Biography* 2d ser., Edited by Jared Sparks. Boston: Charles C. Little and James Brown, 1847.

Persons, Stow. "Darwinism and American Culture." *The Impact of Darwinian Thought on American Life and Culture.* Papers read at the Fourth Annual Meeting of the American Studies Association of Texas, at Houston, Texas, December 5, 1959, pp. 1-10. Austin, Tx.: The University of Texas, 1959.

Peters, Fred J., comp. *Railroad, Indian and Pioneer Prints by N. Currier and Currier and Ives.* New York: Antique Bulletin Publishing Company, 1930.

Peters, Harry T. *America on Stone.* New York: Doubleday, Doran & Co., Inc., 1931.

———. *Currier and Ives: Printmakers to the American People.* 2 vols. Garden City, N.Y.: Doubleday, Doran and Co., 1929.

Porter, Mae Reed and Davenport, Odessa. *Scotsman in Buckskin: Sir William Drummond Stewart and the Rocky Mountain Fur Trade.* New York: Hastings House, 1963.

Prucha, Francis Paul. "American Indian Policy in the 1840s." In *The Frontier Challenge: Responses to the Trans-Mississippi West,* edited by John G. Clark, pp. 81-110. Lawrence, Ks.: The University Press of Kansas, 1971.

———, ed. *Documents of United States Indian Policy.* Lincoln, Neb.: University of Nebraska Press, 1975.

Ranney Collection. Catalogue of Paintings to be sold for the benefit of the Ranney Fund; bound with clippings, etc. New York, New York Historical Society.

Rathbone, Perry T. "Charles Wimar: Indian Frontier Artist." *Magazine of Art* 40 (1947): 315-19.

———. *Charles Wimar, 1828-1862: Painter of the Indian Frontier.* St. Louis: City Art Museum, 1946.

———. *Westward the Way: The Character and Development of the Louisiana Territory as seen by Artists and Writers of the Nineteenth Century.* St. Louis: City Art Museum, 1954.

Ross, Marvin C., ed. *Artists' Letters to Alfred Jacob Miller.* Baltimore, Md.: Walters Art Gallery, 1951.

Rothert, Otto A. "Harding's and Other Portraits of Daniel Boone." *Kentucky School Journal* 13, no. 1 (Sept. 1934): 41-42.

Rowland, Benjamin, Jr. "Popular Romanticism: Art and the Gift Books." *Art Quarterly* 20 (1957): 365-81.

Rusk, Fern Helen. *George Caleb Bingham, The Missouri Artist.* Jefferson City, Mo.: Hugh Stephens Co., 1917.

Rutledge, Anna Wells. *Cumulative Record of Exhibition Catalogues: The Pennsylvania Academy of the Fine Arts, 1807–1870; The Society of Artists, 1800–1814; The Artists' Fund Society 1835–1845.* Philadelphia: American Philosophical Society, 1955.

Ruxton, George Frederick. *Adventures in Mexico and the Rocky Mountains.* New ed. London: John Murray, 1861.

———. *Life in the Far West.* Edited by LeRoy R. Haven. Norman Ok.: University of Oklahoma Press, 1951.

Sanford, Charles L. "The Concept of the Sublime in the Works of Thomas Cole and William Cullen Bryant." *American Literature* 28 (1956–67): 434–48.

Saum, Lewis O. "The Fur Trader and the Noble Savage." *American Quarterly* 15 (1963): 554–71.

Schnell, J. Christopher. "William Gilpin and the Destruction of the Desert Myth." *Colorado Magazine* 46 (1969): 131–44.

Sellers, Charles Coleman. *Benjamin Franklin in Portraiture.* New Haven, Conn.: Yale University Press, 1962.

Sheehan, Bernard W. "Paradise and the Noble Savage in Jeffersonian Thought." *William and Mary Quarterly,* 3rd ser., 26 (1969): 327–59.

———. *Seeds of Extinction: Jeffersonian Philanthropy and the American Indian.* Chapel Hill, N.C.: University of North Carolina Press, for the Institute of Early American History and Culture at Williamsburg, Va., 1973.

Sickels, Robert J. *Race, Marriage, and the Law.* Albuquerque, N.M.: University of New Mexico Press, 1972.

Slate, Joseph. "A Climate Favorable to Darwinian Theories of Race: American Views of the Indian in Art and Literature, 1830–1860." *The Impact of Darwinian Thought on American Life and Culture,* pp. 73–83. Austin, Tx.: The University of Texas, 1959.

Slotkin, Richard. *Regeneration Through Violence: The Mythology of the American Frontier, 1600–1860.* Middletown, Conn.: Wesleyan University Press, 1974.

Smallwood, William Martin. *Natural History and the American Mind.* New York: Columbia University Press, 1941.

Smellie, William. *The Philosophy of Natural History.* Edited by John Ware. 4th ed. Boston: Hilliard, Gray, Little, and Wilkins, 1832.

Smith, Henry Nash. *Virgin Land: The American West as Symbol and Myth.* 1950. reprint. Cambridge, Mass.: Harvard University Press, 1970.

Spencer, Benjamin T. *The Quest for Nationality.* Syracuse, N.Y.: Syracuse University Press, 1957.

Spiess, Lincoln B. "Carl Wimar's Trip up the Missouri River in 1859." *Westward* 4, no. 2 (May 1975): 16–19.

Steckmesser, Kent Ladd. *The Western Hero in History and Legend.* Norman, Ok.: University of Oklahoma Press, 1965.

Stehle, Raymond Louis. " 'Westward Ho!': The History of Leutze's Fresco in the Capitol." In *Records of the Columbia Historical Society of Washington, D.C., 1960–1962,* edited by F. C. Rosenberger. Washington, D.C.: Columbia Historical Society, 1963.

Stein, Roger B. *Seascape and the American Imagination.* New York: Carkson N. Potter, Inc., in association with the Whitney Museum of American Art, 1975.

Stewart, George R. "The Prairie Schooner Got Them There." *American Heritage* 13, no. 2 (Feb. 1962): 4–17ff.

Stiles, Ezra. "The United States Elevated to Glory and Honor. A Sermon...preached ...May 8, 1783." In *The Pulpit of the American Revolution: Political Sermons of the Period of 1776,* edited by John Wingate Thornton. 1860. Reprint. New York: DaCapo Press, 1970.

Story, Joseph. *The Power of Solitude, A Poem in Two Parts.* New ed. Salem, Mass.: Barnard B. Macanulty, 1804.

Sunder, John E. *The Fur Trade on the Upper Missouri, 1840-1865.* Norman, Ok.: University of Oklahoma Press, 1965.

Taft, Robert. *Artists and Illustrators of the Old West, 1850-1900.* New York: Charles Scribner's Son, 1953.

Talbot, William S. "American Visions of Wilderness." *Bulletin of the Cleveland Museum of Art* 56 (1969): 151-66.

Thwaites, Reuben Gold, ed. *Early Western Travels, 1748-1846.* 32 vols. Cleveland: The Arthur H. Clark Co., 1904-07.

Todd, Edgeley W. "Indian Pictures and Two Whitman Poems." *Huntington Library Quarterly* 19, no. 1 (Nov. 1955): 1-11.

Tuckerman, Henry T. *Book of the Artists: American Artist Life.* New York: G. P. Putnam and Son, 1867.

———. *A Memorial of Horatio Greenough.* 1853. Reprint. New York: Benjamin Blom, 1968.

———. "Over the Mountains, or The Western Pioneer." *The Home Book of the Picturesque, or American Scenery, Art, and Literature,* pp. 115-35. New York: G. P. Putnam, 1852.

Turner, Justin G. "Emanuel Leutze's Mural *Westward the Course of Empire Takes Its Way.*" *Manuscripts* 18, no. 2 (Spring 1966); 4-16.

Tuveson, Ernst Lee. *Redeemer Nation: The Idea of America's Millennial Role.* Chicago: University of Chicago Press, 1968.

Voelker, Frederic E. "The French Mountain Men of the Early Far West." In *The French in the Mississippi Valley,* edited by John Francis McDermott. Urbana, Ill.: University of Illinois Press, 1965.

Wadlington, Walter. "The *Loving* Case: Virginia's Anti-Miscegenation Statute in Historical Perspective." *Virginia Law Review* 52 (1966): 1189-1223.

Wagner, Henry R. *The Plains and the Rockies: A Bibliography of Original Narratives of Travel and Adventure, 1800-1865.* 3rd ed., rev. Charles L. Camp. Columbus, Oh.: Long's College Book Company, 1953.

Wallach, Alan P. "Cole, Byron, and *The Course of Empire,*" *Bulletin* 50 (1968): 375-79.

Ward, John William. *Andrew Jackson: Symbol for an Age.* 1962. Reprint. New York: Oxford University Press, 1973.

Washburn, Wilcomb E., ed. *The Indian and the White Man.* Documents in American Civilization Series. Garden City, N.Y.: Doubleday & Co., Inc., 1964.

Webb, Walter Prescott. *The Great Plains.* 1931. Reprint. New York: Grosset & Dunlap, 1957.

Webber, C. W. *The Hunter-Naturalist: The Romance of Sporting.* Philadelphia: Lippincott, Grambo & Co., 1852.

Wecter, Dixon. *The Hero in America: A Chronicle of Hero-Worship.* New York: Charles Scribner's Sons, 1941.

Weinberg, Albert K. *Manifest Destiny: A Study of Nationalist Expansionism in American History.* 1935. Reprint. Chicago: Quadrangle Books, 1963.

Welter, Rush. "The Frontier West as Image of American Society, 1776-1860." *Pacific Northwest Quarterly* 52 (1961): 1-6.

Westervelt, Robert F. "The Whig Painter of Missouri." *American Art Journal* 2, no. 1 (Spring 1970): 46-53.

Williams, George Huntston. "The Wilderness and Paradise in the History of the Church." *Church History* 28 (1959): 3-24.

Wimar, Carl. Carl Wimar Papers. St. Louis Missouri Historical Society, Archives and Manuscripts Division.

Winther, Oscar Osburn. *A Classified Bibliography of the Periodical Literature of the Trans-Mississippi West (1811–1957).* Bloomington, Ind.: Indiana University Press, 1964.

Zanger, Jules. "The Frontiersman in Popular Fiction, 1820–1860." In *The Frontier Re-examined,* edited by John Francis McDermott, pp. 141-53. Urbana, Ill.: University of Illinois Press, 1967.

Index